8658/12
£29.95.

# THE ALLURE OF MEN

391.1
BAU

© Assouline Publishing
601 West 26th Street, 18th Floor
New York, NY 10001
www.assouline.com

Translated from the French by Simon Pleasance and Fronza Woods

Color separation: Gravor (Switzerland)
Printed and bound by Canale (Italy)

ISBN: 2 84323 215 5

*Front cover*: Portrait of Gary Cooper by Cecil Beaton, 1931.
*Back cover*: Jean-Michel Basquiat, at the *Palladium* in May 1985.

# FRANÇOIS BAUDOT

# THE ALLURE OF MEN

ASSOULINE

# THE ALLURE & THE MEN

T hrough pictures, selectively juxtaposed, our perforce subjective intent here is to single out some of the molecules which have gone into the creation of the masculine look and style since the Romantic period. For it was in that period that the form and outline of today's man started to take shape. Allure, which is a mixture of magnetism and movement, doesn't have to do either with the resources of the individuals giving expression to it, or with their background or circles. In all the variants currently espoused by the term, the "look" touches on all generations and involves the most diverse of conditions, be they social or geographical. It may embrace outdated traditions. It may refer to exotic costumes. It may convey appreciable differences in the way clothes are made and the art of putting them together. Be the look hostile or familiar, rebellious or civilized, modest or haughty, allure is rootless and futureless, and has no precise explanations or motives. It does not even have any specific usefulness. It doesn't pay. It can even end up costing a lot. That's natural. It's a pointless act.

Two centuries of evolution have witnessed a thousand and one metamorphoses of the masculine image. Yet this saga has less to do with a history of fashion than with a history of behavior and comportment. The look is a gentle mix of customs and wear and tear. It is also associated with economic standards, class struggles, the imaginary, a culture, countless weighty matters and a dash of vital lightheartedness.

*Introduction*

Covering. Choosing. Convincing. Collecting… Creating a look. Coming up with a style. Every piece of clothing contains within it a certain number of signs. In the modern man, these signs are usually discreet, though much less so in his feminine counterpart. As a direct extension of the skin, and more or less as sensitive, eruptive

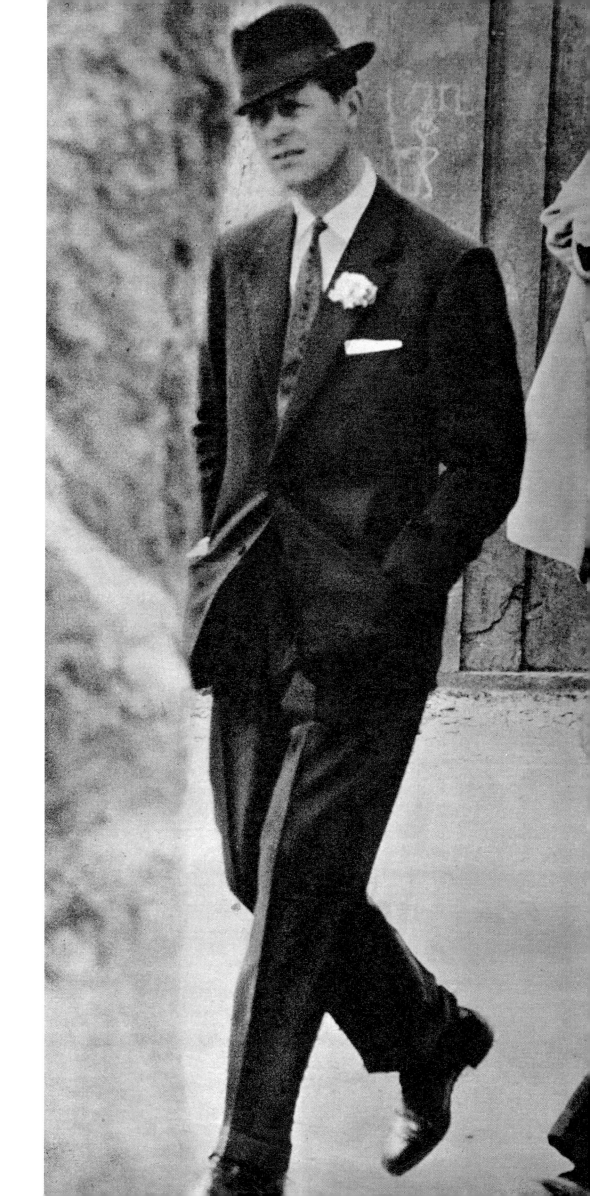

Philip, Duke of Edinburgh,
in London during the fifties.

and vulnerable as nakedness, the outer wrapping often has quite a lot more to it. No appearance, no apparel, and no look are ever altogether neutral. Any more than a military uniform does away with all trace of individuality, or the monk's habit dodges all manner of showiness. As for Adam's birthday suit, the history of art shows that it conveys its very own fashions promoted as ever-changing canons, from the Primitives of the Middle Ages to Bruce Weber's models, by way of Michelangelo's anatomical studies and Canova's nudes. Just the outline, perhaps?... But then life steals away. The fact is that fashion is made to be experienced and lived. At the very least to bring back memories. When all we can recall of a departed one is the silhouette. A shadow puppet of the clothes he wore like nobody else. In the year 2000, how many students retain of André Malraux just a blurred image squeezed into the clothes of a young adventurer. A simple cocked hat makes Napoleon loom large. Mao, deceased, stays in his Mao suit. All of Joan of Arc is contained in a hairdo. Richelieu can be summed up by a shoe. Jean Cocteau's look has outlived his poetry. Andy Warhol's is still more decipherable than his work. For thousands of intertwined bodies, Calvin Klein is just a label. The label, on a pair of underpants, that points to the final step to cloud nine. As for Gianni Agnelli, who still reigns peerlessly over Italian hearts, does he have his power to thank for this, or his haughtiness? The same applies to Winston Churchill, that hero whose unforgettable elephant-like profile sported an absolute elegance, no matter what the circumstance. In this way, by adding more and more examples, we might emphasize the role that the composition of his appearance has played for man, from time immemorial. Yet through a paradox that is tacitly accepted in the modern West, this subject is still taboo at the dawn of the third millennium.

If the so-called stronger sex does have style, it only exists provided that it is never talked about. The world of masculine dress is one of silence, which is only violated at the risk of there being dire ambiguity. Obliged to leave things unsaid, any development in the masculine look occurs by would-be natural shifts, with no conspicuous break. Whence a dearth of comment inversely proportionate to those enjoyed since the year dot by feminine fashion. The fashion system, as introduced in the mid-19th century, with the advent of haute couture, roundly spares the male half of the Old World. Giving the impression that for the middle-class gent, his integrity is at stake. Even if each season, for the most part, it is men who decide what women will wear. There is no feminine counterpart of "grand couturier."

Yet up until the demise of the Ancien Régime in France, the undisputed arbiter of fashion, the two sexes vied to outdazzle the other, uncomplexed and uninhibited. Yet from Antiquity to the end of the Middle Ages, men wore dresses. Yet, in the animal

kingdom, it is accepted that the male's lustre outshines the female's. Yet, within religious congregations and the law, in many faraway lands, from the popes to the sultans, from African kings to Balinese dancers, men do not know what trousers are, and still show a sense of finery, taste and embellishment. Whatever!

Since the emergence of the industrial society across the Channel, at the very end of the 18th century, masculine dress in Europe kept a low profile. Apart from one or two peripheral circles--treated henceforth with caution--its classicism, recycling all manner of invention and new discovery, reworked the style, with time, into a unique formula--that of the suit. It was an eloquent metaphor, since it described both a specific item of clothing and the sum of all the others. As if the unsinkable "suit-and-tie" twosome, dear to the contemporary managerial class, represented the sole, intangible and unsurpassable synthesis of masculine elegance. So much so that many women, themselves preoccupied with efficiency, adopted it for themselves, with a few variants. Like a new version of armor. For use by an executive who likes to think of himself as a winner.

George Bryan Brummell, born in 1778, is reckoned to be the father of the modern suit. He made his appearance among the entourage of the English Regent 20 years later. This inveterate, impertinent, unruffled gambler managed to enthrall all London in just a few months, without ever showing an ounce of ambition or stature. "Beau Brummell," manipulative and magnetic, but with no illustrious genealogy, was the self-proclaimed arbiter of everything one should do to deserve the untranslatable epithet, "fashionable." Going against the grain of those then wielding power, his refinement espoused a radical stance. Inveighing squarely against the garish habits of the elites, this stance banished ribbons and bows to the attic of the Ancients. And accommodated nothing less than the strictest kind of dress. More or less unchanging in its sobriety, the young man's style came into its own. People imitated it. It spread abroad from London throughout Europe. So much so that Brummell's very name became part of ordinary vocabulary. A phrase he is credited with sums up everything that was innovative and abstract about this sartorial conduct: "Real elegance goes unnoticed". Borrowed time and again, and, needless to add, too often, this pithy canon, which ended up losing any hint of subversiveness, still encapsulates the deliberate confinement in which the masculine look then became entrenched. A form of asceticism that was all the more severe because it posed as something happy-go-lucky. From Balzac to Baudelaire, Lord Byron to Barbey d'Aurevilly, and Drieu La Rochelle to Romain Gary, a whole literature attests to this difficulty of being. Such that it forever haunts the male individual facing his own image in front of the

cheval-glass of his dressing-room.

Modern woman, a second-class citizen to whom, until the mid-20th century, the law granted no more than minimal rights, must make do with the albeit considerable powers created by her charms. This clear-cut splitting of the world into two made the Romantic age both inapplicable and incomprehensible to men--the reasons and passions informing feminine elegance.

As a commoner of somewhat obscure ancestry, the 20-year-old Brummell, triumphant in the mere authority of his insolence, would, in the end of the day and for these selfsame reasons, end up rejected, in debt and exile. He died in a French lunatic asylum in 1840, in superb solitude and indifferent to his own self. Thus did he scale the absolute heights of dandyism. A posture which can only exist if an arm's length is kept between it and the society it is distancing itself from.

Would Brummell have remained in the collective memory had one of the major shifts in masculine behavior to occur since the Renaissance not become embodied, at the right time, in his symbolic figure? The end of the French monarchy as a prelude, in Europe, to five decades of upheavals. The isolationism of England, the spirit of democracy that developed there at a very early stage, the excessive soft spot for the outdoor life and physical exercise, and the absence of any etiquette which, at the end of the 18th century, still made so many European courts so starchy, all this made England a harbinger and forerunner admired by many enlightened minds. The Anglo-Saxon propensity for a kind of Puritanism. The fact that, unlike the continental aristocracy, this latter island counterpart was entitled to indulge in industrial and commercial pursuits, whereby it often chalked up considerable profits, in tandem with the development of English textile mills and their early experiments with mass-production... Between Revolution and Empire, all these circumstances would redefine patterns of behavior and men's current attire for the next two centuries. So the quality of hosiery, along with the quality of the cut, the yarn, cotton and wool, the weave, the texture and the shades of colour, would take over from the garish style dictated by the Ancien Régime, and replace that eye-catching panache with a new and subtle code. A way of being and looking gradually came into being that was compatible with the philosophy of the Enlightenment and the new ruling class. The famous dictum "more is less" coined by Mies van der Rohe for the international architectural style in the 1920s, merely borrowed Brummell's aphorism for dress, albeit for a slightly different subject.

A small boy adjusts his tie before the impressive mirror in the foyer of the *Grand Hotel*, St. Moritz, 1932.

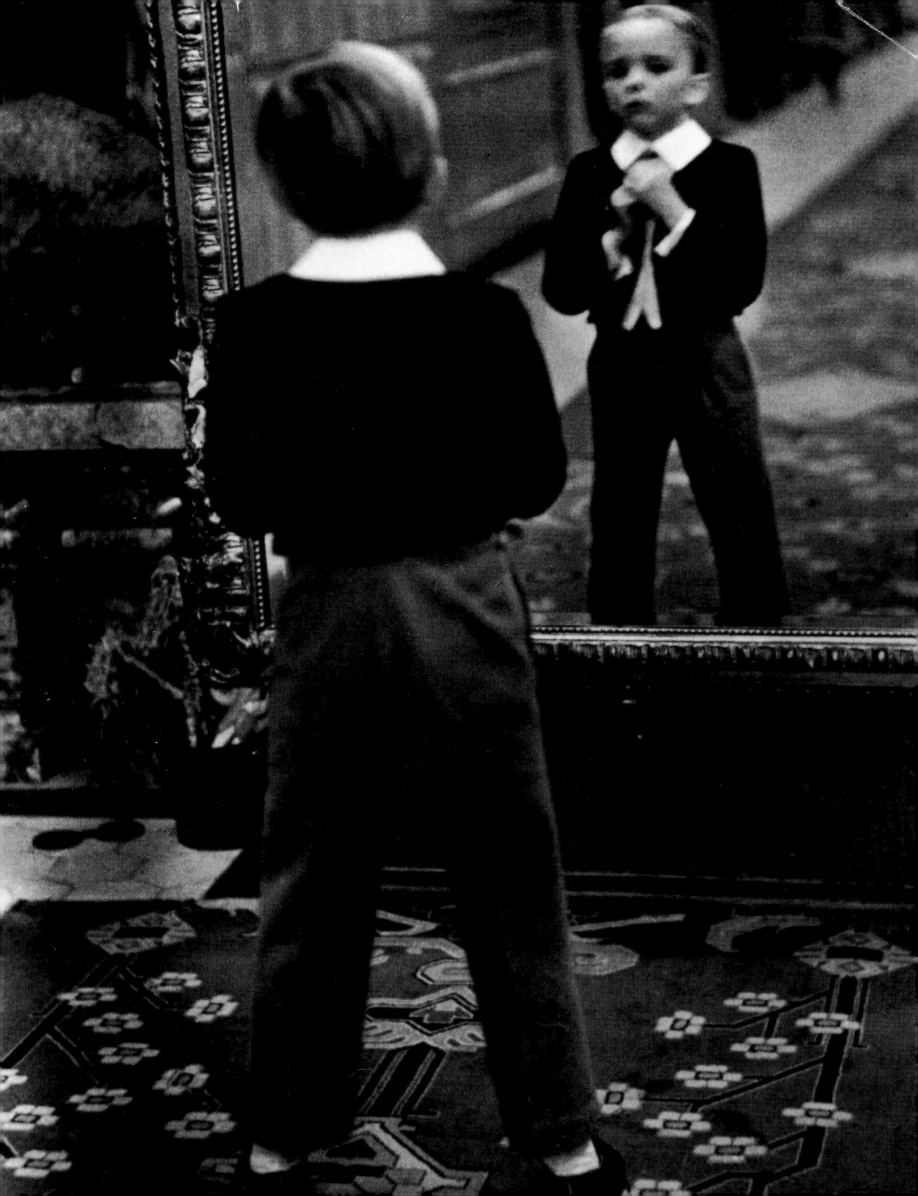

In their quest for simplification, abstraction and the unsaid, modern artists, from those belonging to the Bauhaus and De Stijl to a whole American art avant-garde, would take this minimalist movement to its culmination before it was even invented. It is still strange, however, that the cut of a simple frock coat, two hundred years ago, should have so prosaically permitted the very first clear-cut declaration of this claim to economy. Having become the watchword for a whole life-style, simplicity would turn into the last sanctuary for complicated people.

Made up of next to nothing, yet never any old how, men's dressing-rooms have still had their own precise codes for two centuries. The way they have evolved has been not so much slow as subject to brief upheavals surreptitiously permeating the social corpus. Thus, at regular though unpredictable intervals, without anyone having passed the word on, everyone is agreed, one fine day, that a jacket should have three rather than two buttons; that a shirt collar should be elongated, or rounded, or made smaller, or worn unbuttoned. It only takes the slightest thing for a wider jacket lapel, or a deeper turn-up of the trousers, to make the narrowness of the previous styles look ridiculous and dated, styles which in turn…, and so on and so forth. Frizzy hair. Shaved head. Crew-cut. Razor cut… Jeans may be faded or ripped, clinging or flared! Anything goes! Nobody says a word about it. For man usually only defines his choice of clothes by turning his back on their opposites. There is no need for Peter or Paul to adopt a stance towards this style or that. All they need to do is reject the others. Period. Got it. All these decrees swiftly become passwords. Imperceptible landmarks revealing a man's membership of his day and age. This is why many men--and this is by no means their least charming feature--remain loyal all their lives to the stylish looks of their heyday. The fact remains, however, that none of these considerations explains what we call a "look," an "allure".

It is a well-kept secret that a look is neither a quality nor a talent, but rather a special kind of elegance. People either have it, or they don't. In both instances, it is beyond dispute! Most of those who do have it are born with it. While pretending invariably not to realize it. As for the rest, they wonder what they might have to do to come by it. And the more they look and wonder, the less they discover.

A look is as incommunicable as it is inexpressible, and bestows no title. It is happy merely to assert a differentness. Time alone decides which masculine figures will really give the events of a particular period relevance. As far as our era is concerned,

James Joyce in Paris during the twenties,
when his *Ulysses* was published.

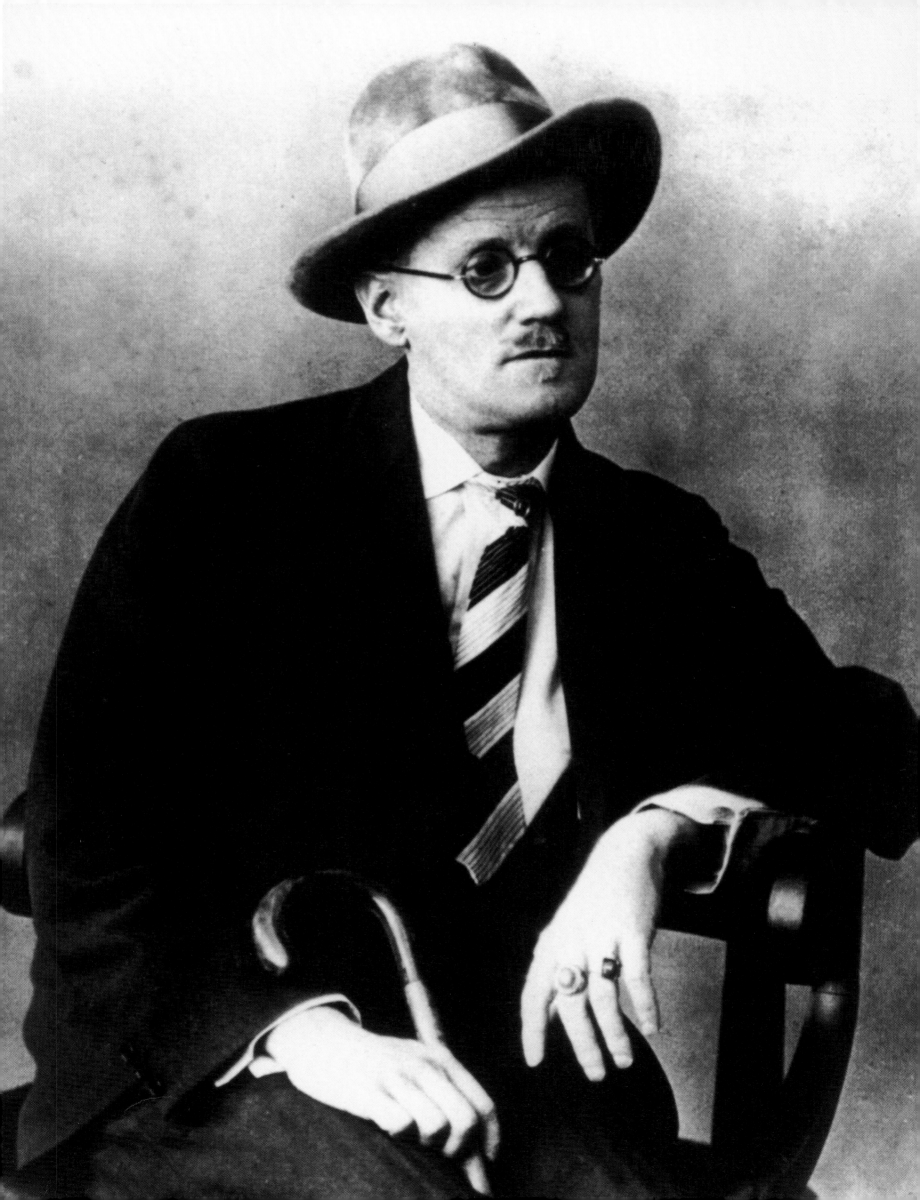

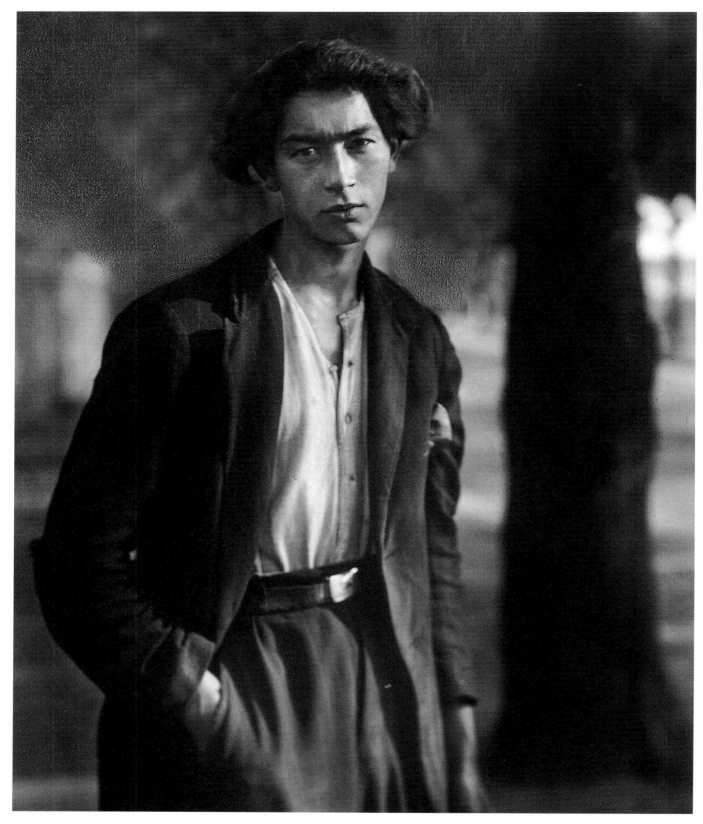

*Above:*
Portrait of a young gipsy, by August Sander, Germany, 1938.

*Opposite:*
Yohji Yamamoto, by Alexia Silvagni, photographed in Nagaoka in 1999.

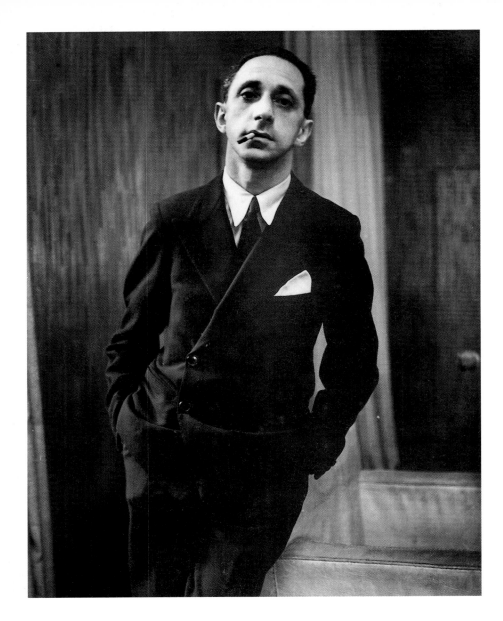

nothing points to any imminent revolutions in this area. But what is developing more rapidly than basic sartorial principles is the way clothes are being worn nowadays. The way stereotypes are being subverted. So that they can be adapted to new requirements in terms of comfort and originality. In this game, the look becomes a master trump card. For it is the allure that makes all the difference.

Without clothing worn, rubbed, and touched by reality. Without any confrontation with the things of life. Without regret, without some remorse, there would be no history of the masculine look. The slightly too well established separation of their respective roles would have women forever in search of endless novelty. While men would only agree to change provided that they remain themselves. One would be versatile, while the other is meant to be constant. At a time when man is also becoming an object of desire and the subject of exponential depiction, this *de facto* division might well have had its day. In twenty years, the world economy has become aware of the considerable potential still represented by masculine consumption of a wide range of products: clothing, accessories, fragrances, and cosmetics... The differences level out beyond the world of men and the world of women. By gaining real freedom, women are

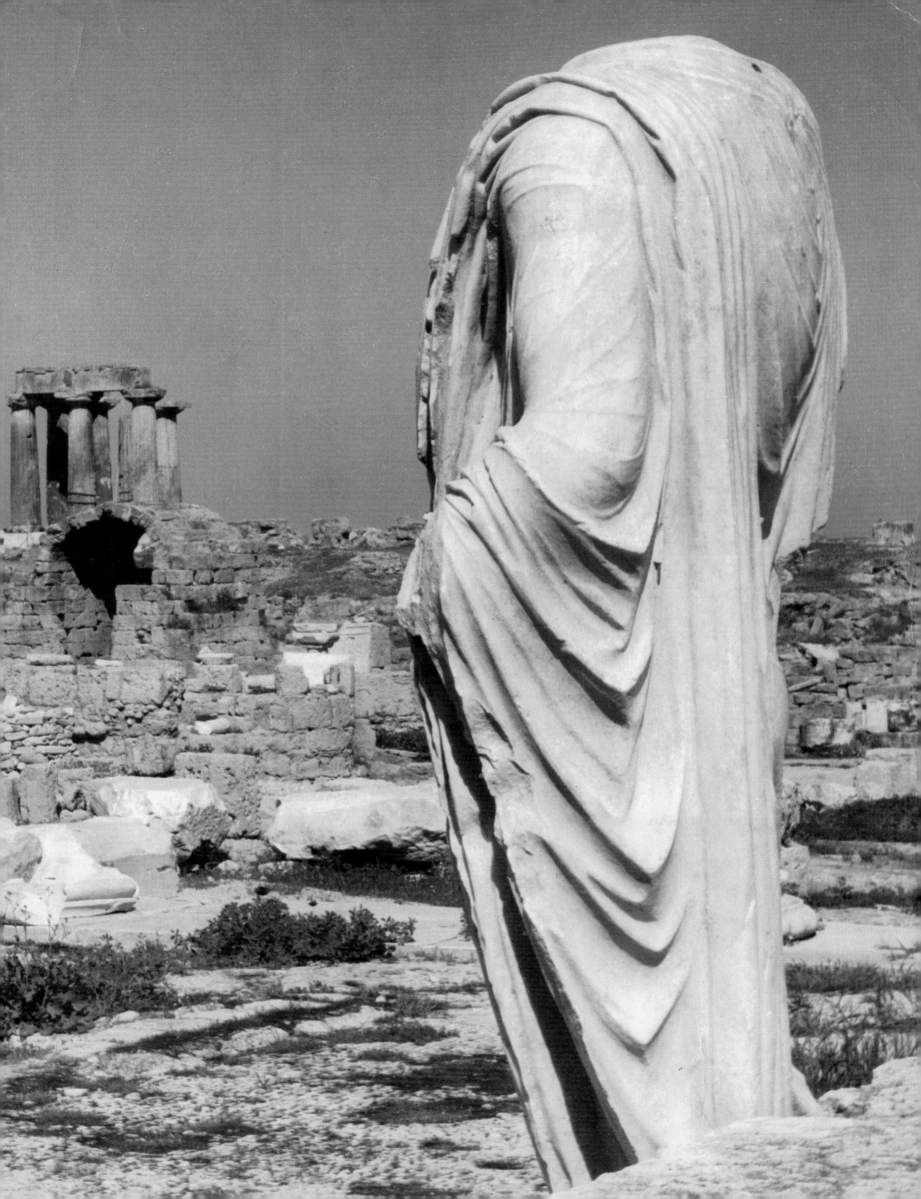

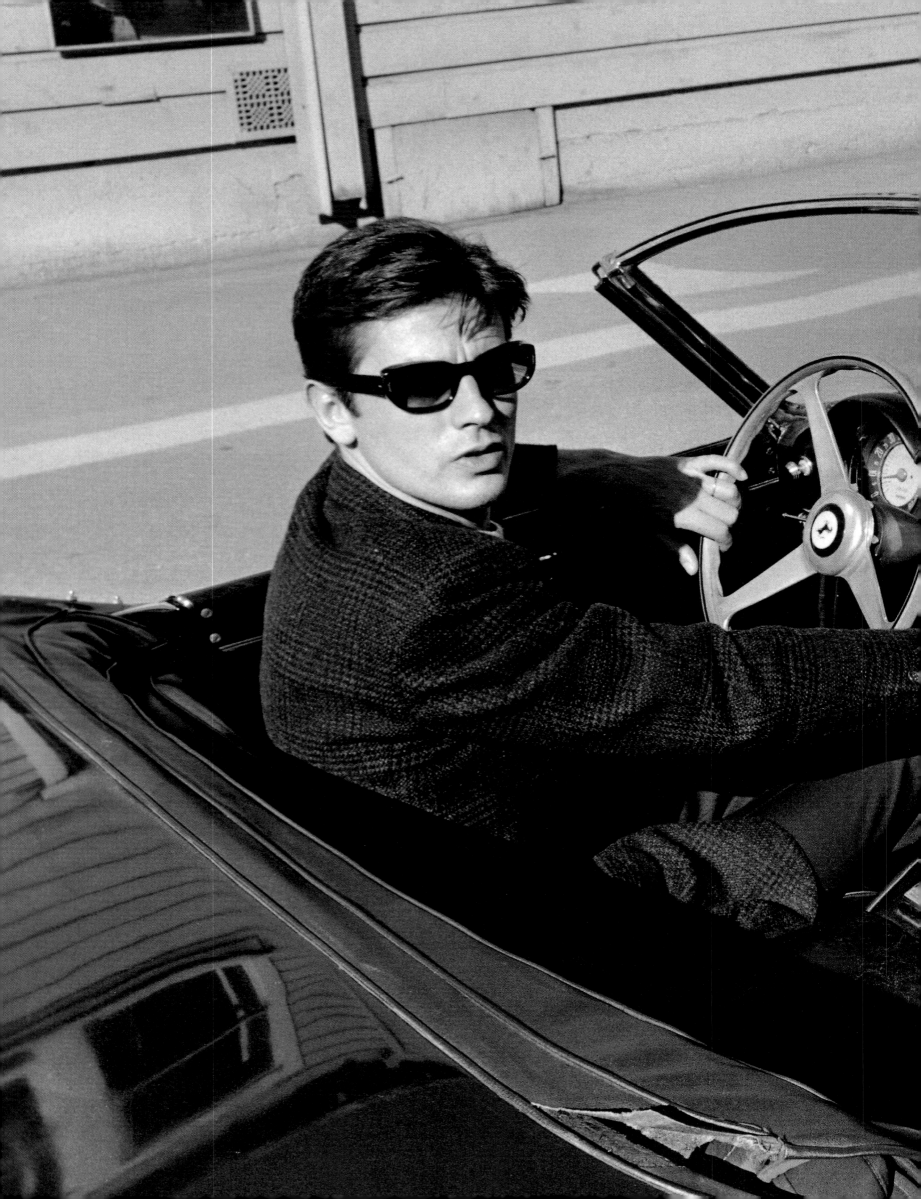

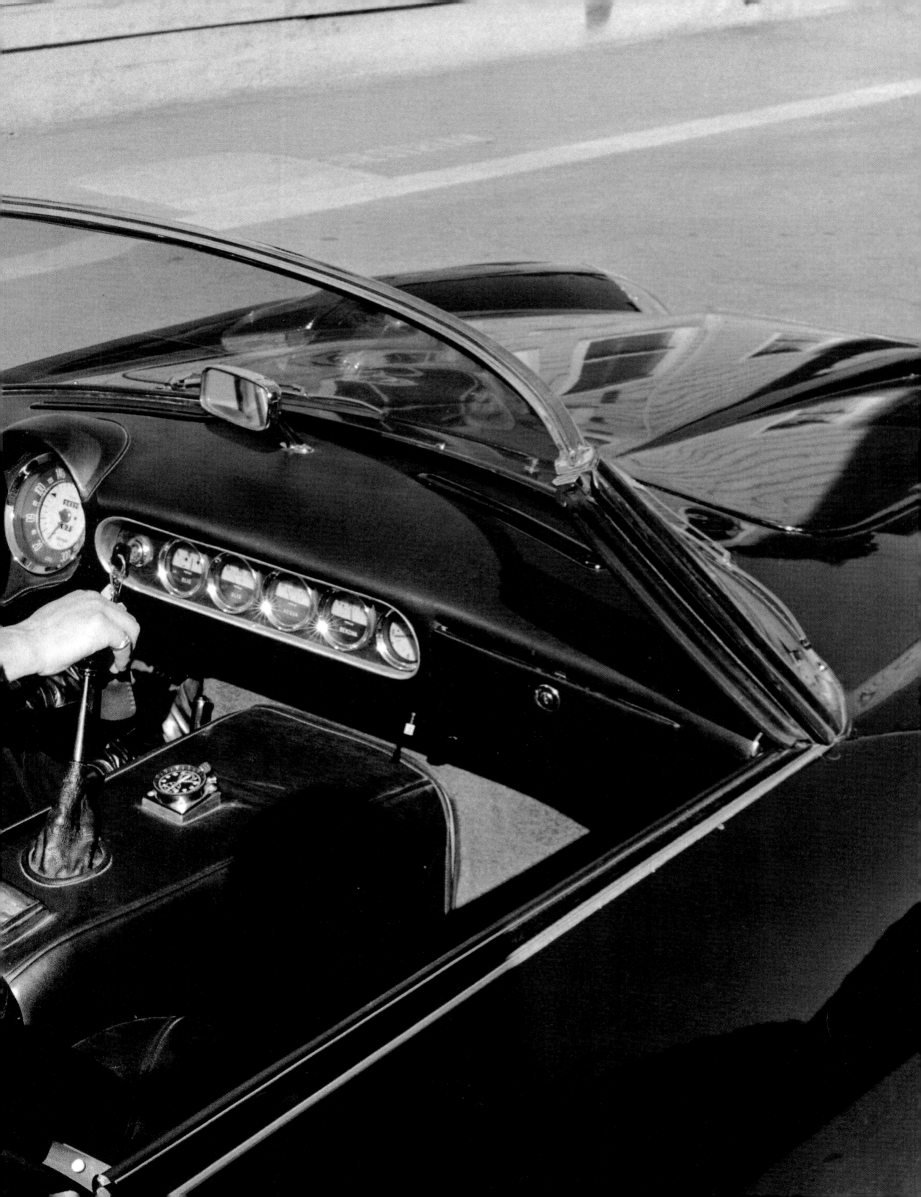

claiming their rights and getting them today in a much more obvious way.

So it is perhaps not a bad thing to go back over the past two centuries during which the sartorial codes of classic masculine elegance have been drawn up. The rebellions still being triggered by these codes today are happening simultaneously. From the grand Savile Row tailor to mass produced clothing, from the dandy to the punk, from the Parisian to the Latino, and so on and so forth, a whole gallery of creative individuality is unfolding through the handful of items in the masculine wardrobe. This series of positions, with its delicate balance but bewitching through its ongoing renewal, sketches a history of simplicity within a society governed by the law of the largest number. Because photography's freeze-frames enable it to suspend the quick sketch in mid-air and because photography freezes it, this has been the memory of this society from the outset. Thanks must thus be given to those whose pictures make up this anthology. Each picture shows that its author, himself, possesses this component--a sense of the split-second integral to the subject concerning us.

### History

The plentiful hairiness of our caveman ancestors did not stop them bedecking themselves with the fur of the wild creatures that they drew and quartered. To protect themselves from the cold? Probably, but didn't some kind of barbaric vanity play a part, even then, in this assertion of the rights of the mightiest? A few episodes later, Hercules donned the hide of the lion of Nemea, classical statuary made this its trade mark. Before, the demi-god will have succumbed to the charms of the Lydian queen. She cast such a successful spell over him that he let himself be dressed like a woman and crowned with flowers, as he played his lyre at her feet. Although mythology tolerates disparate, muddled feelings, its judgment of this foreshadowing of the man as an object is severe. Long tunics were worn by men up until the Renaissance, but they never prompted them to shed their responsibilities. The tunic is even a distinguishing feature of the clergy, scholars, and the nobility… groups of people who do not work with their hands.

Throughout the Middle Ages, Christianity merges its faithful souls--with the exception of a few symbolic figures--in the unisex anonymity of the pure alb of the elect. The earliest depictions of real people are usually dated from 1434, with Van Eyck's portrait of the Arnolfini's. Since the mid-14th century, the gradual abandonment of long,

*Preceding pages:*
French actor Alain Delon in *Once a Thief,*
movie directed by Ralph Nelson, 1964.

*Opposite:* Baron Nicolas de Gunzburg poses for Horst, Paris, 1934.

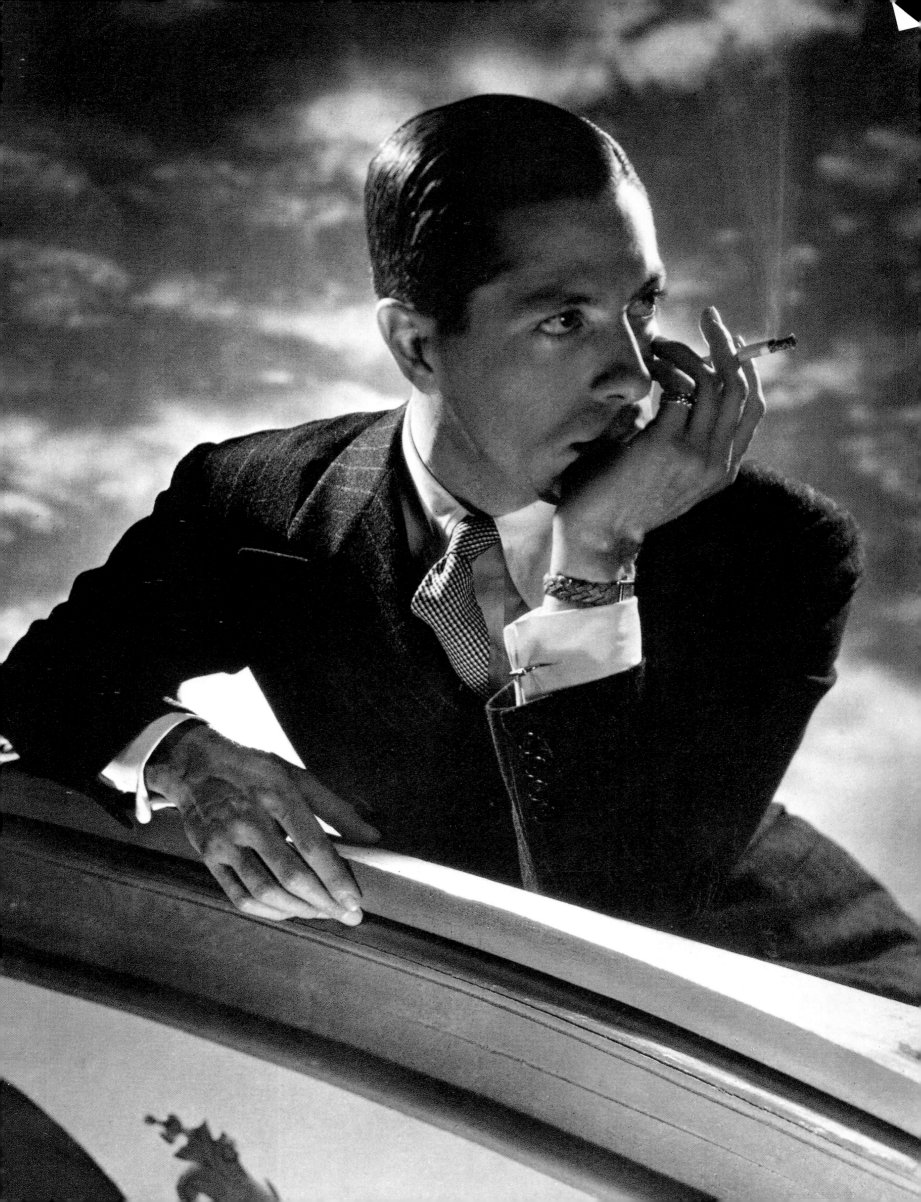

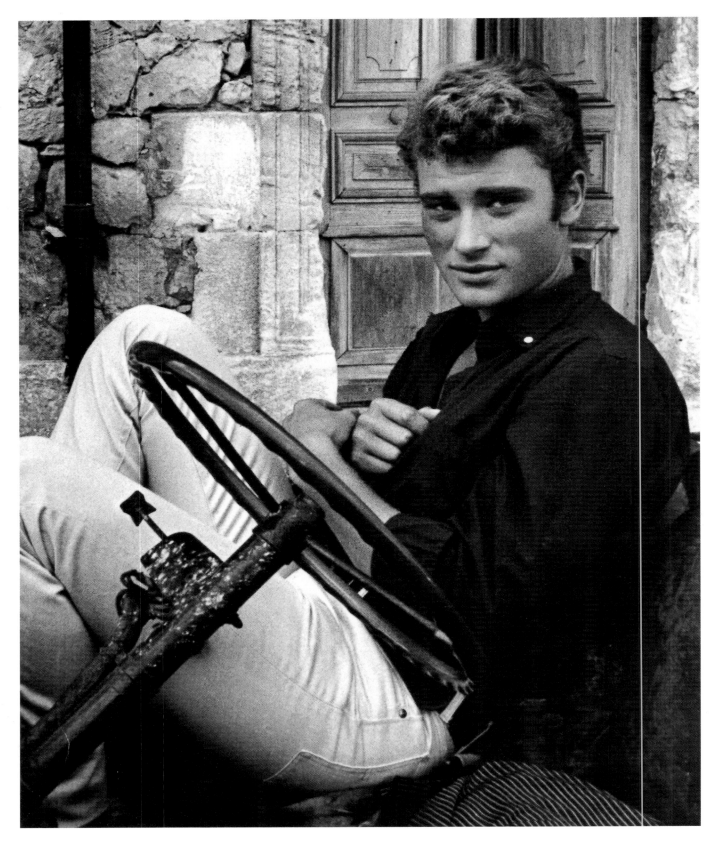

*Above:*
Johnny Hallyday during the filming of the documentary *D'où viens-tu Johnny?*,
directed by Noël Howard, 1963.

*Opposite:*
General De Gaulle, serving as President of the temporary government
of France at the end of the Second World War, 1945.

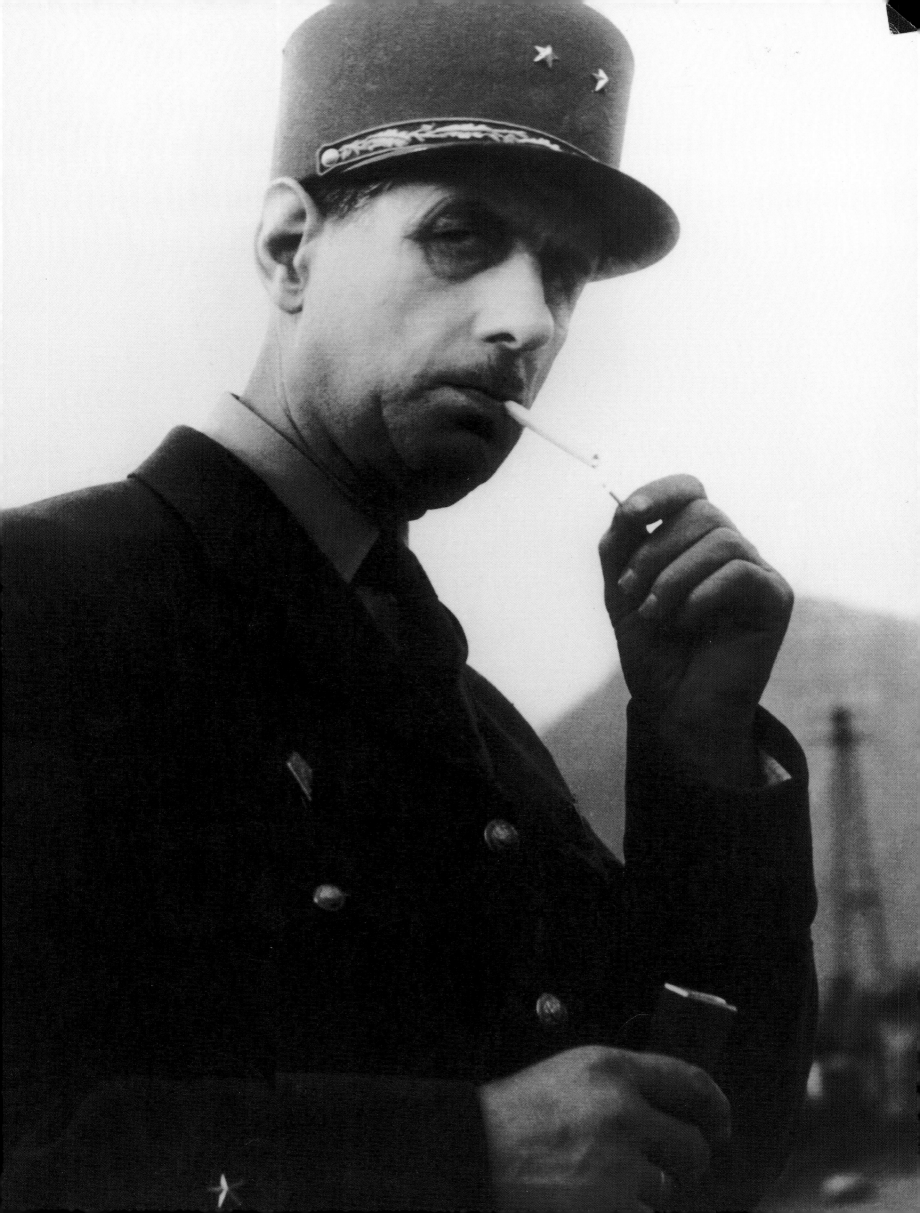

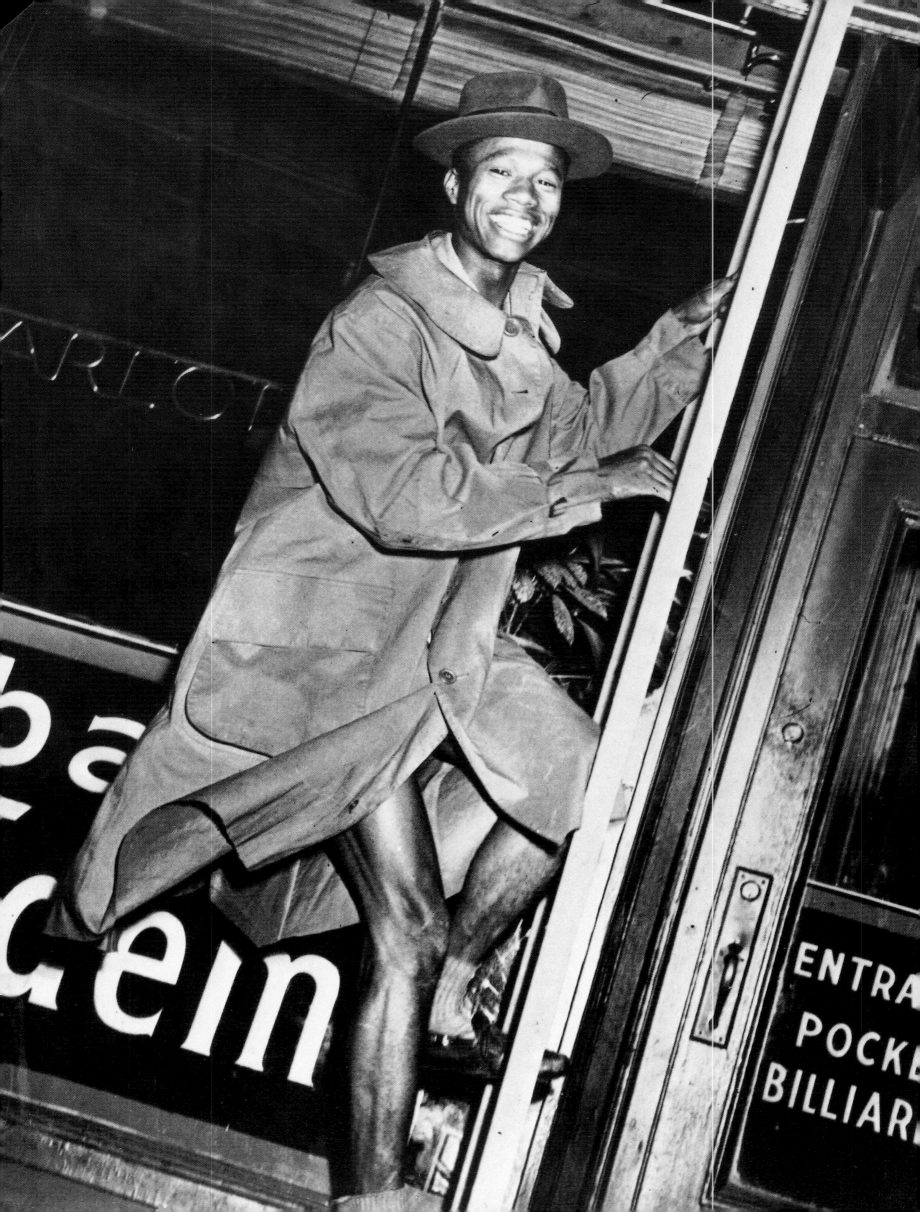

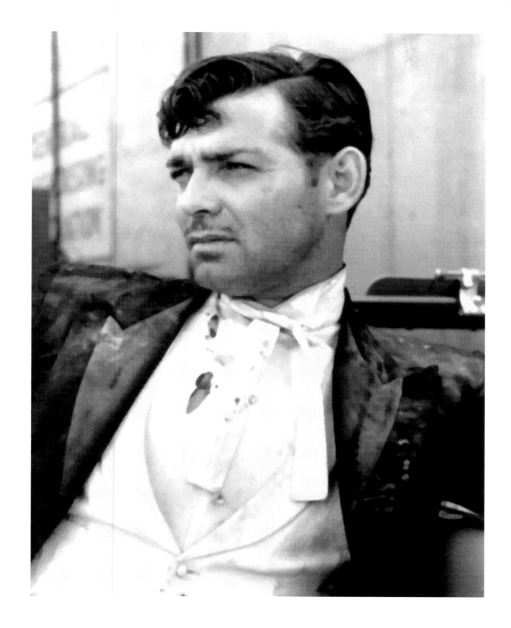

flowing attire, worn by both men and women, triggered the first and possibly only true revolution in male dress of the second millennium. While lords loosened their hold over the peasantry. In order to join forces with a courtly society, the middle-classes began to expand through trade. From that moment on, given that purchasing power was on the rise in all European societies, masculine dress was enhanced by items which had less to do with any established order or strict necessity than with pure fantasy. These distinctive identities, influenced as they were by national taste and local production, developed apace. During the 14th and 15th centuries, individuality for one and all became the decisive factor in the way people looked. This reassertion of the ego, encouraging humanism to the detriment of religiosity, oversaw an exponential growth of signs of refinement and elegance. From that time on, it was possible to talk in terms of fashions, in the broadest sense of the term--even if these fashions complied with cycles and obeyed very different laws from what we understand thereby today.

Jewelry, lace, ribbons, embroidery, and patterns of every kind became personality-forming factors for Renaissance man. And all the more so because the discovery of

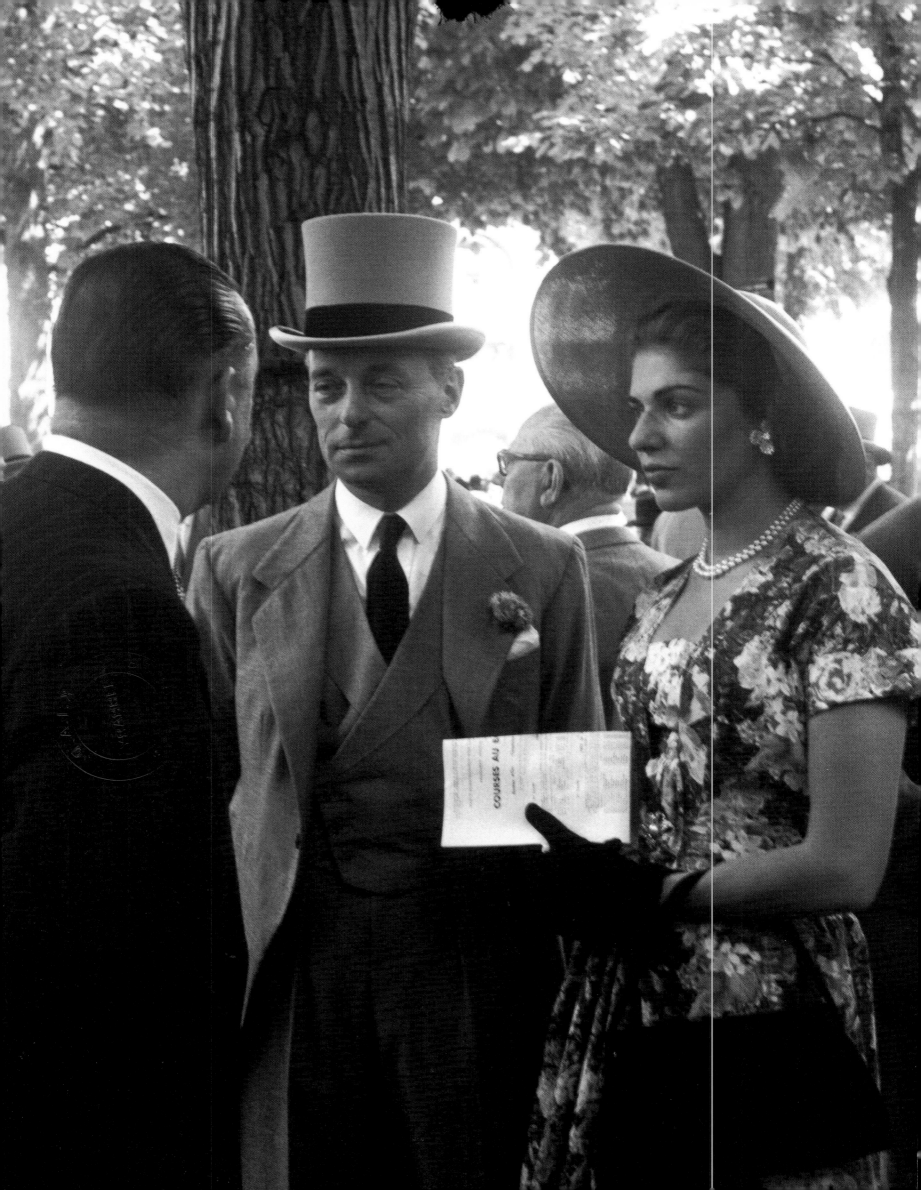

distant lands which were promptly colonized brought a flood of precious materials and stones to Europe. Craftsmen, often hailing from Italy, handled them with ever greater virtuosity. Before long, large factories sprang up and made fine fabrics less of a rarity. In the 16th century, luxury had become a concept in its own right. As both product and symbol, luxury reasserted the status of the lords and their ladies in society. Even if it was the prince, with his pivotal power, who, through protocol, laid down the standards of finery in most European courts. In spite of the differences peculiar to each court, those of Italy, Spain, England and France obeyed the same rules of excess. We still have evidence of this today in portraits painted by Bronzino, Velázquez, Clouet and Holbein… The regions which subscribed to the Lutheran Counter-Reformation, represented the only exceptions to this glitzy game of finery. Following the example of the Netherlands, they formulated an austere and sombre style. Most of the countries of northern Europe would adopt it, often right up until the 20th century. Similarly, the pioneers who set off, wearing black frock coats and clutching Bibles, to open up the New World, would also impose this Puritan look throughout North America. On that side of the Atlantic, it was not until the hippy movement that colorful attire for men stopped being associated with the noble savage. But apart from these most inflexible Protestants, dress under the Ancien Régime generally involved pleasure and quest, putting men and women on an equal footing--and even pitting them against each other.

Whatever the appreciable developments shown by the sartorial fantasy of court costumes may have been, it still evolved slowly enough for each costume period to be categorized--as with furniture--under the name of the monarch in power at the time. The picture is definitely simplistic, but it enables us to flit quickly to the 20th century. Fashions then picked up speed, as did production and consumption. From then on, fashions would be identified by decades--and today, even by seasons.

In the development of dress for the courtier, it was, above all, the details which, down the years, made the difference, until Louis XIV came to power. This crucial stage in the history of the look involving an assertion of his absolutism, led the Sun King to use masculine clothing as nothing less than a political instrument. The young sovereign, who had been elected by divine right, and personally took over the running of matters of State, also set himself up as the artistic director for a whole era. Even before embarking on the grand buildings which marked his reign, and styling himself as the

Baron Guy de Rothschild and the Baroness
at the Longchamp racetrack, c. 1955.

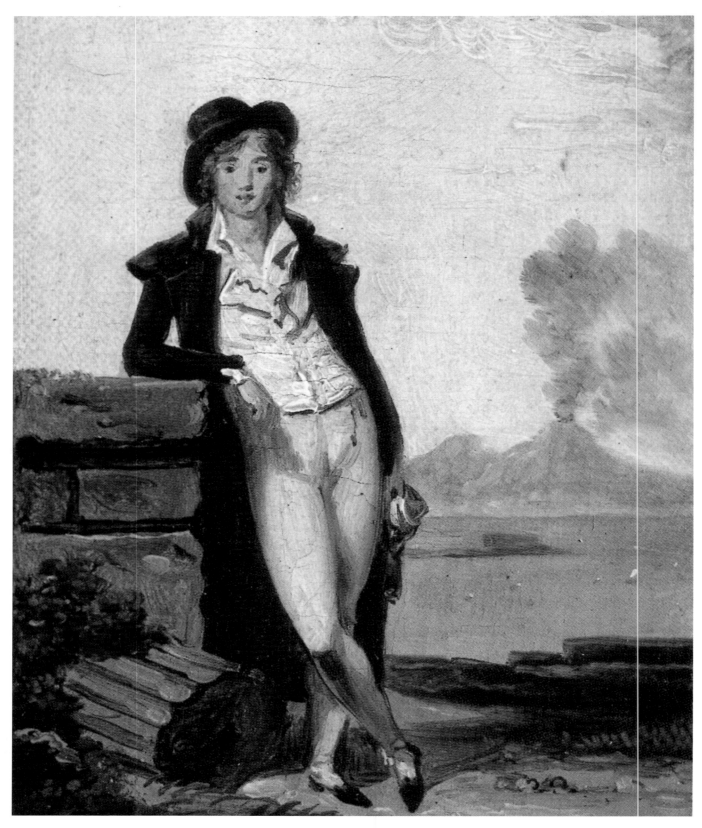

*Above:*
Full-length portrait of a young man in front of Vesuvius,
by Louis Gauffier (1761-1801). Once belonging to Karl Lagerfeld,
excerpted from Christie's catalogue, New York, May 23, 2000.

*Opposite:*
Coco Chanel on vacation in Biarritz, here in the company of dancer Serge Lifar, 1935.

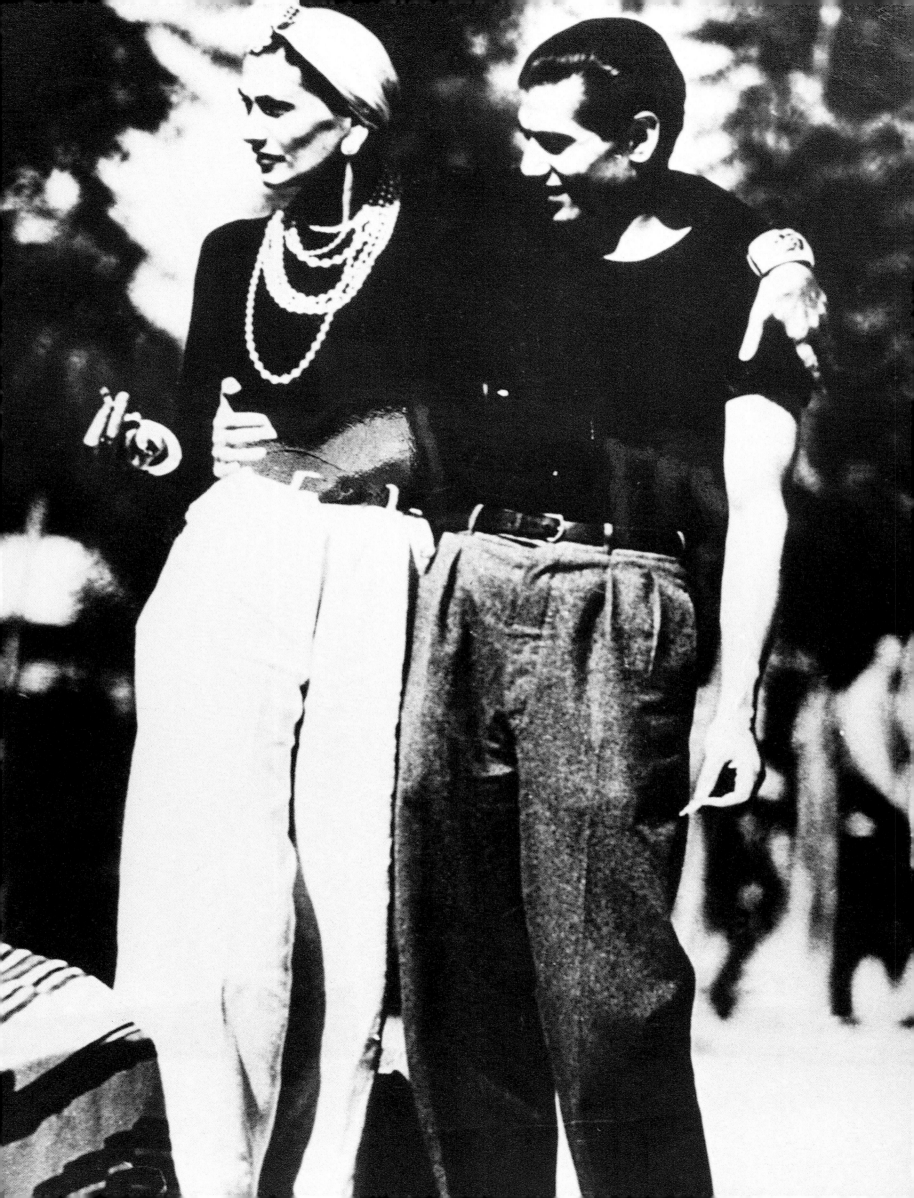

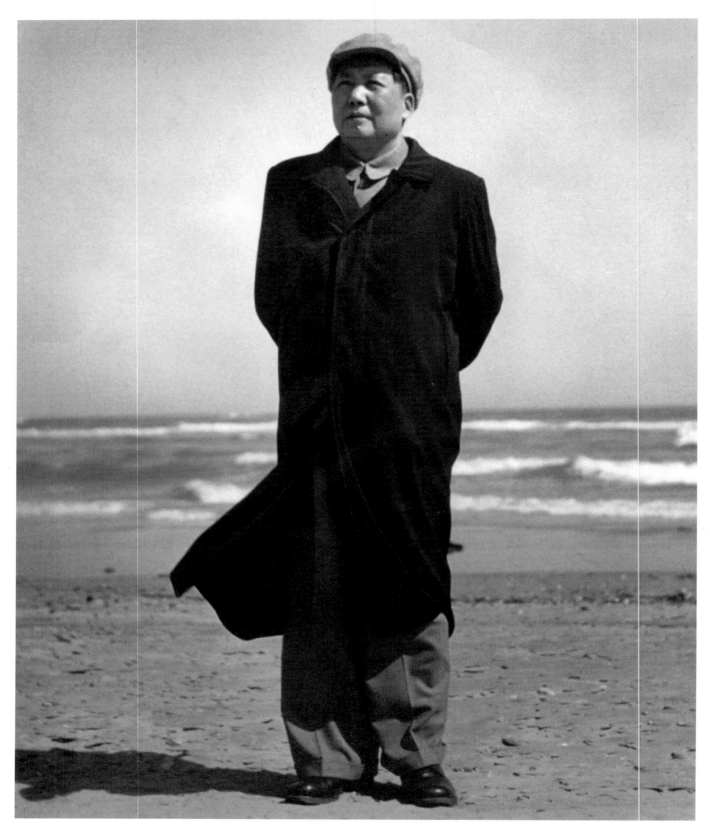

*Above:*
Official portrait of Mao Tse-tung,
President of the People's Republic of China.

*Opposite:*
India during the legendary times of the Maharajas.
The Nawab of Bahawalpur, 1887.

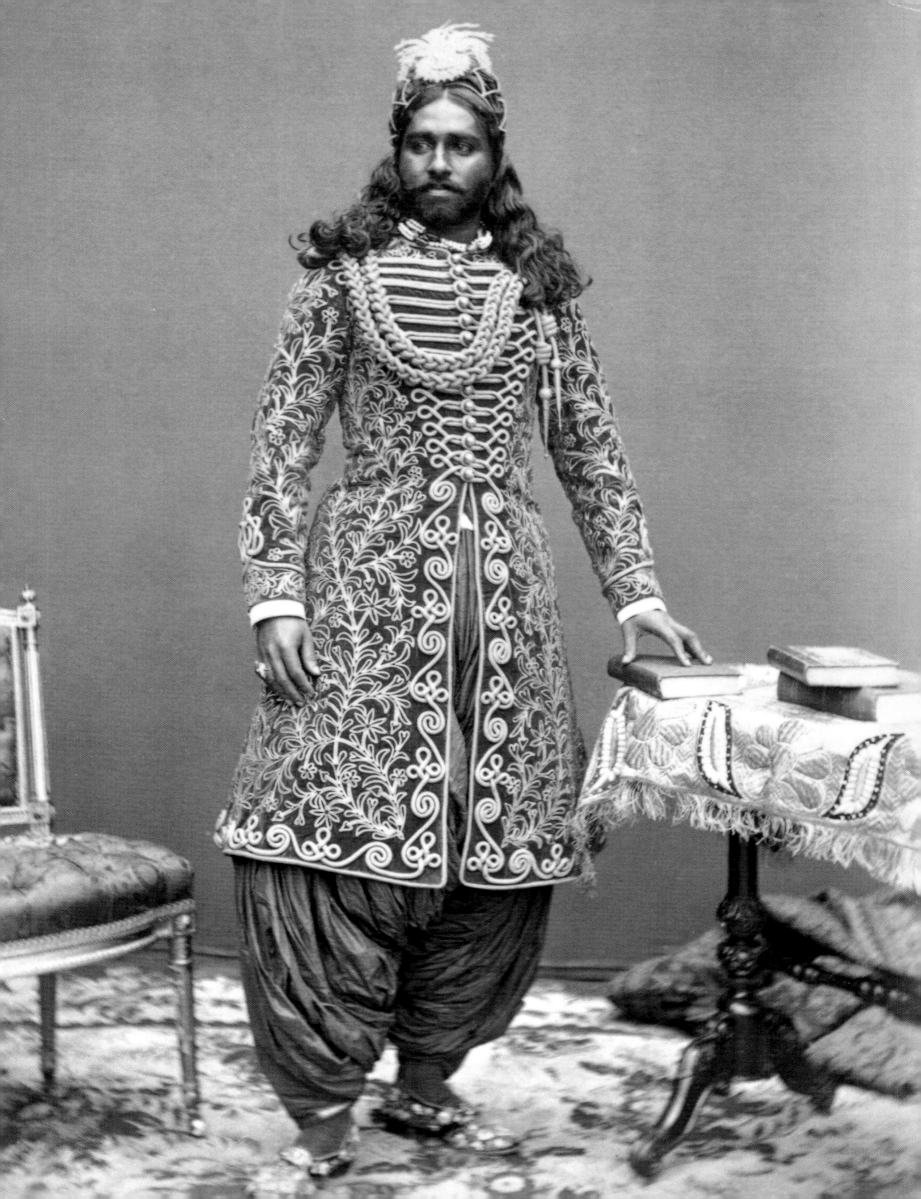

world's premier sovereign, the Sun King appeared to be mainly interested in frills and flounces. What was comfort for the great and the good should also have alerted them. The standard dress that he designed and, in no time, imposed upon his court, represented the surest way of subjugating the most recalcitrant of members. Vanity, competitiveness, blind ambition... Between 1635 and 1655, the heirs of the most illustrious families, that dangerous, rebellious, overbearing aristocracy, were wearing multi-coloured silk stockings and breeches so voluminous that they made walking a problem. Not to mention the *rochet*--a small short coat or cloak--beneath which billowed a shirt covered with lace. High-heeled shoes, their bows shaped like a windmill's sails, round hats sporting a monumental plume, a long cane, lace, again, for the cuffs, and garters, embroidery, ribbons, carbuncles, make-up, powder, rings, sword hanging at the side... The worst aspect of this form of subservience was perhaps the wig. Tall, long, hot, and costing a small fortune... Younger men would have holes made in their wigs, through which sprouted locks of their own hair. Never, as at Versailles, that gilded cage which all Europe copied, had the nobility seemed so removed from the State. Over a century and a half, through three reigns, fashion had caused it to lose all contact with reality. Even though, in the 18th century, people only observed it in order to grumble about it, the etiquette of Versailles and its pomp and circumstance remained just the same.

Not for nothing was it that, during the French Revolution, the name given to those wretched of the earth yelling at castle bars was "sans-culotte" or, literally, "breechless." The decline of the monarchy could already be sensed through the changes happening in the life style of elegant Parisians from the middle of Louis XVI's reign on. The court was still blissfully unaware of any such thing. But in the city people had stopped making fun of that cloak borrowed from coachmen by eccentric Londoners. Paris turned the "riding-coat" into the *redingote*. Its comfort, line and elegance would all develop imperceptibly throughout the 19th century--before turning into the somewhat abbreviated jacket in the early 20th century.

In the 18th century, the gentleman was the noblest conquest of the thoroughbred. The craze for those swift, new, highly-strung horses gave rise to sporting mounts, as we might say today of certain cars. It would have a decisive effect on the look of their riders. With its aloof, accessible, offhand ways, anglomania embarked upon a reign that is still going on today in many aspects. "Perfidious Albion," soon to become the

Jean Cocteau, as captured on the set of his film
*Beauty and the Beast* in January 1946 by Walter Carone.

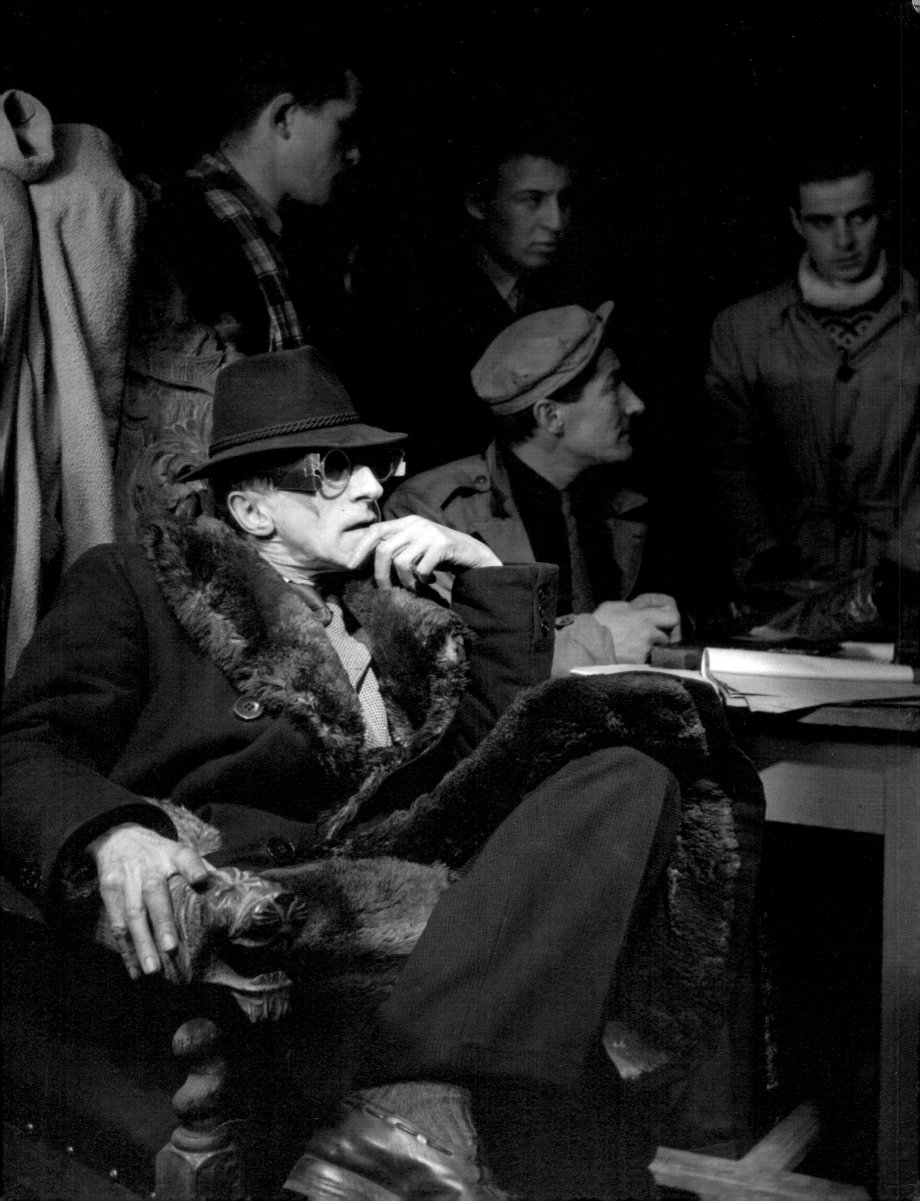

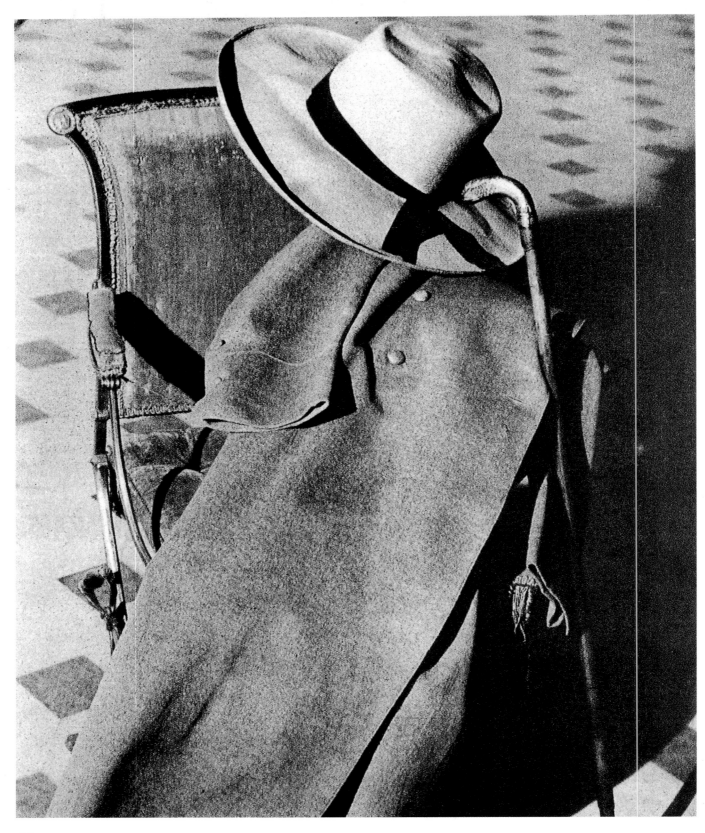

*Above:*
Hat, coat and cane worn by the Emperor Napoleon I
during his exile in St. Helena Island, 1820.

*Opposite:*
Napoleon Bonaparte in the official garb of First Consul,
1804, by Jean Auguste Dominique Ingres.

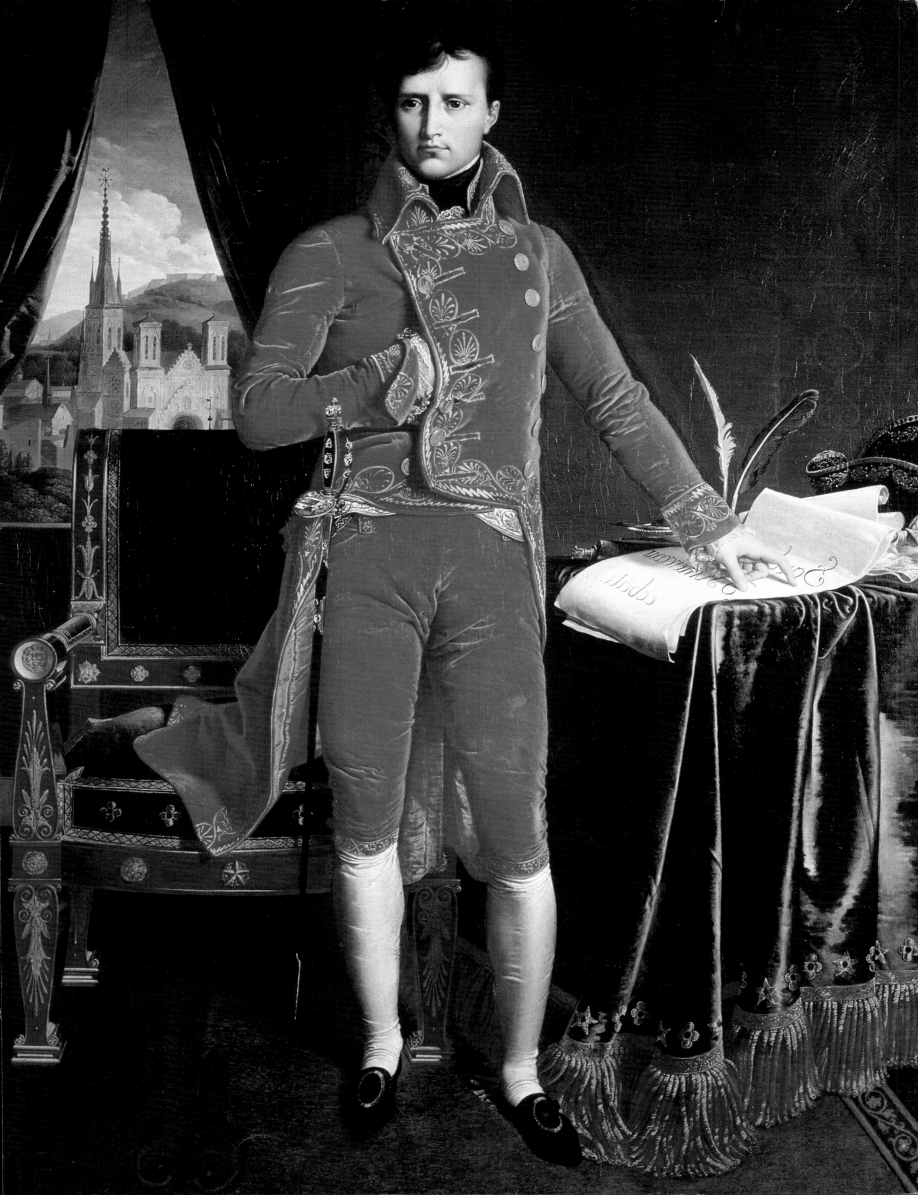

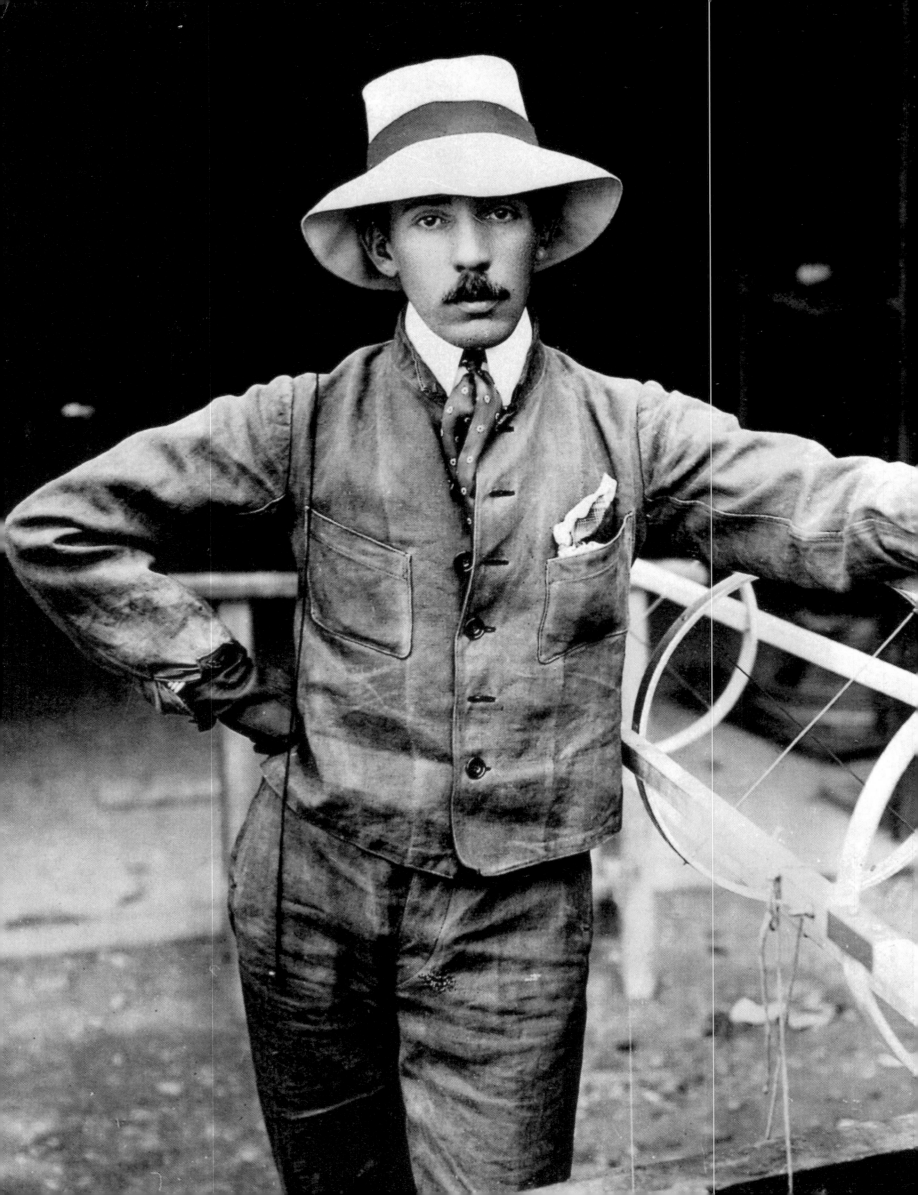

world's mightiest empire, and the only one capable of competing with Napoleon's, imposed with moderation its masculine ways and customs.

In the 19th century, between the splendor of the Ancien Régime and the Puritan rigor dictated by English elegance, masculine dress went through a kind of lull, which we should discuss. Revolution is not a hollow word. Each one gives rise to its secondary phenomena and by-products. As unpredictable, fleeting and atypical as those embodied in 1795 and thereabouts, at the end of the Terror, by a small group of young people. Paris of the day christened them the "Incroyables" or "Unbelievables." The peristyle of the Palais-Royal gardens delimited their turf. In the very heart of the capital, this was the fashionable walk. "Inc'oyables" and "Me'veilleuses" (Ma'vellous) (for they hadn't found any better way to recognize one another than to do away with all the "r"s in their own language) would gather there and show off. Skimpy frock coats, high collars, shawls with winged lapels, tight breeches made of striped velvet, silk stockings, high cravats, quivering… Heads swollen with self-importance, these young Casanovas and blades wore a long, thin cocked hat decorated with tassels, their long tumbling curls powdered snow white. This insolent youth was more reactionary and flaunting than noble. Made up essentially of young middle-class scions, little interested in defending the Republic, its aim was simply to dodge the conscription of 1793. The Committee of Public Salvation was still rife, so it took courage or foolhardiness to inflict, for all to see, a veritable insult to Republican virtue with such frivolous dress.

From a stylistic point of view, the Consulate and the Empire would prolong this surge of youth outburst, by streamlining it. Reference to classical art, recurring in the new powers-that-be, then gave rise to a feminine fashion which, by abandoning for a while the traditional hourglass figure, saw the birth of a creature with flowing lines inspired by the frescoes of Pompeii. An enlightened Europe betook itself, furthermore, *en masse* down there to renew its repertory of shapes. But this neo-classicism would not have any real influence on men's dress. Apart from a few efforts made by Bonaparte, without much success, when this latter decided to link the power of the consulate with an attire embodying this new order. The First Consul, a brilliant man, but too overextended to bring things full circle, then entrusted the painter David, an ardent revolutionary, with the task of designing, in addition to many decors, a set of clothes combining ancient Rome with Romanticism: tight trousers, light braided ankle-boots,

The Brazilian Alberto Santos-Dumont (1873-1932),
pioneer of aeronautical engineering and aviation hero,
leaning against the frame of his plane in 1906.

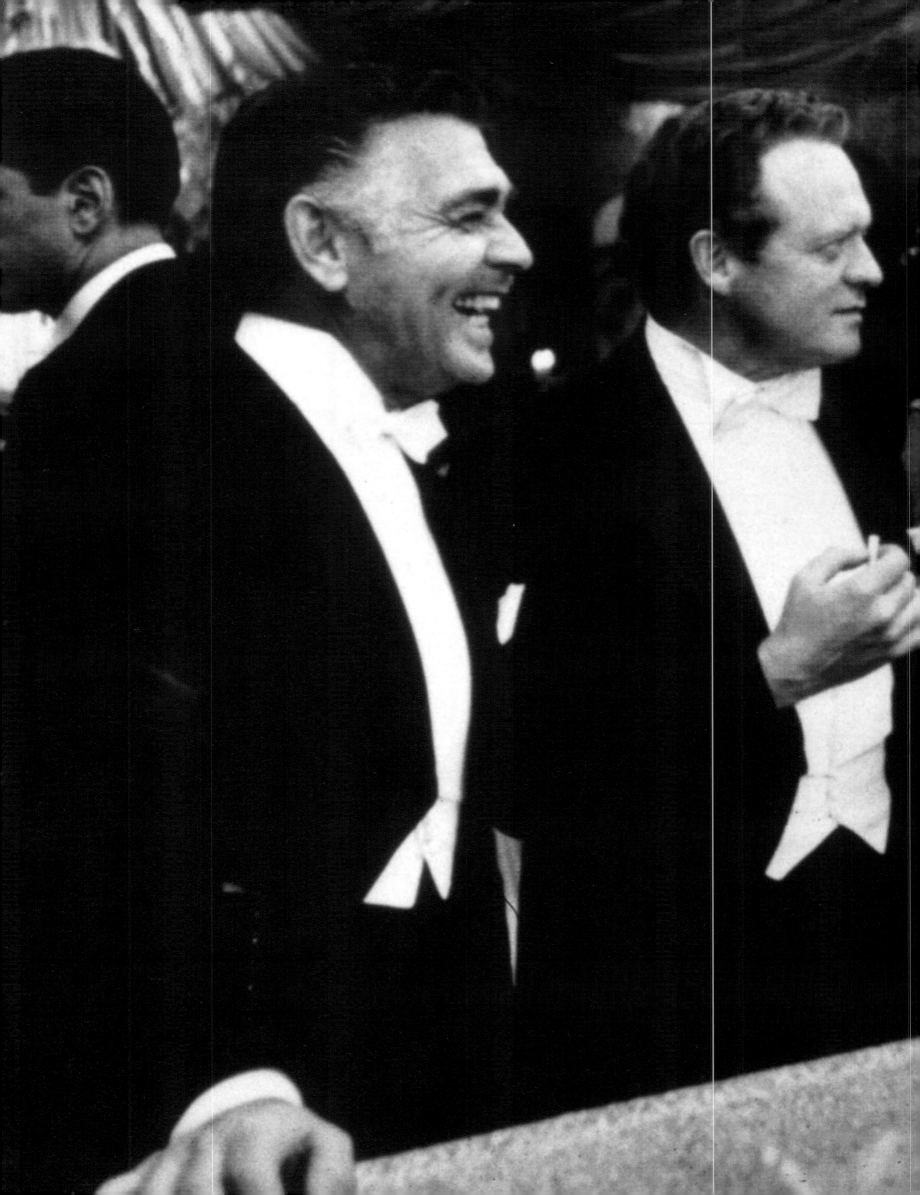

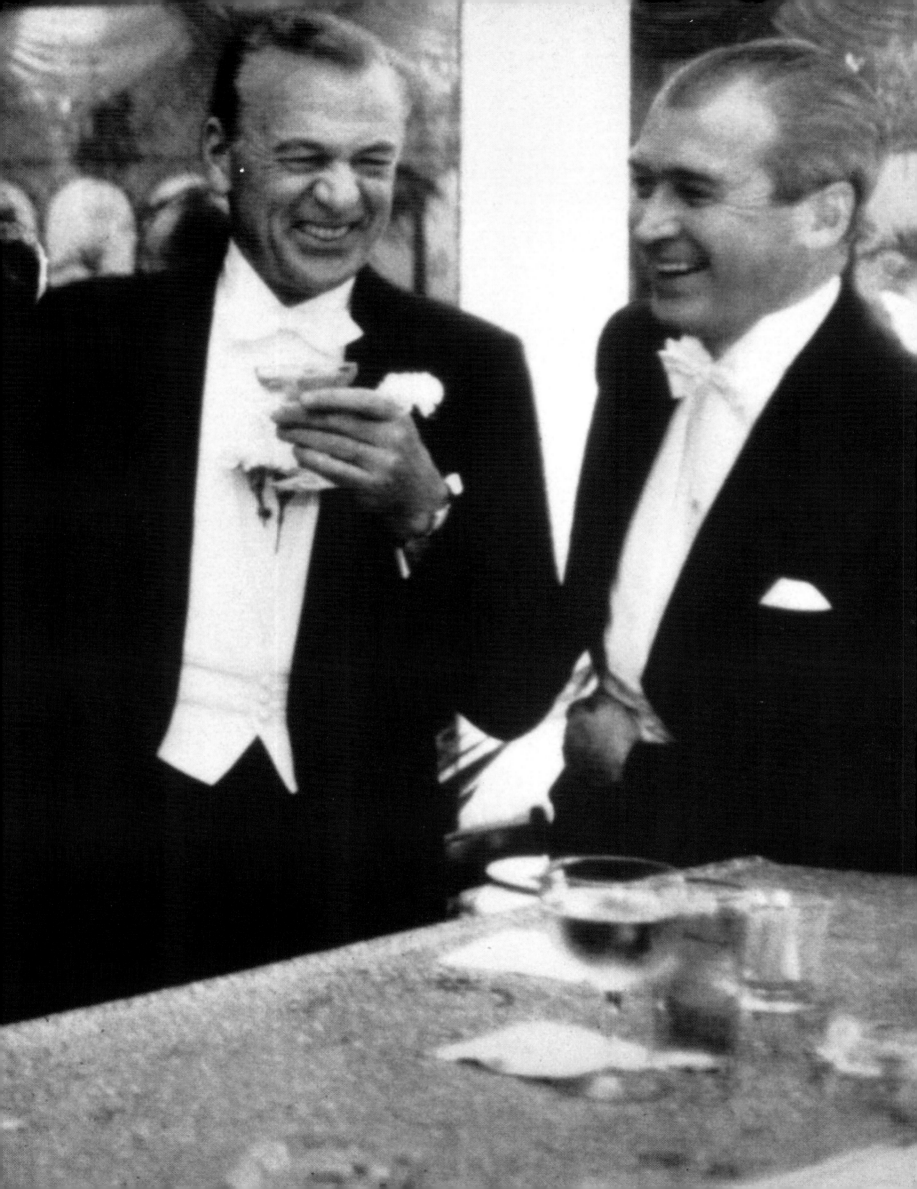

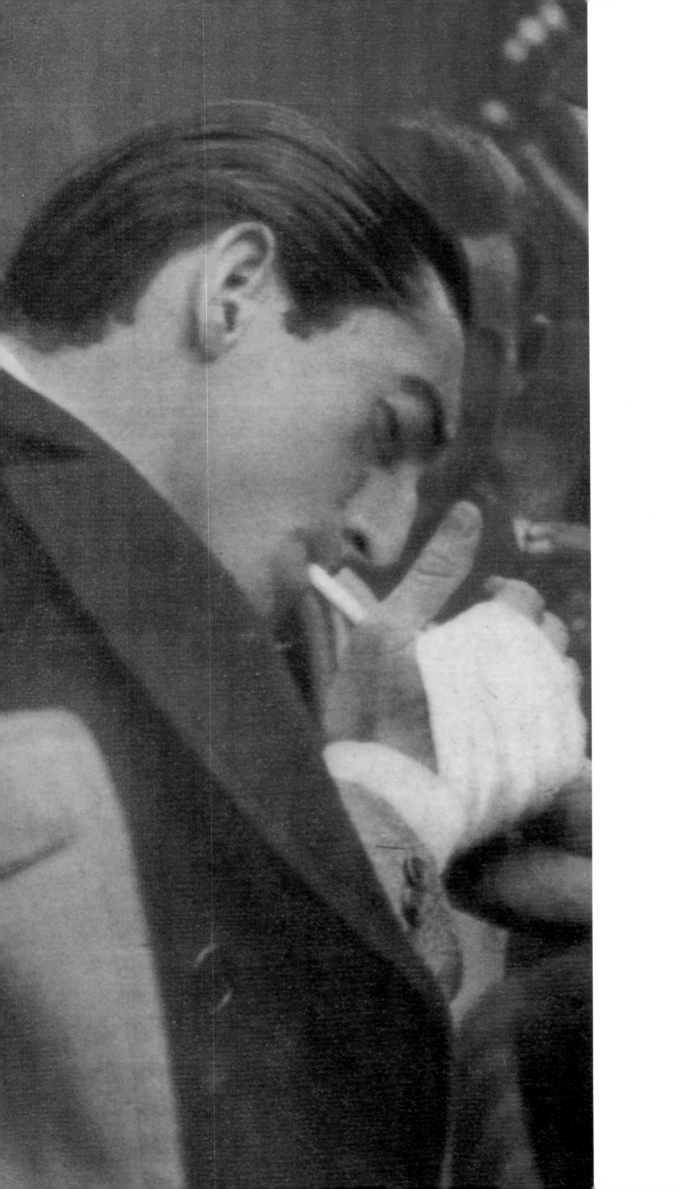

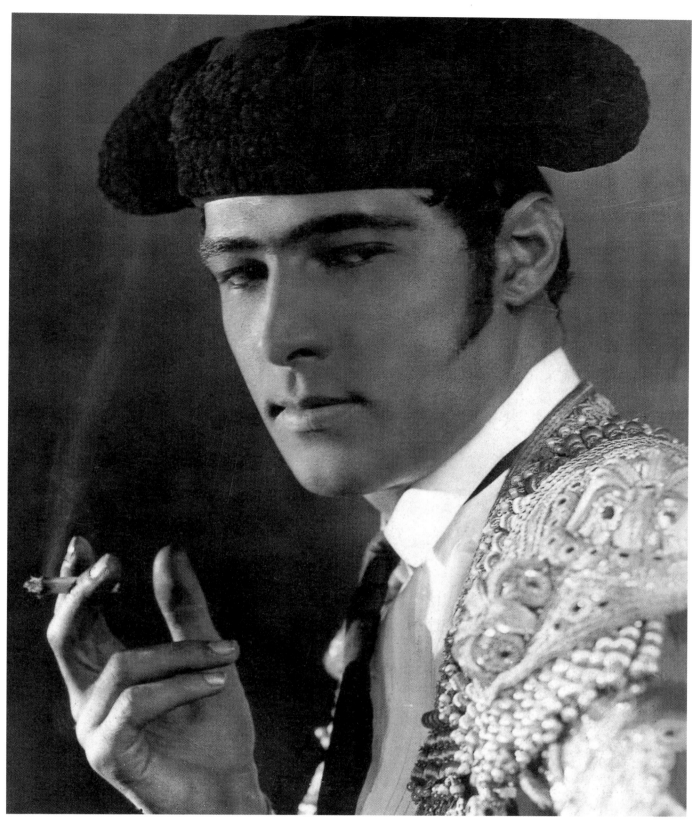

*Preceding pages:*
Clark Gable, Van Heflin, Gary Cooper and James Stewart
share a laugh at the 1957 New Year's Eve party in the
Crown Room of the Romanov.  Photo by Slim Aarons.

*Opposite:*
The famous bullfighter from Cordoba, Manuel Rodriguez Sanchez,
known as Manolete, shortly before his death in the Arena at Linares, c. 1946.

*Above:*
Rudolph Valentino in his toreador costume for *Blood and Sand,*
directed by Fred Niblo for Paramount in 1922.

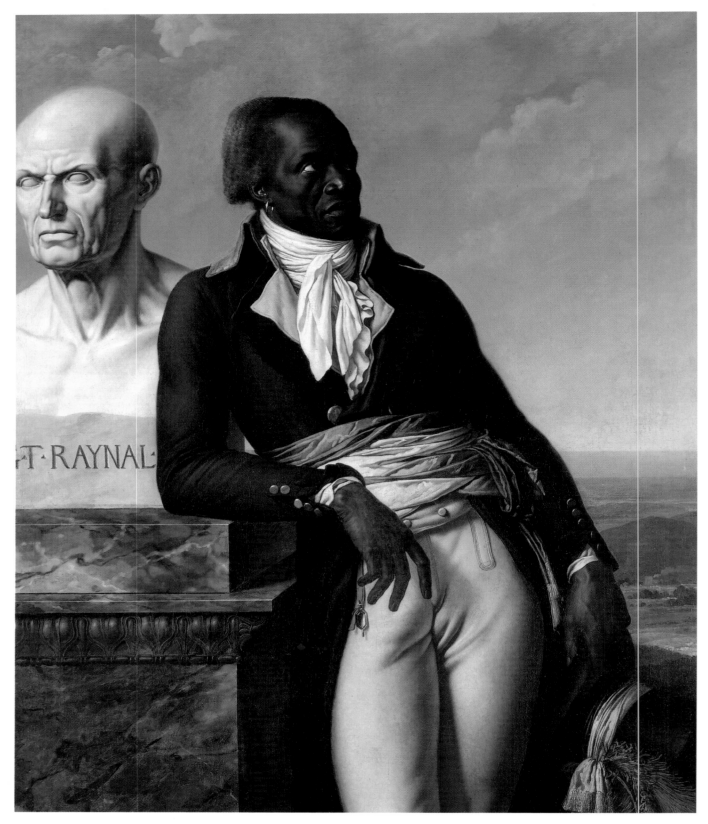

*Above:*
Jean-Baptiste Belley, Deputy of Santo Domingo,
by Anne Louis Girodet de Roussy-Trioson,
painted during the French Revolution, 1797.
National Museum of the Chateau de Versailles.

*Opposite:*
The Nuba tribe of Sudan, 1949.

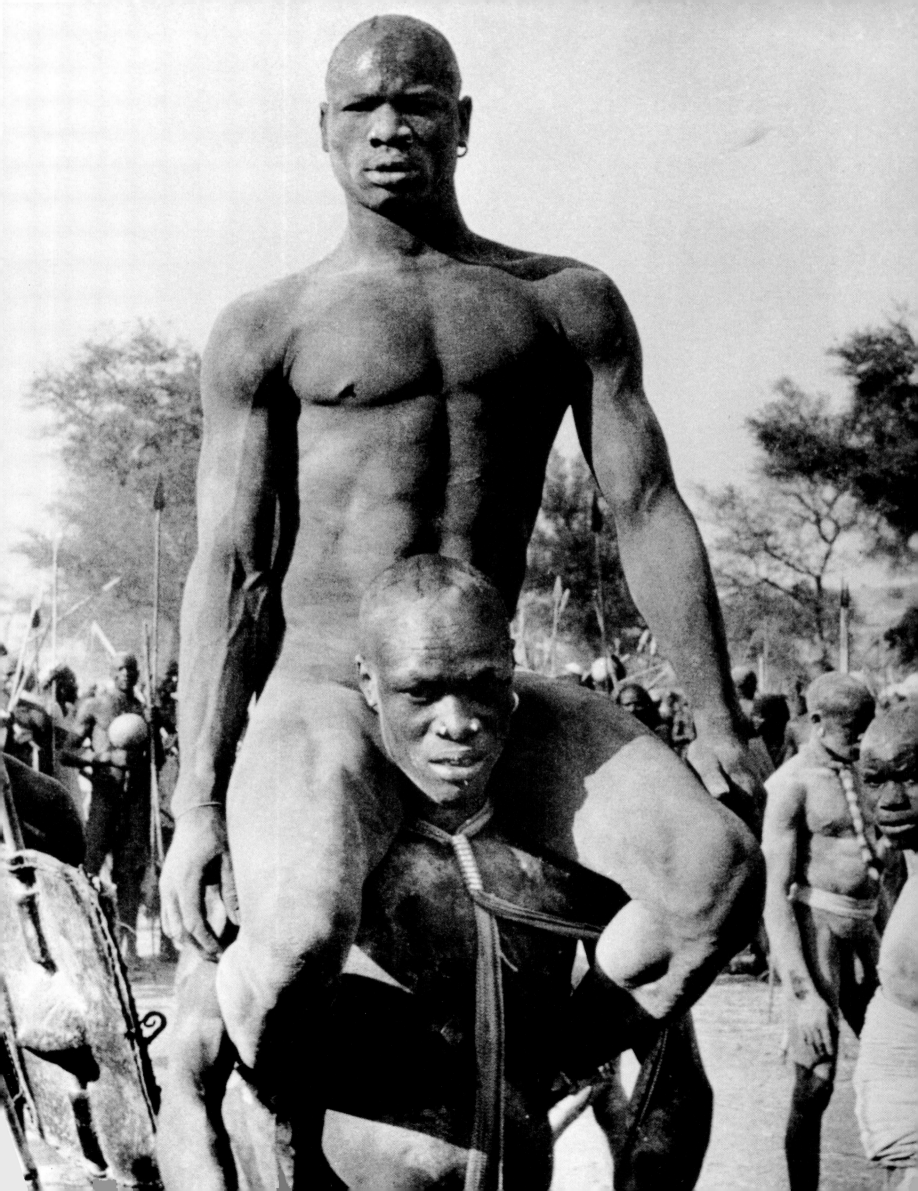

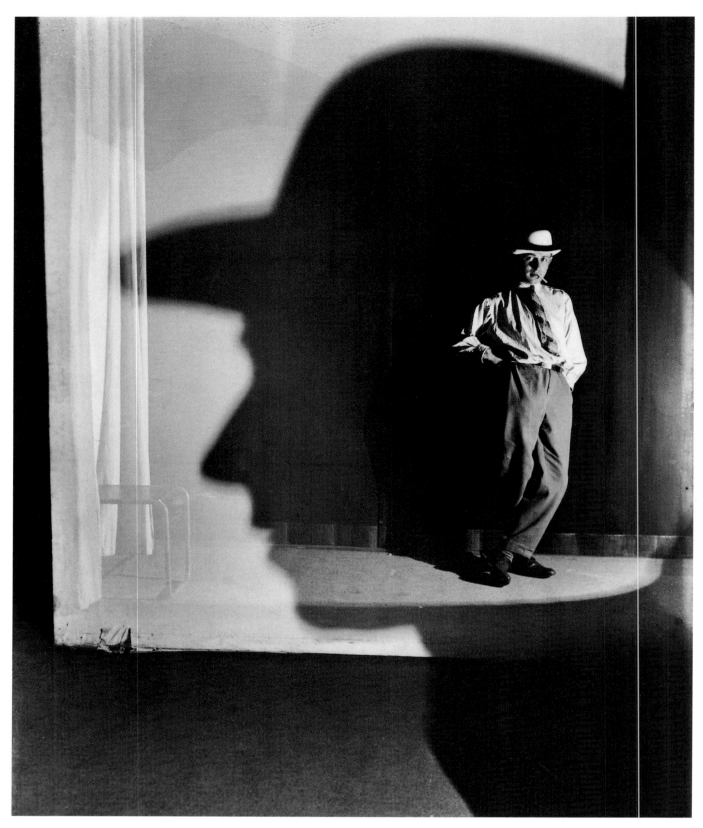

*Above:*
Full-length portrait with profile in shadow,
by Heinz Loew and Edmund Collein, Bauhaus, 1927.

*Opposite:*
Count Halifax, Secretary of State,
arriving at the Foreign Office in London, 1938.

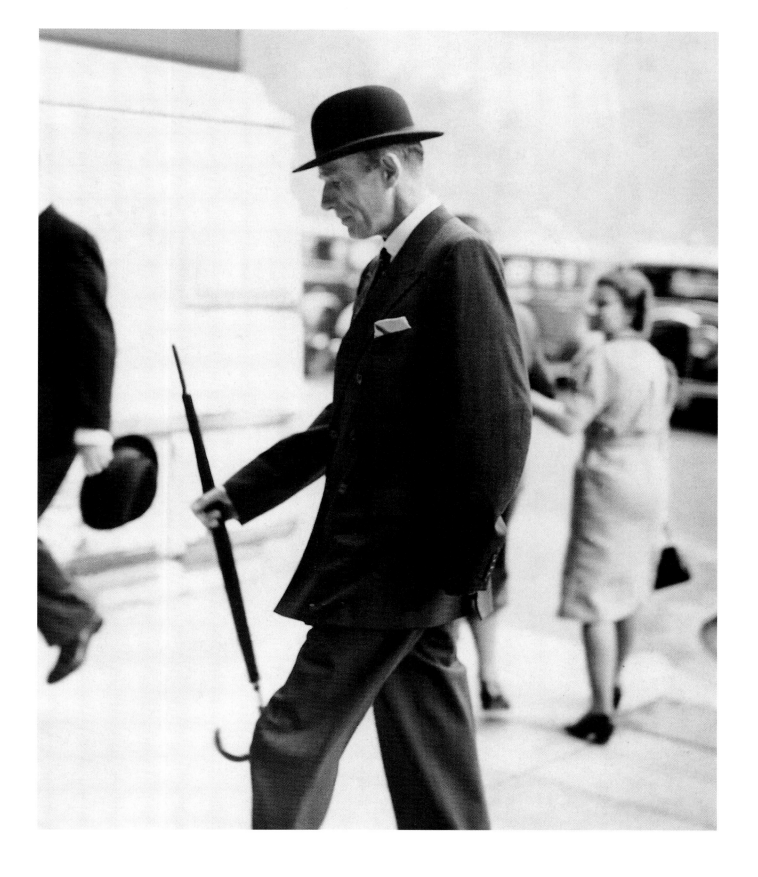

a round plumed cap, a broad belt, and an embroidered cloak, flowing over the shoulders… The Louis XIV effect was not to be reproduced. As if, thenceforth, in his dress, modern man could now only proceed by way of successively and irreversibly discarding things. The good old days, marked by the visible accumulation of outward signs of his power, were well and truly over for the male.

Among the middle-classes, in about 1770, it was a custom to dress small boys in "sailor suits." Using those long flowing flared trousers that sailors wear. One or two dandies would borrow this style at the very end of the century. They wore their trousers tight and buttoned at the ankle or else tucked into a soft boot with a tawny-coloured flap. Johnny Walker was not yet a brand of whisky.

But one thing is certain: from that time on, the leg was no longer one of the criteria of masculine beauty. Because the frock coat had become the daily attire of the elegant man, the tail coat, buttoned in the French style, was brought out essentially for evening wear and grand occasions. It was worn over breeches with garters and silk stockings, and patent leather shoes with silver buckles. But this custom would dwindle as the 19th century progressed. Guaranteeing, from before the Second Empire, the supremacy of the trouser. Henceforth, as happens with many formal styles of dress, breeches would be relegated to domestic staff, court staff and government. They were worn in France up until the *Belle Epoque*, sporting the livery of those wielding power, and also lasted in one or two other countries for exotic and much sought-after ceremonies.

In *Remembrance of Things Past*, with merciless detail, Marcel Proust breaks down the masculine look and style of those happy few whom he admired as much as he dominated. As the culmination of 100 years of elegance, art of living, much privilege, the Belle Epoque style would carry on until the great split caused by the First World War. As an heir of the dandy, the elegant blade of the 1900s was not very different, either in his line or in his behavior. Five minutes before the irreversible fall of the last Romanovs, the Hapsburgs and the Hohenzollerns, while President Loubet was inaugurating the great World Fair on the banks of the Seine, clothes, in Europe, still made the man. Enabling him--in principle--to recognize his peers, in a glance. The only real innovation was the short jacket, which appeared in about 1870, a few years ahead of the three piece suit with waistcoat. These three pieces, cut in the same fabric, would first of all represent informal attire that the elegant man kept for his

Intermission during a Mozart opera at the Glyndebourne Festival, photographed by Henri Cartier-Bresson. East Sussex, 1953.

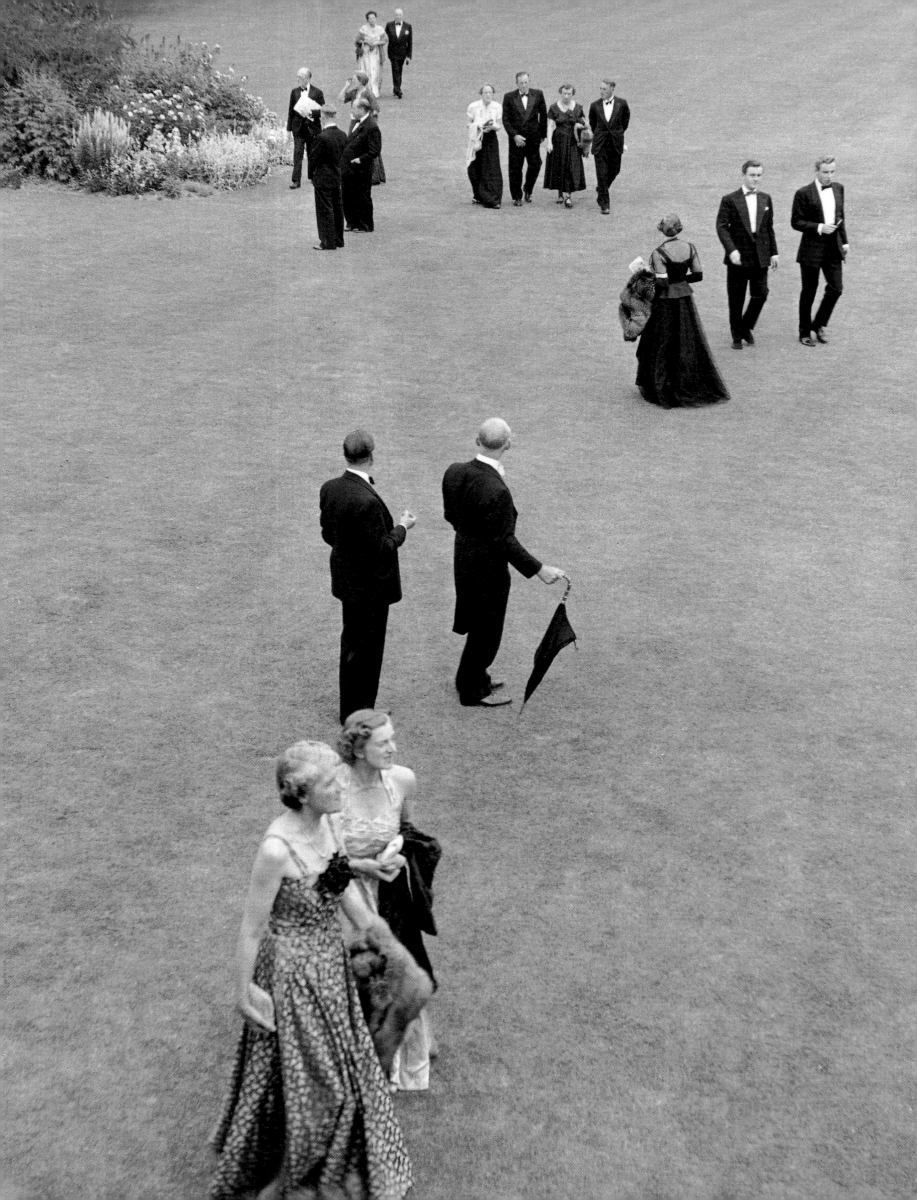

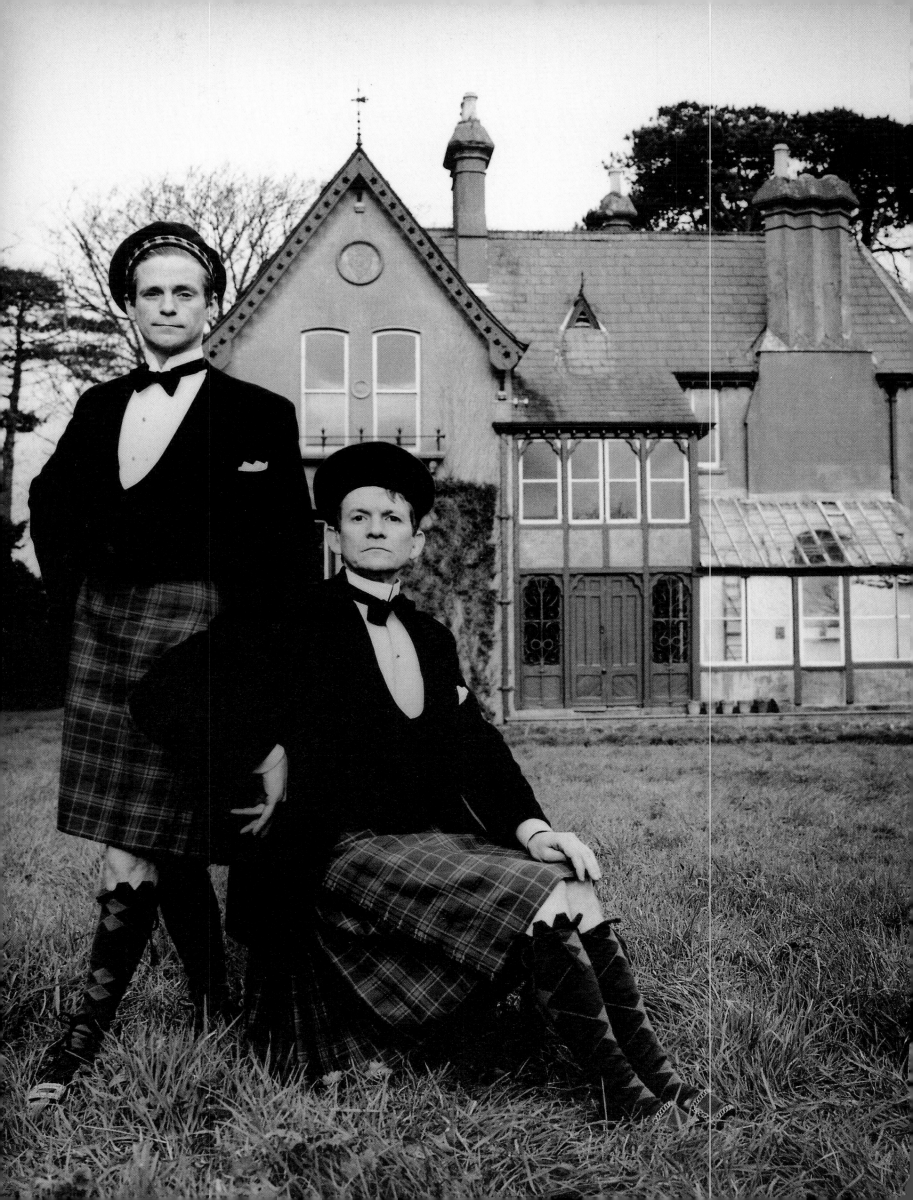

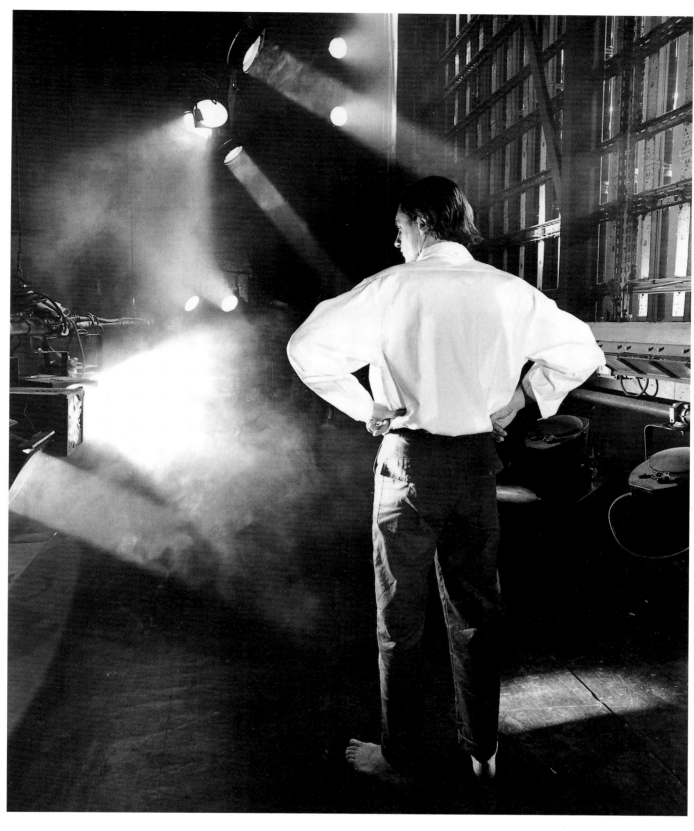

*Opposite:*
Messrs MacDermot and MacGough,
New York conceptual artists in their home surroundings.

*Above:*
At *Le Palace* Theater, French painter Gerard Garouste
photographed by Keiichi Tahara, Paris, 1982.

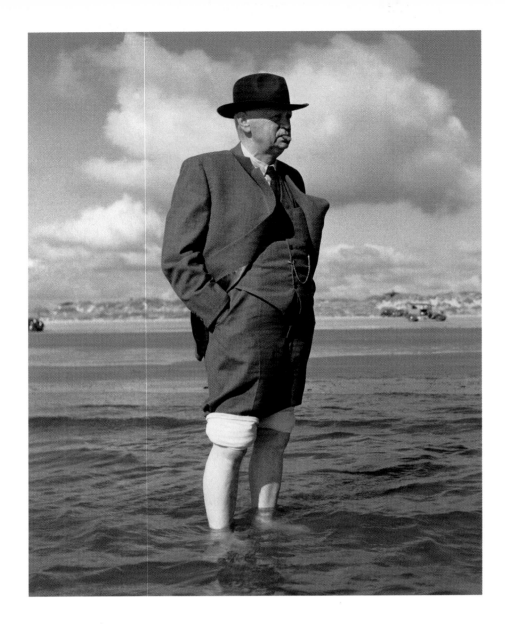

morning walks, and visits to the country and the seaside. For whenever he went out
"on the town," his uniform once again became unchanged. Frock coat or dark jacket
worn over striped or even hound's-tooth trousers, patent leather shoes often fitted
with gaiters (grey felt gaiters in winter, and starched white linen in summer) pale
colored waistcoat, a full cravat fixed with a pearl, a light cane, buttoned gloves, the
whole effect crowned by a top hat… The high class man only differed from his peer in
one or two details, imperceptible to ordinary mortals. Their very discretion lent the
elegant man added distinction. So it was enough for Proust to mention that Charles
Swann lined his pearl grey hat with green leather or that in a salon, he would still
adopt the very old custom of placing his hat upside down, close to his seat on the
parquet floor, to suggest what worldly and fashionable superiority is revealed by so
many infinitesimal details.

How is it that those 17th century birds of paradise, those little marquises with their
red heels and powdered wigs, turned themselves into jet-black crows? The rules of the
economic and social game, as introduced with the industrial society of the latter years
of Romanticism, profoundly altered the image that man had of himself. The heroes of

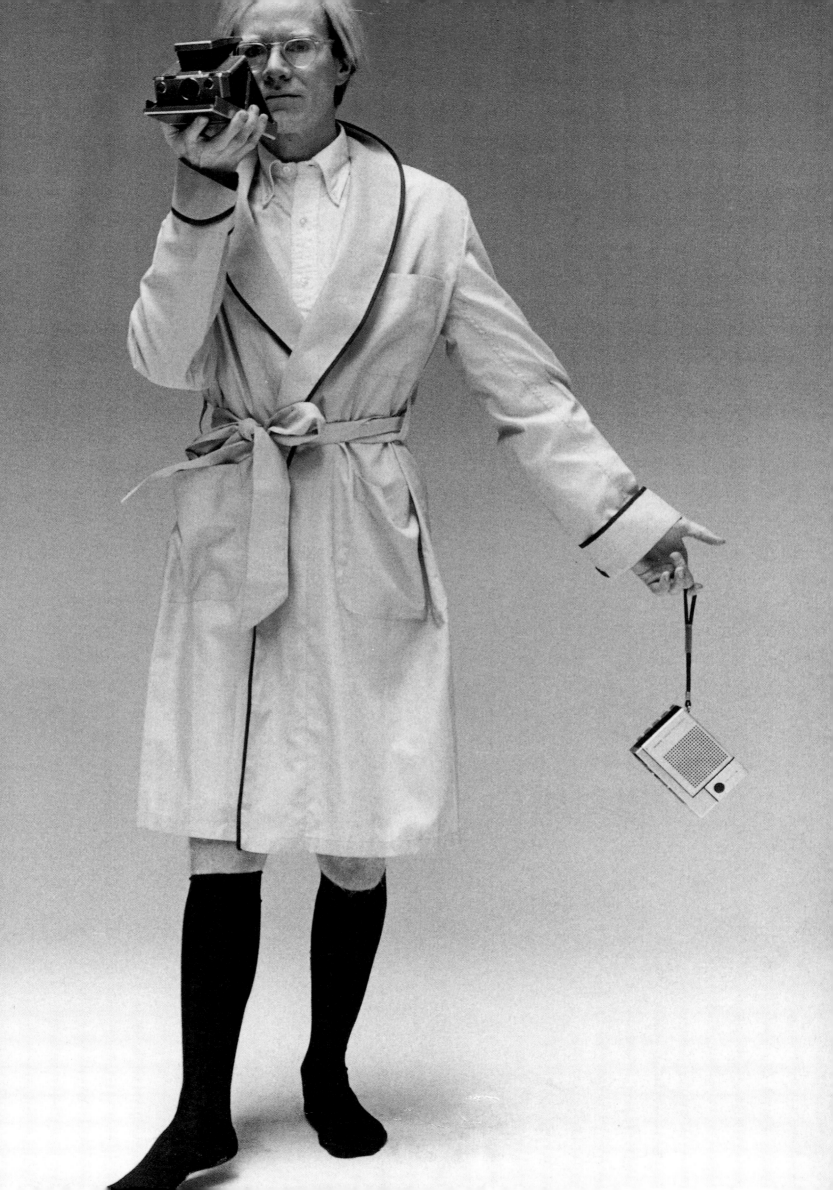

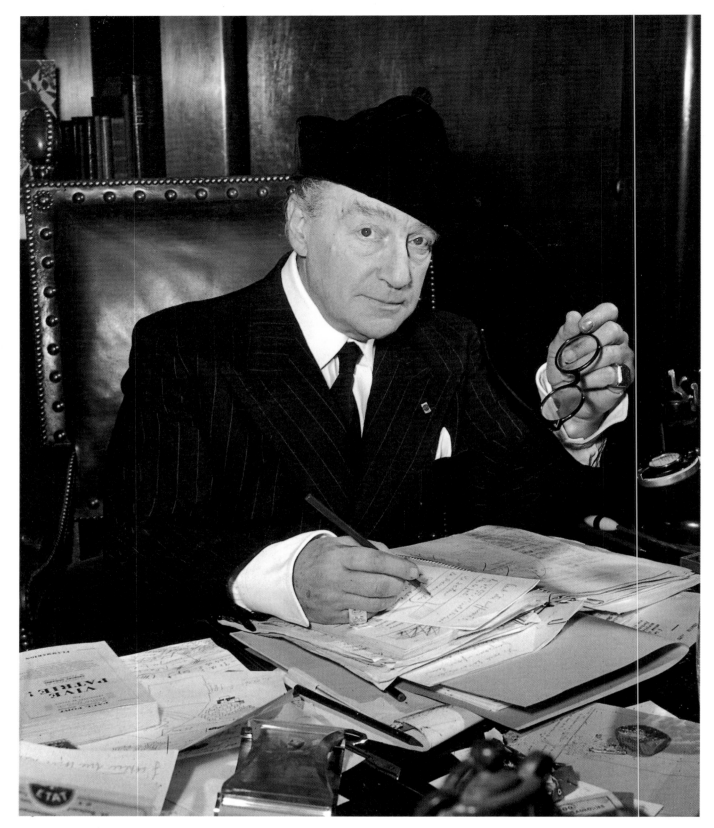

*Above:*
Sacha Guitry in his townhouse
on Avenue Élisée-Reclus in November 1949.

*Opposite:*
Salvador Dalí enjoying the boatride across the English Channel
on May 6, 1959, on his way to the party being thrown in London
to celebrate publication of the book *The Case of Dalí*.

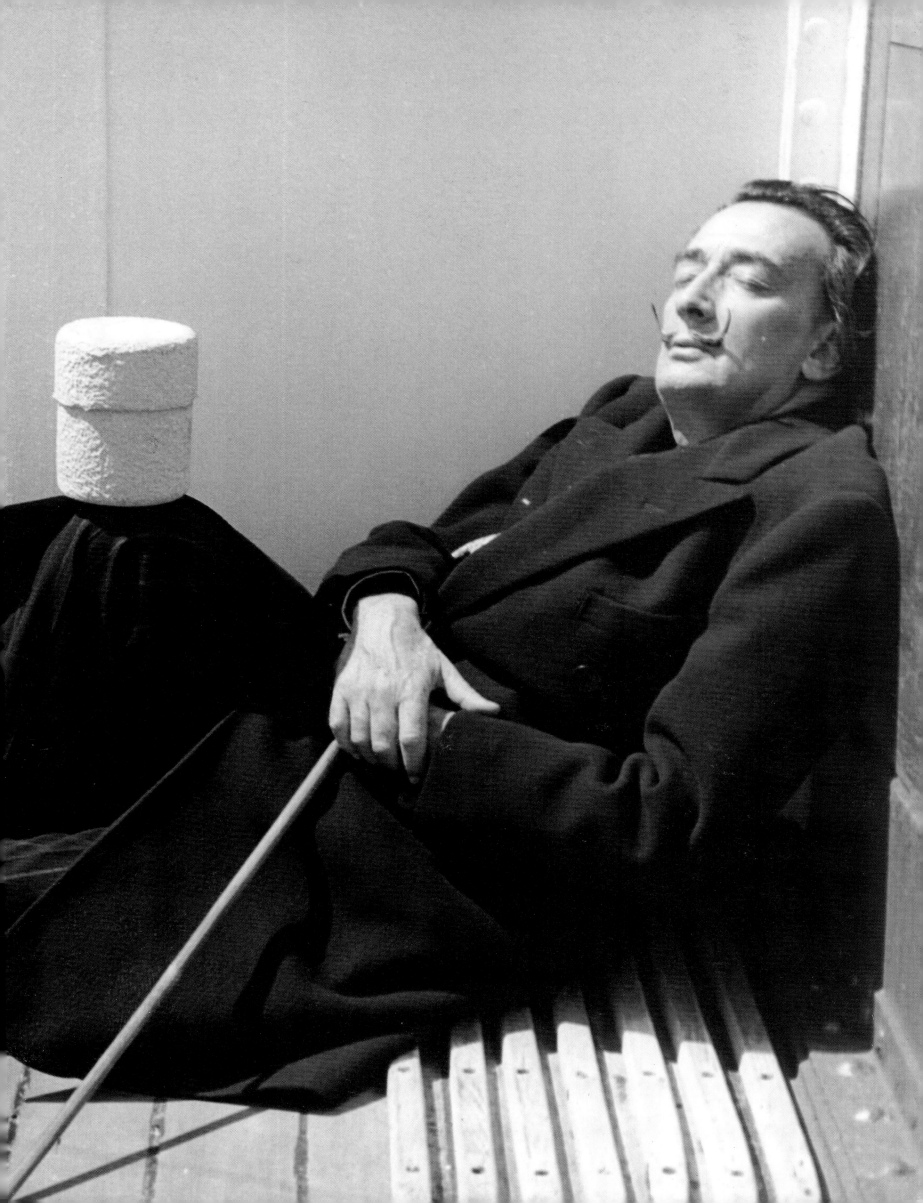

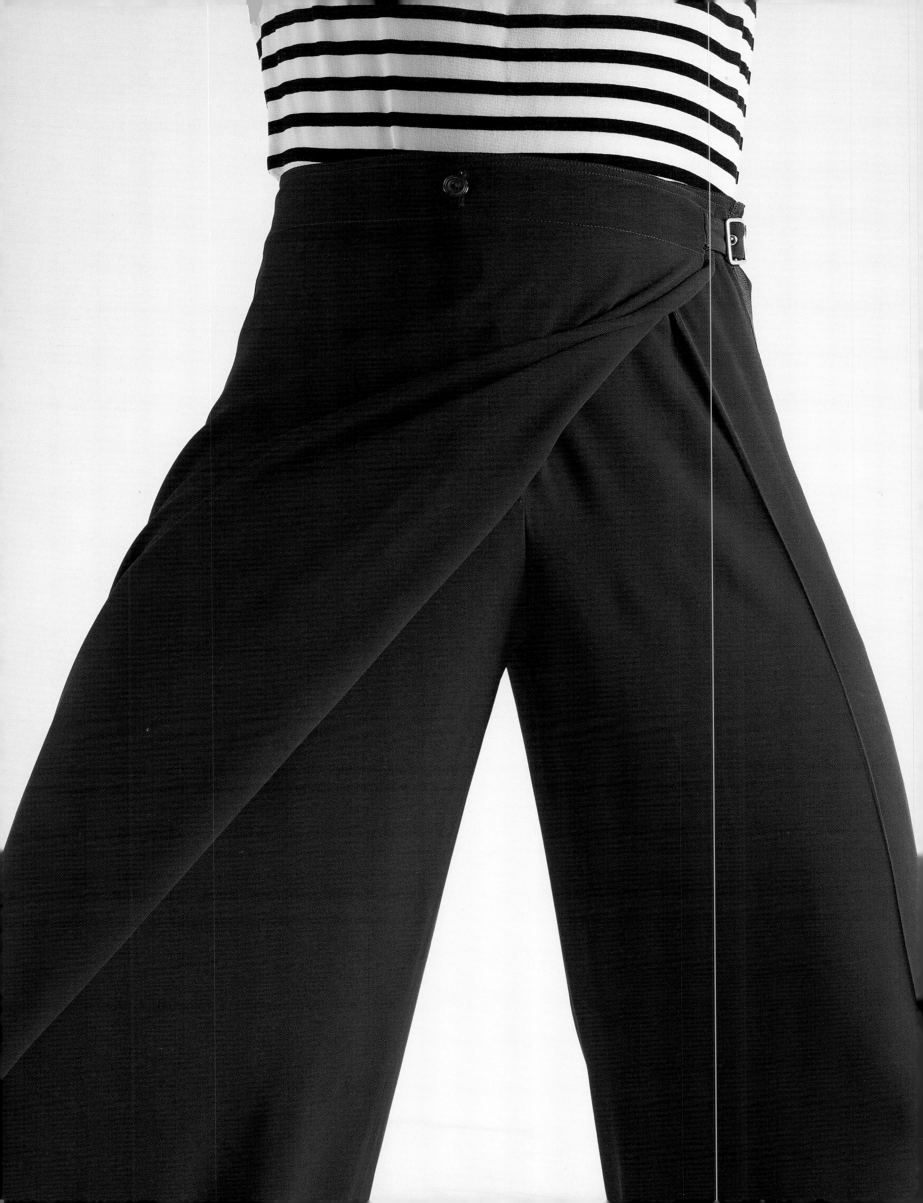

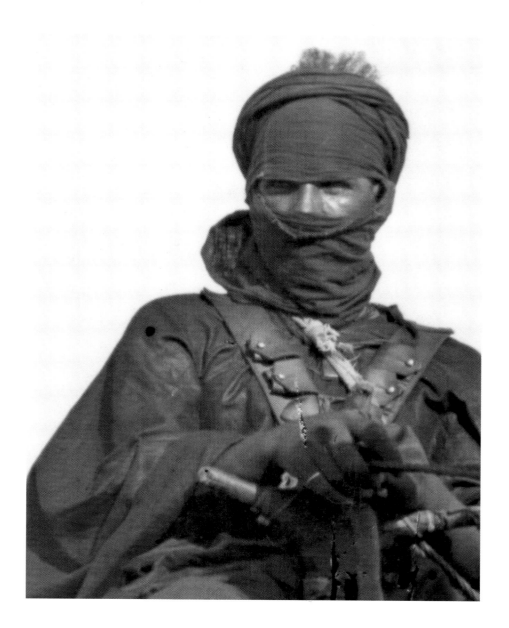

the "human comedy" as still admiringly described by Balzac, were followed by the infinitely more prosaic versions of an author like Zola. "Get rich!," Thiers' watchword to his contemporaries prompted even those with the lowest profile to action and authorized every manner of speculation. A deeply different society, originating from lower classes and devoid of any genetic heritage, gradually occupied the concentric spheres of established power. The cards changed hands.

With merit holding sway over seniority, Second Empire man worked behind the scenes to create prosperity for his family. To do so he adopted the neutral and functional uniform which would very broadly remain the uniform of the service sector throughout the 20th century. In this context, the role of seeing and being seen at the many social events of 19th century middle-class life, fell to women, for on the whole, women did not work. A veritable symbol of the power of her spouse, father or protector, the embodiment of the weaker sex--her generous forms, signs of plenty, her finery, which looked like the contents of a safe, her hooped petticoat, her whale bone corset, the decorative excess of her outfit... robbed the decked out woman of the freedom of movement needed for practical living, and turned her into an idol, a mother, or an

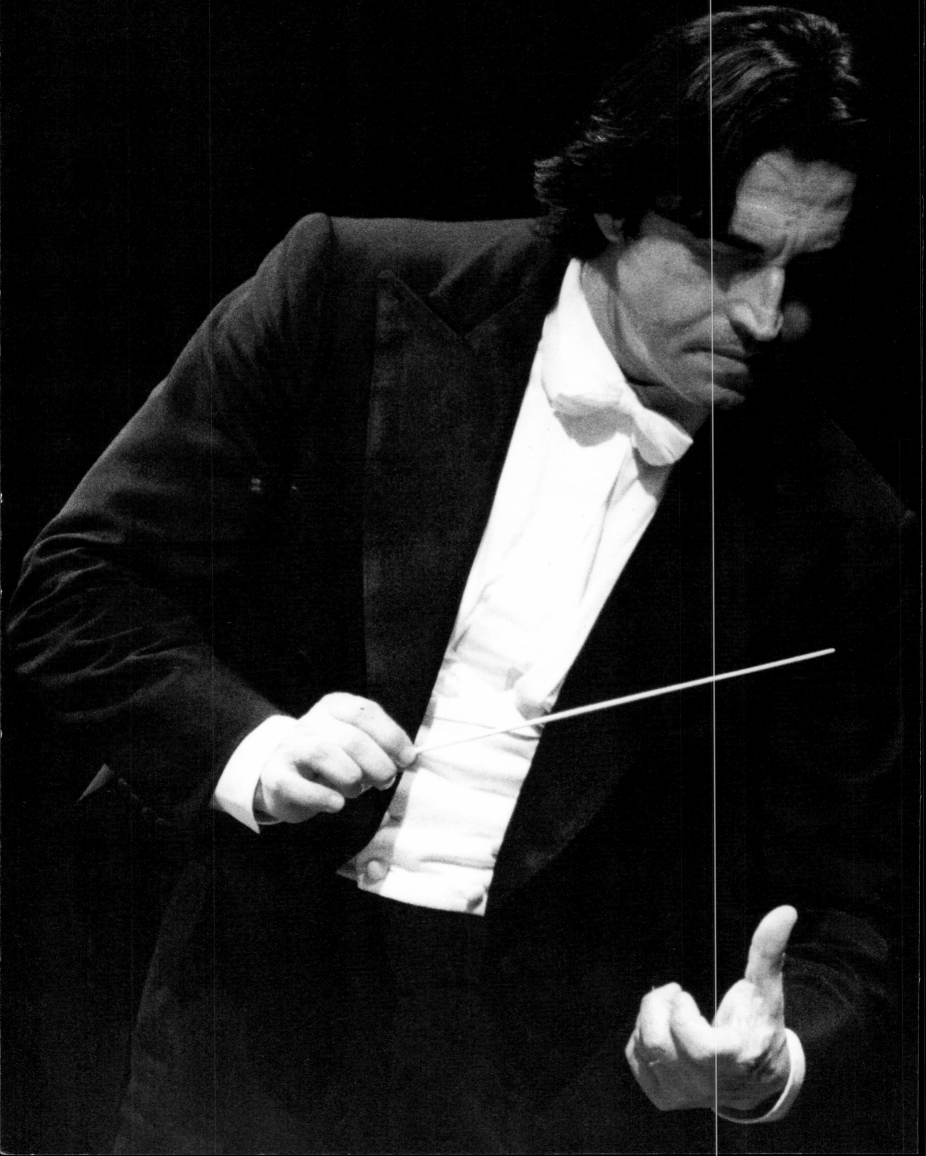

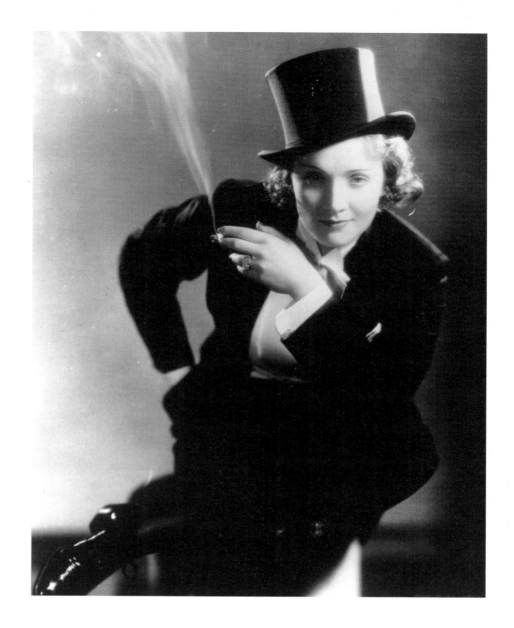

object. Her domesticity relieved her of any obligation that did not contribute to her elegance. Behind this vibrant ruche, the army of men was reduced to silhouettes. A gloomy screen, made up of a costume highlighted solely by the starched whiteness of the shirt front. Furthermore, a lordly luxury was best conveyed by the noteworthy development of linen and its corollary, laundry. People realized that those Parisian women who did the washing and the ironing were not nearly as good as those north of the Channel! At regular intervals, the well-dressed would send their clothes there, duly monogrammed, to be laundered. And the laundry came back in batches, impeccably cleaned, a few months later. For many years, *"se faire blanchir à Londres"* (Having one's laundry done in London) remained a popular Paris expression. In 1770, the groundbreaking tailor, Dartigalongue made it known that he could make "ready-made" clothes in all sizes, and dispatch them anywhere. Could this overlooked craftsman have speculated that future tailoring would mainly concern the masculine wardrobe, its uniformity of style requiring much less innovation, virtuosity and know-how than feminine finery? In middle-class society from the 19th century to the mid-20th century, the tailor would indeed continue to be an important figure in the life of a

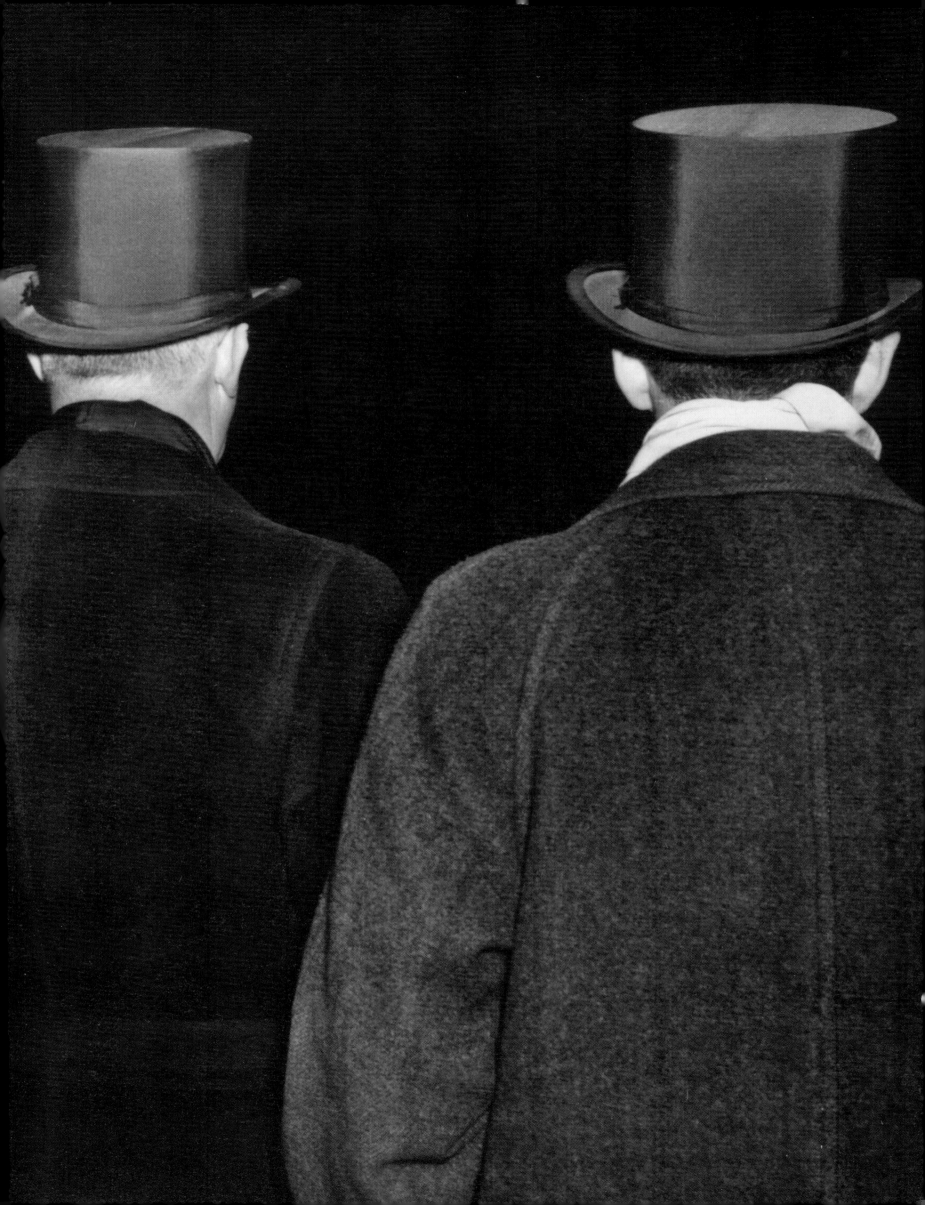

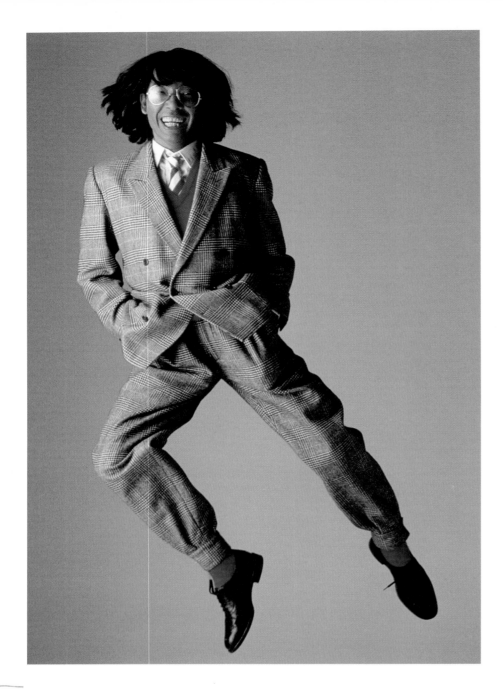

*Preceding pages:*
Top hats, after an evening at the Metropolitan Opera House in New York, by Weegee, December 1941.

*Left:*
Designer Kenzo Takada in a checked suit, photographed by Denis Broussard, 1985.

*Right:*
Hirohito, when he was crown prince of Japan, photographed during a stay in Paris, 1921.

well-born young man, now turned into the well to-do gent with his made-to-measure clothes. The standardization of the suit nevertheless encouraged the mass production of certain items in his wardrobe. This was the case in particular with the "paletot-sac" or a kind of loose outer coat which made its appearance in cities in about 1835. This short overcoat, supple, straight, and shapeless before such a style had come into being, inspired by the sailor's jacket--mariner and horseman alike are the forebears of the sportsman--, did away with shaping and did not call for any skill in terms of the cut. It was easy to make in large quantities and would be adopted by all types of middle-class men.

In addition to the precious remains that poor young men haggled over with second-hand clothes dealers, some of them already had the cunning idea of making small sets of clothing--similar in appearance, though not in quality. This old custom was taken up again in the 1970s, with the retro fashion, and the routine whereby, come the weekend, new eccentrics would visit flea markets to rummage through bundles of clothing. Many open air stands gradually turned into "ready-to-wear" shops. In

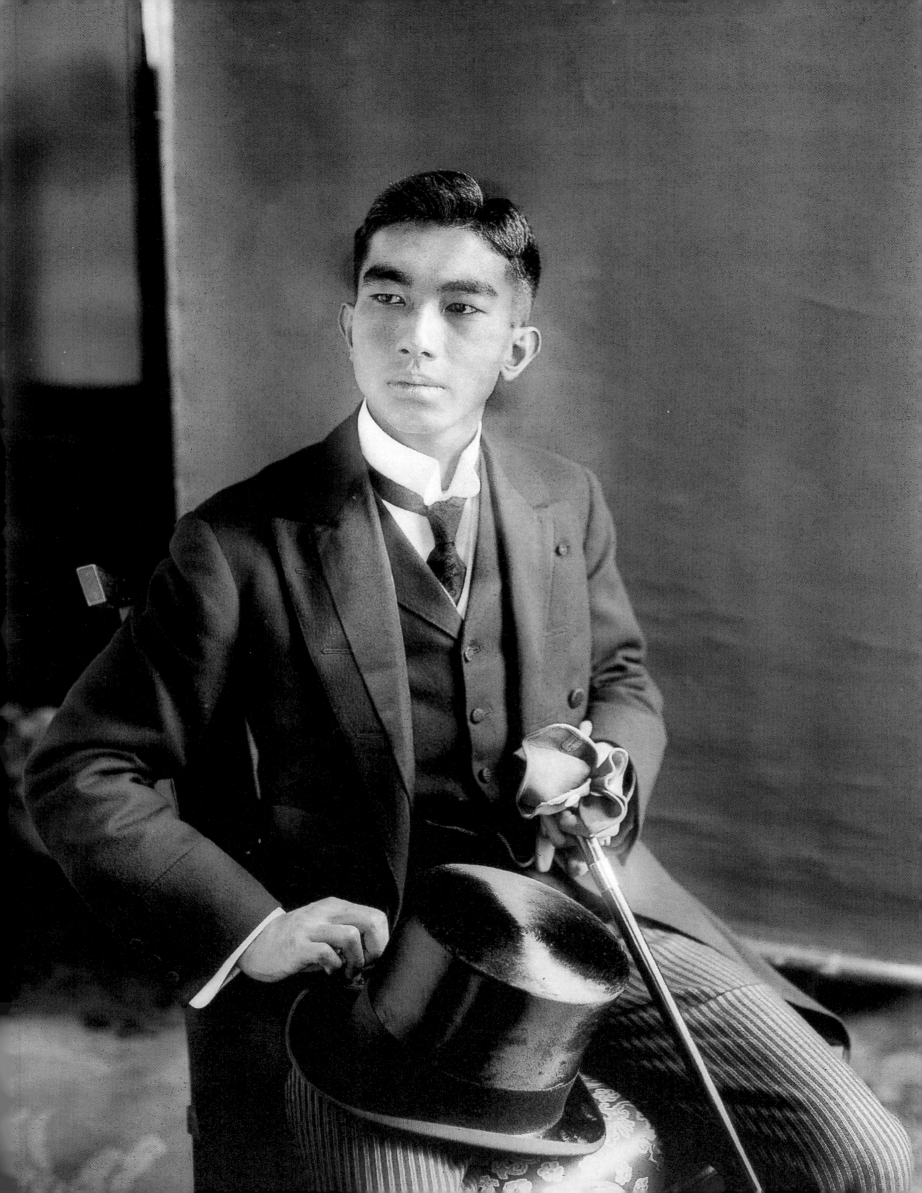

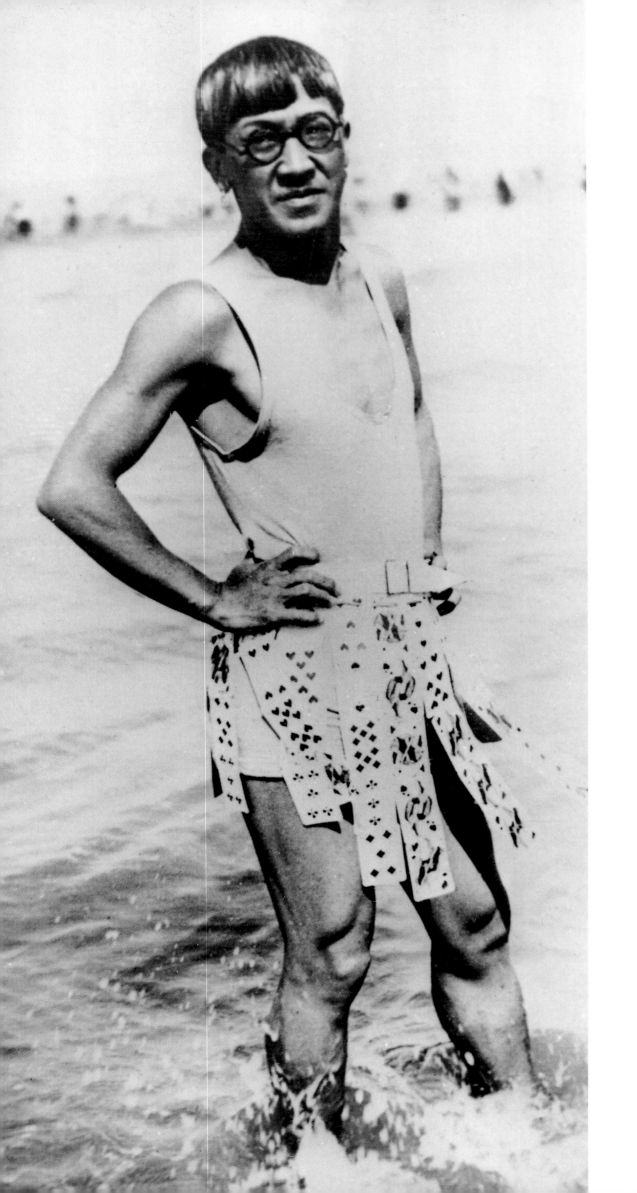

*Left:*
Fujita takes a dip in a bathing suit he designed himself, photographed by Eugene Marsan in June 1927.

*Right:*
Zissou Rouzat, by Jacques-Henri Lartigue, 1911.

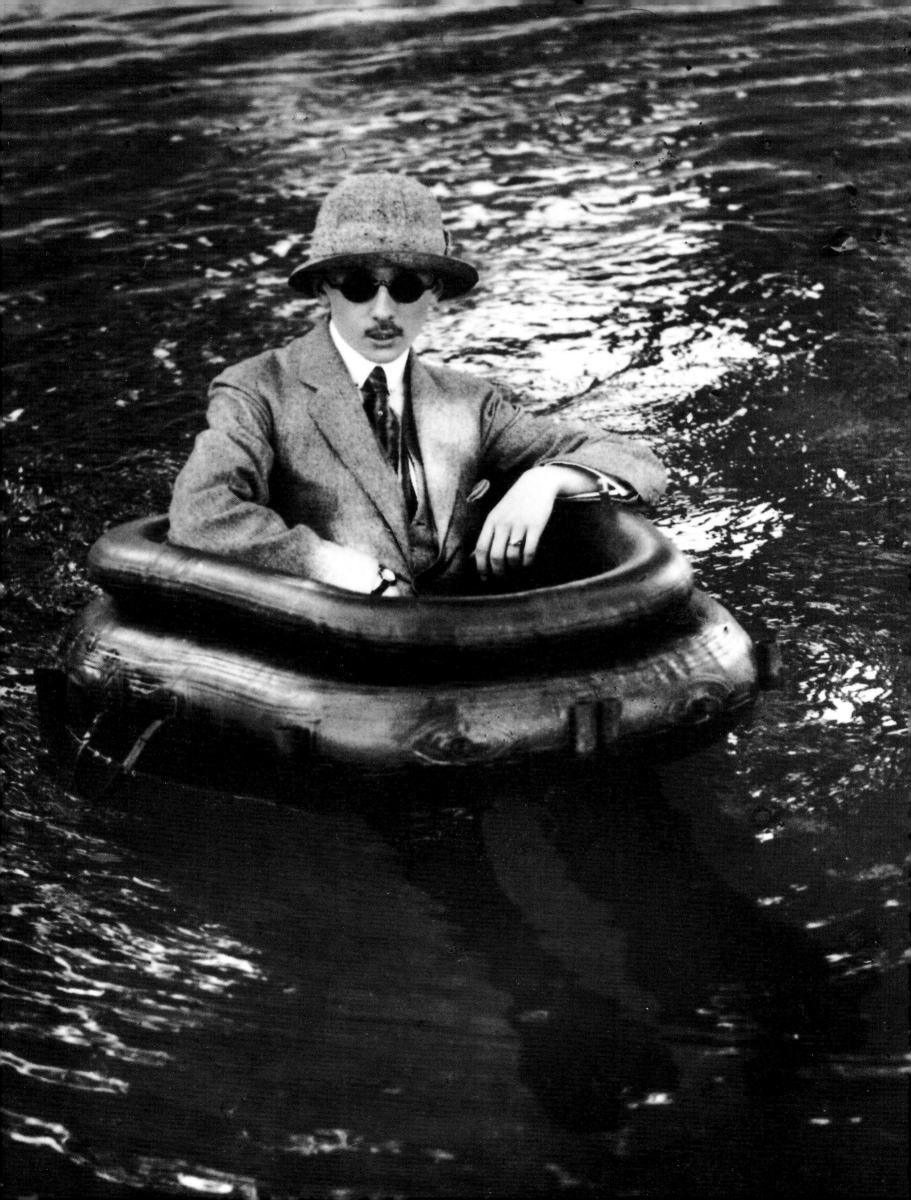

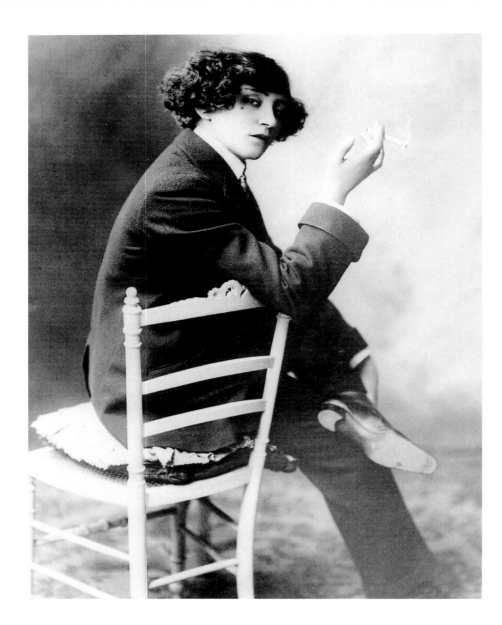

London, in the early 1980s, the elegant Hackett ran a market stall stocked with the gentry's cast-offs, much to the delight of a whole swathe of hip young people. Today, though still faithful to a certain style, he has burgeoned into a thriving company with many branches. On a larger, American scale, in that same period, Ralph Lauren tapped the yuppie imagination. By industrially manufacturing a "New England" concept, which has turned many rootless Americans into unlikely offsprings of the Duke of Windsor. But we're jumping the gun!

With the steady rise in purchasing power occurring between the late 19th and the mid-20th century, clothing manufacturers, which were taken over by the department stores, endeavored above all to meet the demand of new population groups setting out to discover the initial pleasures of the consumer society. While throughout Europe, and before long in North and South America too, a whole *élite* shopped in the sacrosanct Savile Row, in London, whose tailors were still unmatched. As were English bootmakers and, in St. James's Street, the undisputed king of hatters, Lock & Co. In Paris, only Hermès, the saddler, on the Faubourg Saint-Honoré, could compete, prestige-wise, with those greatest of purveyors. And Hermès' activities were more or

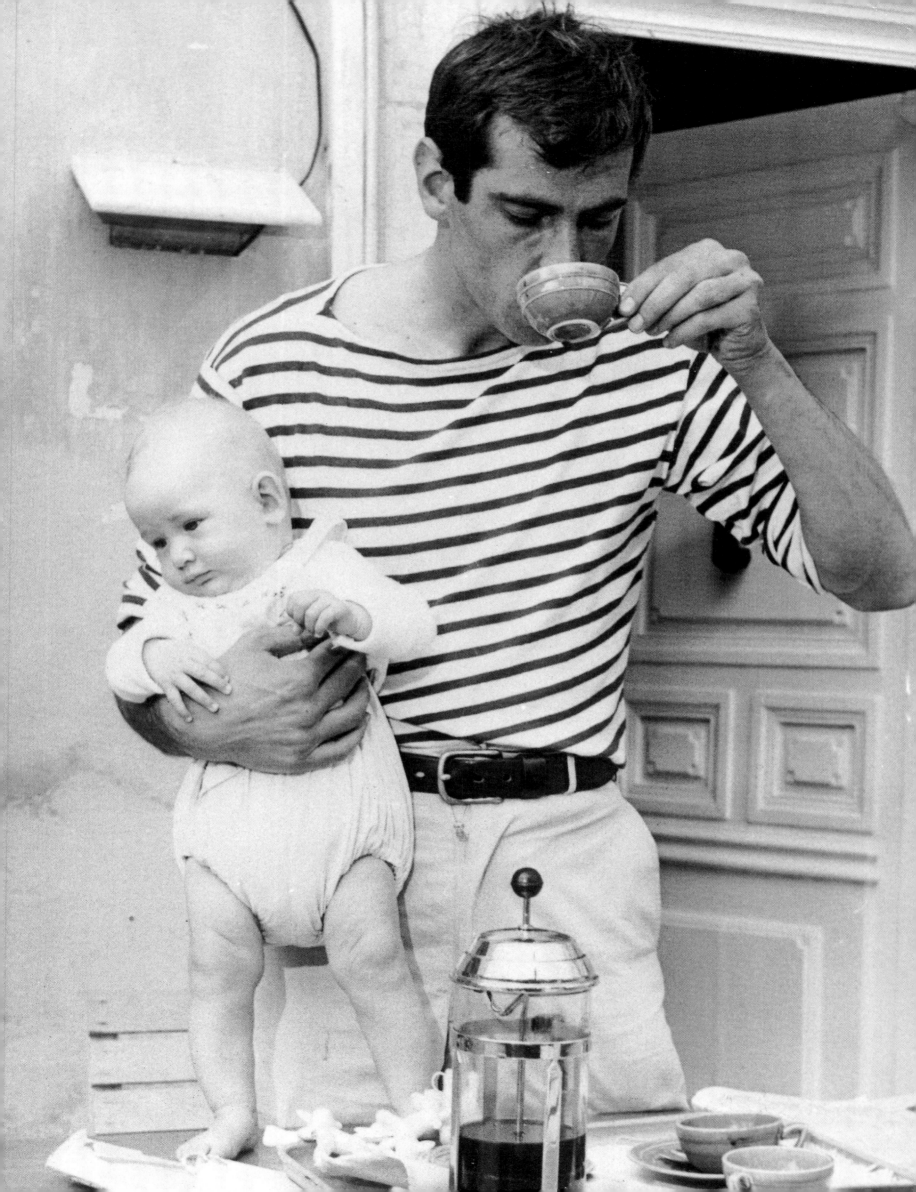

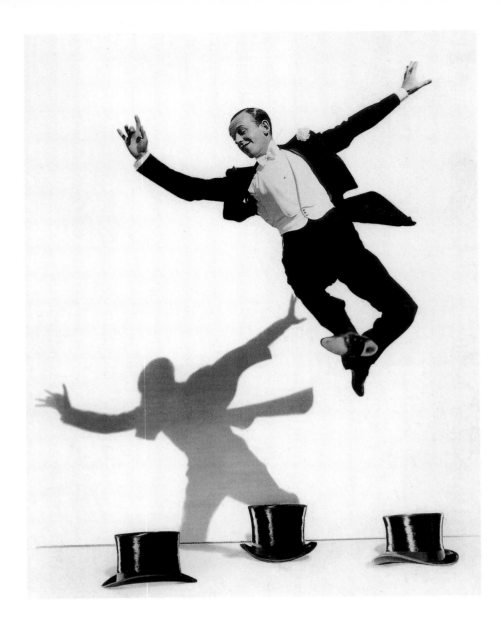

less confined to equipping horses and their riders.

The time of classical elegance was nigh. "Life, that wretched quarter hour peopled with delightful moments..." A whole decadent and aloof attitude was summed up in Oscar Wilde's quip. In 1900, he was just one of the first people throughout the 20th century to refer to that heyday of insolence--and arrogance--which represented the golden age of dandyism for young men seeking their identity. And from time to time it bobs back to the surface, for better or for worse. A Parisian department store, for example, devoted exclusively to dressing a middle-class clientele, now assumes the patronymic "Brummell," does it not?

Between 1914 and 1918 the wholesale slaughter in the trenches reshaped all of Europe, toppled crowned heads, recast the world order and, at the same time, came up with a new set of social rules of play. *The Harried Man* described by Paul Morand is in a hurry to experience the hard-won peace. For this man, speed would be a new form of aristocracy. Athletic speed, firstly, with any kind of competition and race embodying the most obvious demonstration thereof. From the Olympic Games to motor-racing, from the first Davis Cup victory of four young French players--"the musketeers of

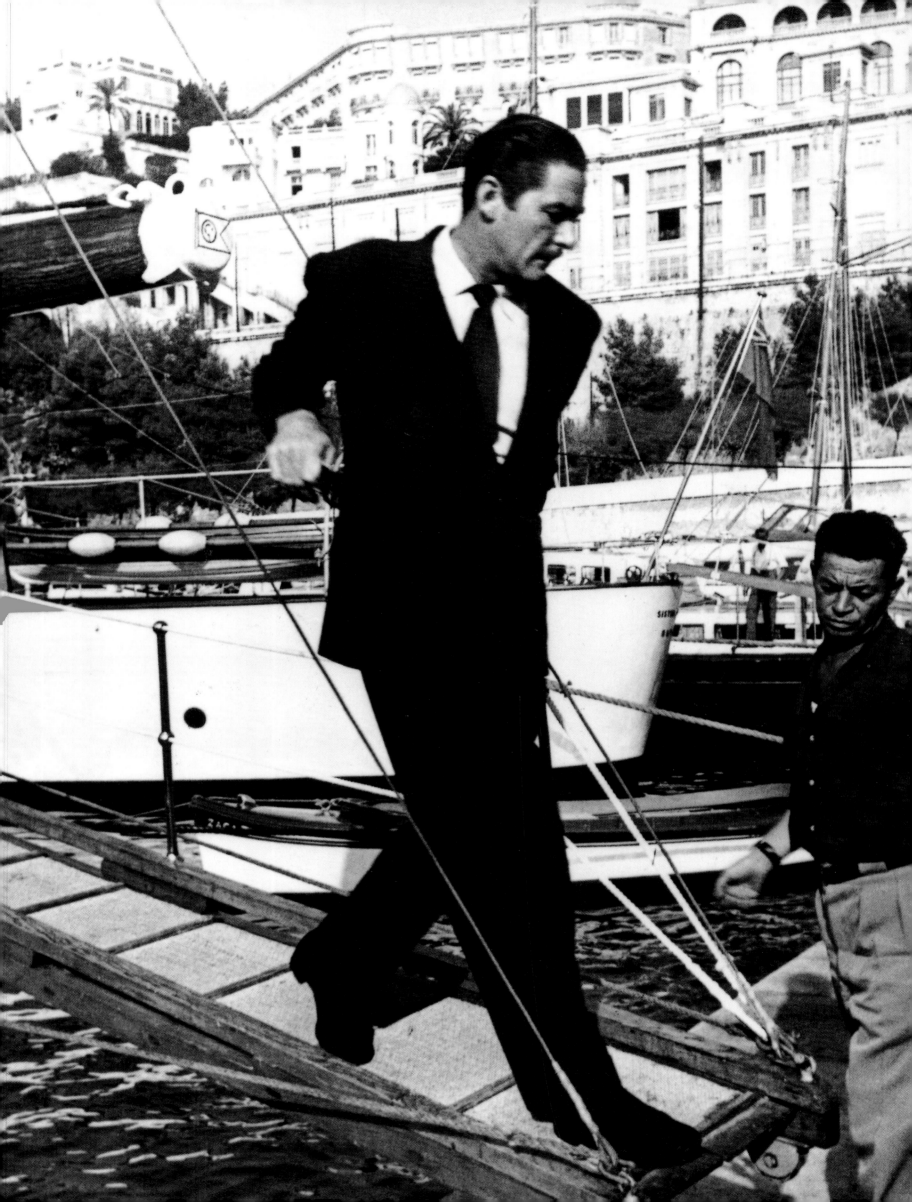

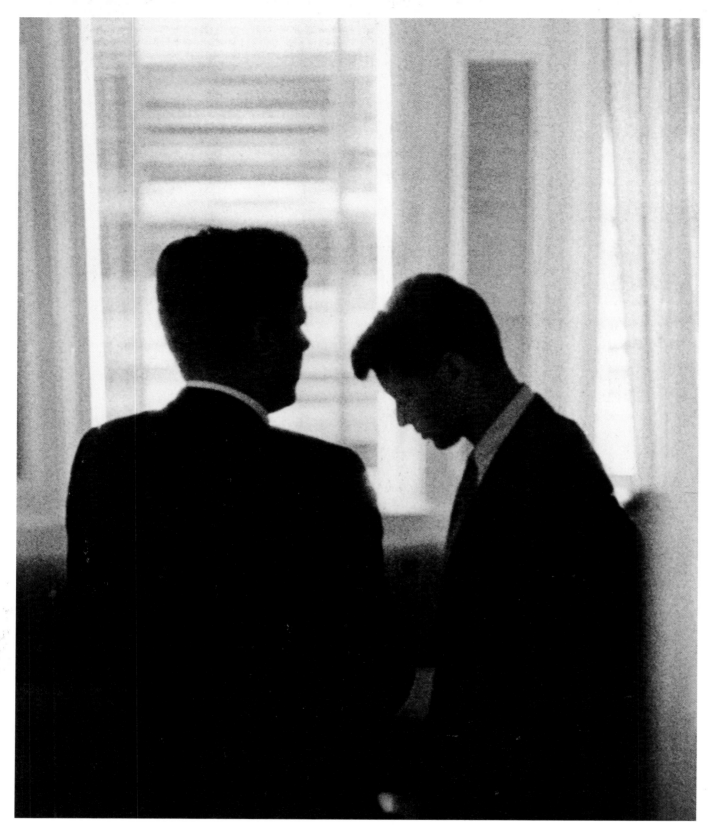

*Above:*
John Fitzgerald Kennedy and Bobby Kennedy,
captured on film by Jacques Lowe, Washington, 1960.

*Opposite:*
John Fitzgerald Kennedy, aboard a boat
in Coos Bay, Oregon, 1960.

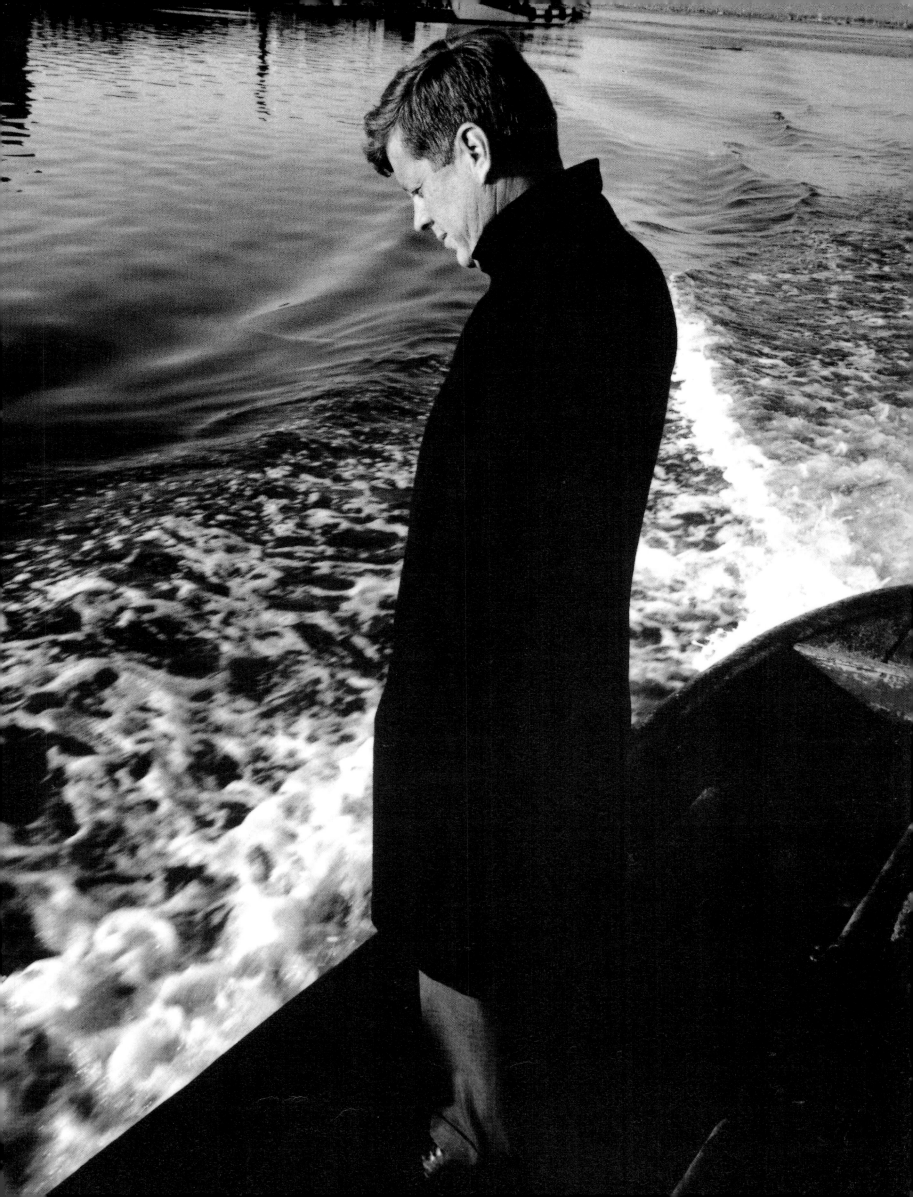

French tennis"--to the postwar feats of flying aces, all sporting activities associated with a relative improvement of living conditions transformed bodies. And as bodies became longer and more agile, and their performances were enhanced, so they demanded a similar flexibility in traditional sportswear. England, once again, set the fashion. In the early years of the 20th century, the heir to the English throne--the future Edward VII, who had been left to his leisurely pursuits until the ripe old age of sixty, thanks to the lengthy reign of his mother, Queen Victoria--linked his name with one or two innovations that were as remarkable as they were acclaimed in the masculine wardrobe. Essentially by embodying a requirement that was still brand new in old Europe--comfort, in both clothing, incidentally, and in furnishing. Despite the ample form of his Royal Highness, his particularly relaxed style contrasted with the "dressed-to-the-nines" elegance of someone like Prince Boni de Castellane, the model for a whole turn of the century aristocracy. Yet his manner of dress was still suitable for the many official duties carried out by that English prince who was extremely popular on both sides of the Channel. He was, to boot, a lover of fine food, loose women, leisure and escapades, a prince whom coach drivers called by his first name,

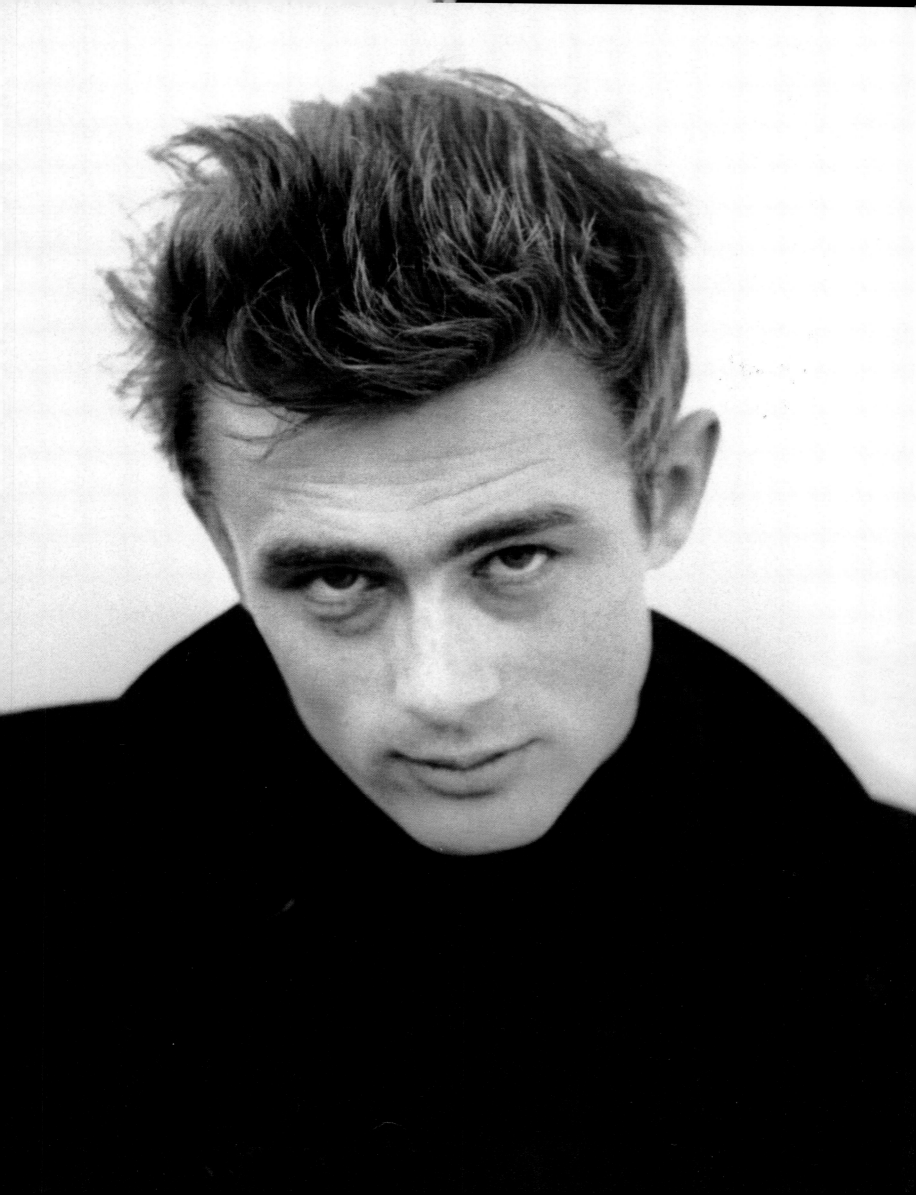

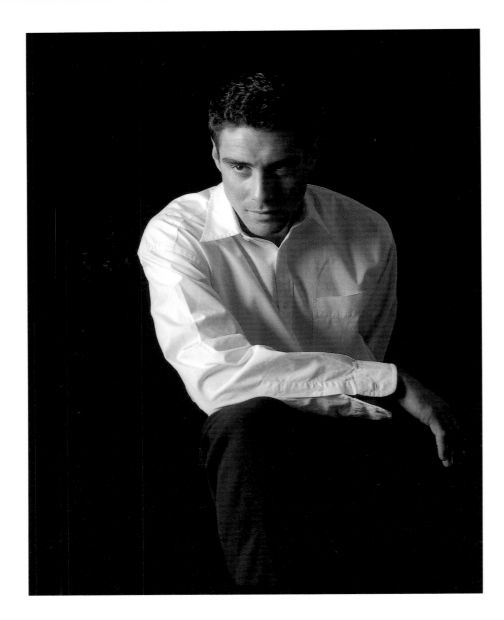

and as such he popularized abroad the systematic use of English fabrics which were as
supple as they were luxurious. Tweeds and flannels thus ushered in their reign over
the "Made in England" wardrobe.

The grandson of that Prince of Wales, whose title christened a variety of fabrics, would
in his turn carry on the tradition. Having acceded to the throne for just a few months,
before then hastily relinquishing it, he became for all time, as from 1937, the
legendary, unforgettable, and equally as elusive Duke of Windsor, a sphinx without a
riddle but a living museum of contemporary style in its most imaginative entrenched
positions. Some 40 years of exile, idleness, affectation, together with a host of
pictures, heavily touched up and then reproduced and captioned, produced, in a half a
century, a pose culminating in a form of dandyism put into practice--doing nothing,
but with such flair!  That small man--David, to those who knew him well, will have
been the first and perhaps the only truly male top model of the 20th century. A
comparison of the respective dressing-rooms of the two Edwards gives a fairly clear
idea of how dress, men and their attitudes evolved over some three decades. With the
first Edward, juggling with conventions was still tantamount to arranging them, the

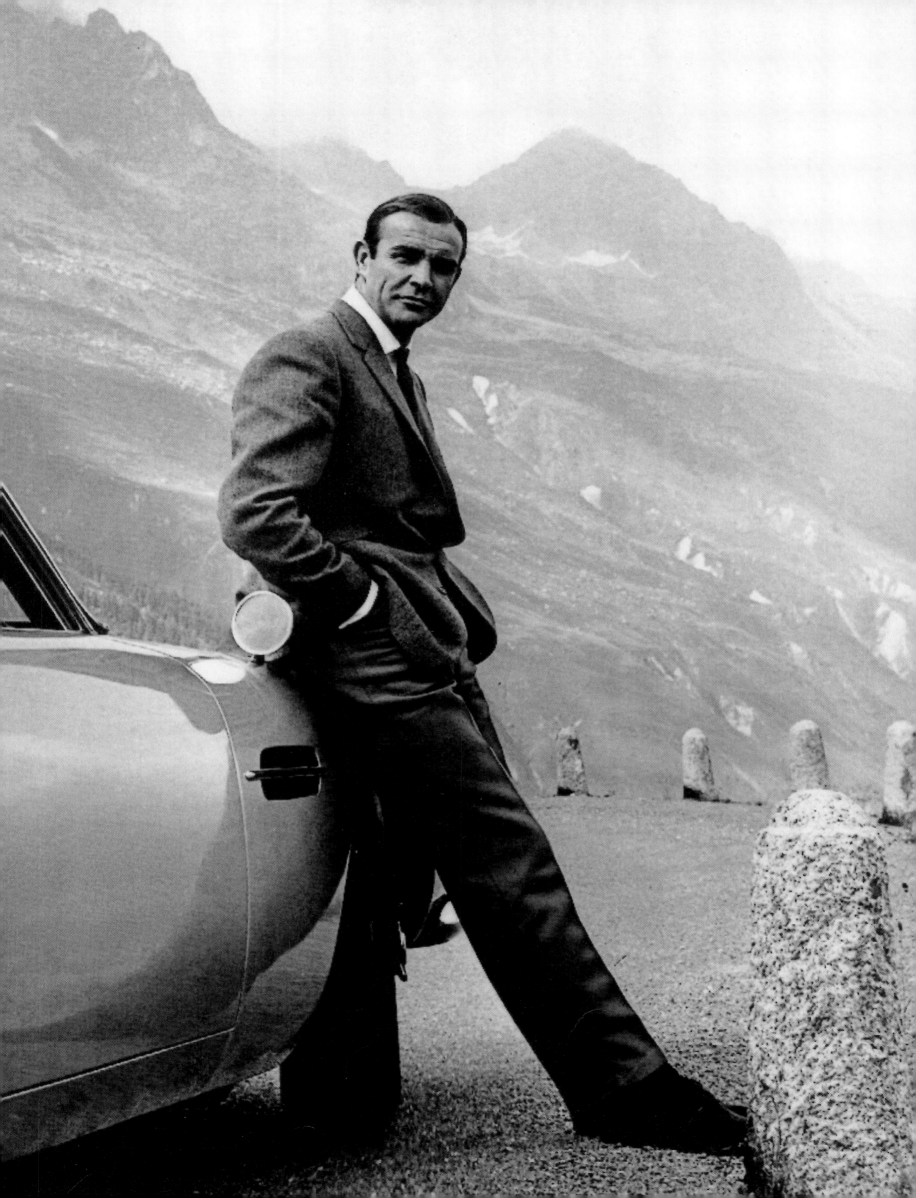

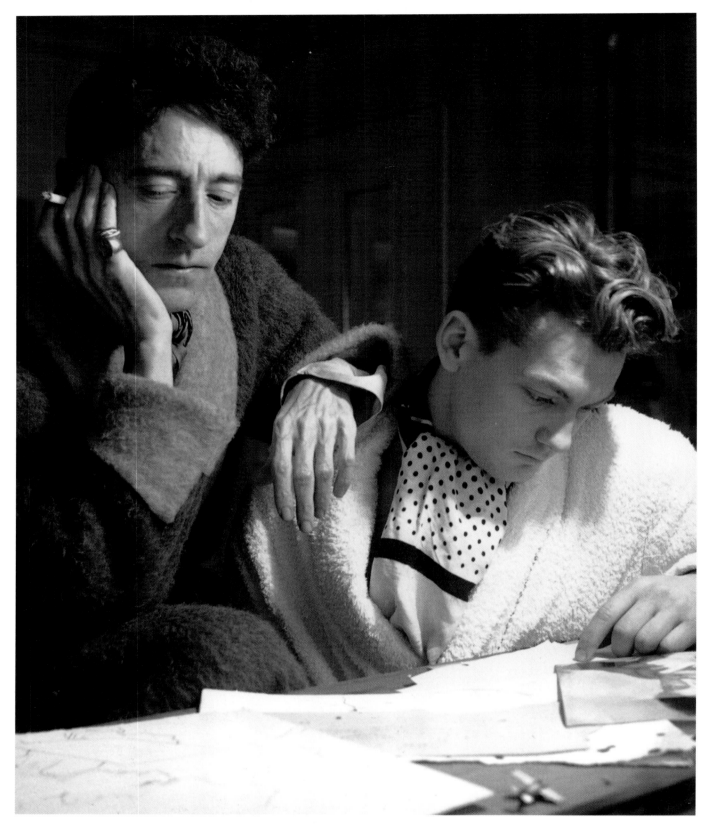

*Above:*
Jean Cocteau and actor Jean Marais,
portrait by Cecil Beaton, 1930.

*Opposite:*
Yves Saint Laurent, at the time in charge of haute couture
at Christian Dior Fashion House, photographed by Horst, Paris, 1958.

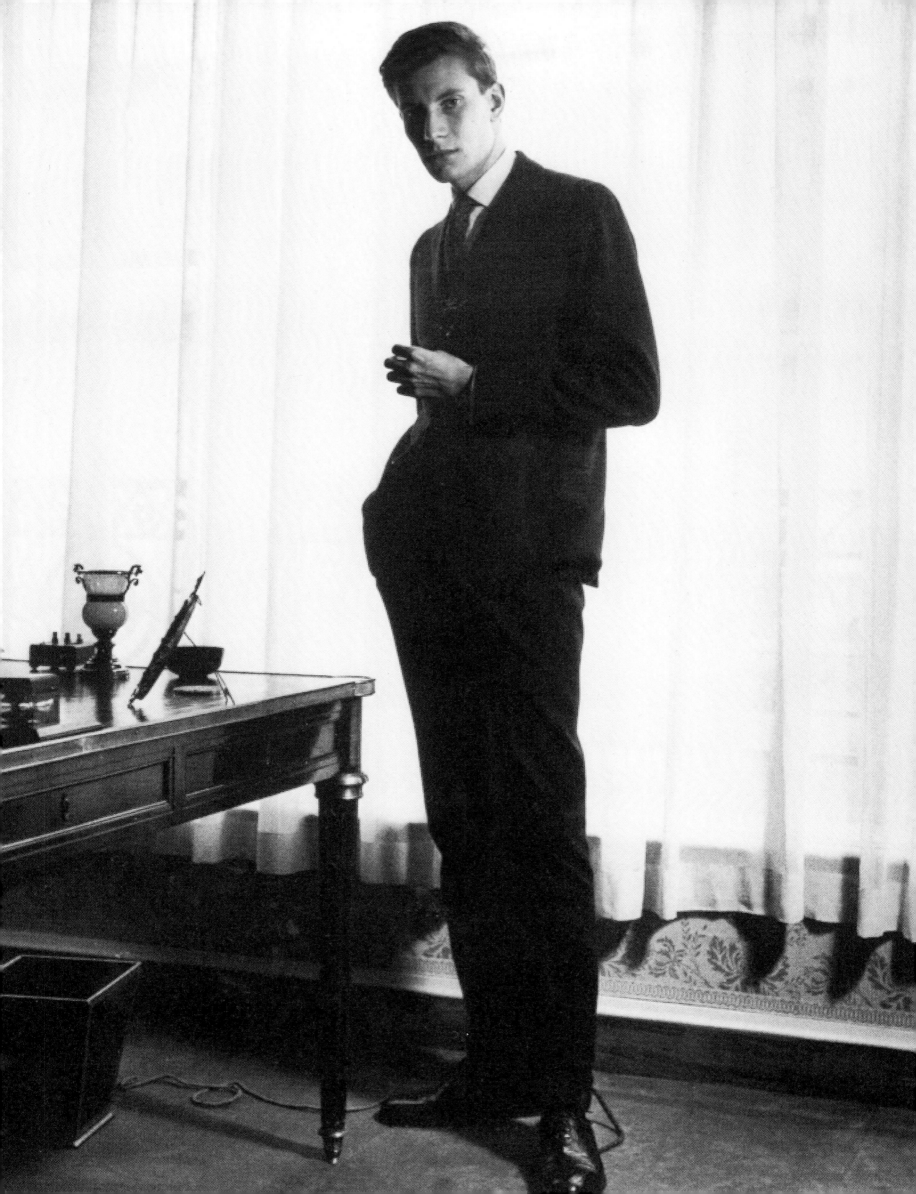

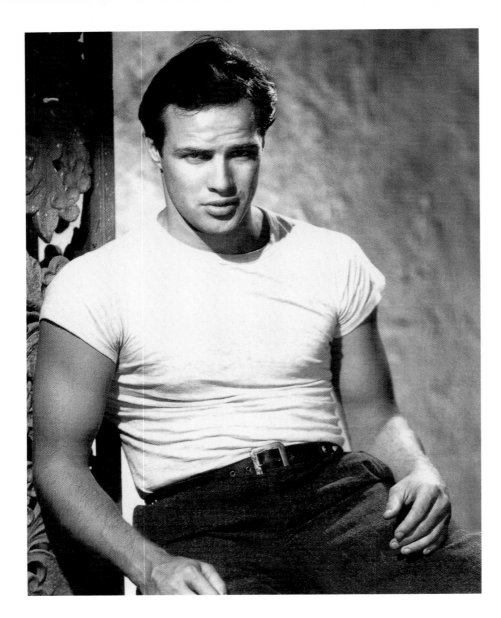

better to comply with the rules. With the second, a thorough abandonment of all that was involved. Where Edward VII stood out as an example for his world, Edward VIII was just the model of his.

When Edward, born in 1894, the eldest son of George V, relinquished to his brother George VI his crown and his influence, he had already set a style. With no restrictions holding him back, he was in a position to give voice to it. And once more, but with greater candor, the Duke of Windsor would become the high-flying stylist of casualness, comfort, well-being and good living. By adopting, for his daily round, that slightly weary ease where the staples of the old smart set vied with disconcerting and distorting mixtures of prints, materials and pre-established lines--small, soft shirt collar, sweater tied loosely around the shoulder, loose trousers with deep pockets, braces replaced by belts, fob watches by wrist watches. His often unlined jackets sported soft shoulders and loose sleeves, with a preference for materials that could not be worn out. David always kept a close eye on his figure. He was one of the first to use zips, and buckskin shoes which were still disparaged by the Establishment (who saw in them an acknowledgement of the homosexuals in their midst). This whole New Look

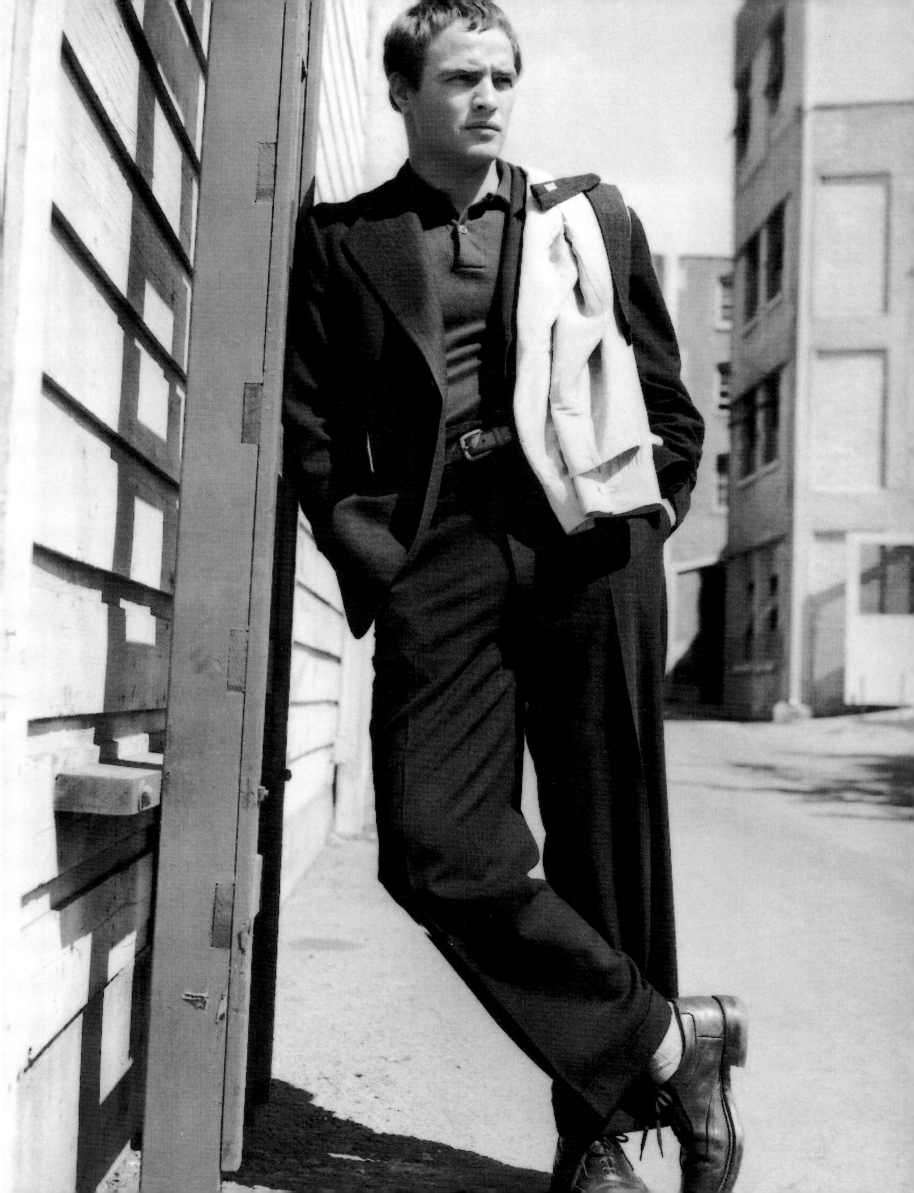

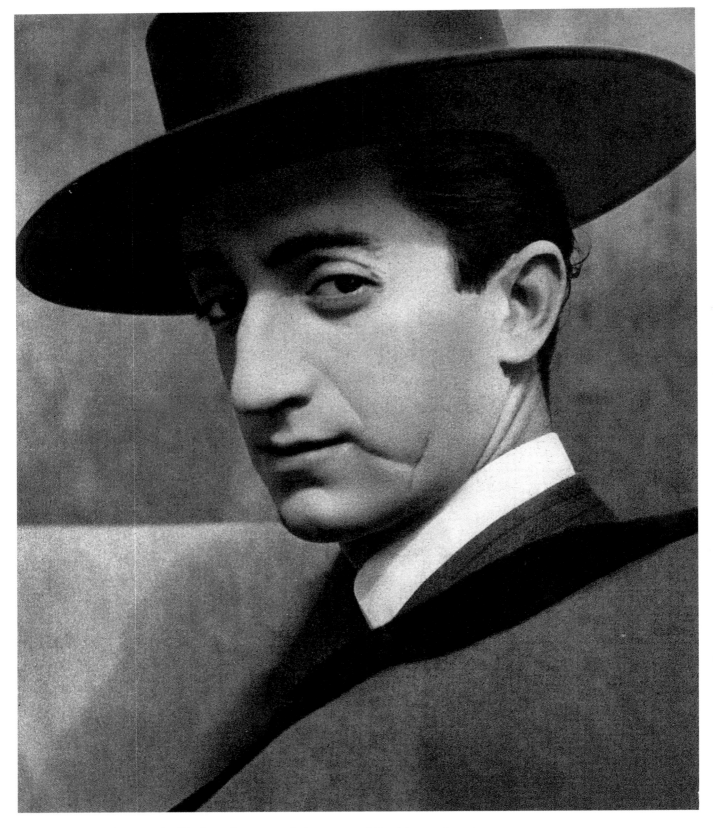

Portrait of the famous bullfighter from Cordoba Manuel Rodriguez Sanchez, known as Manolete, by Martin Santos Yuberos, c. 1946.

Robert Mitchum, 1947.

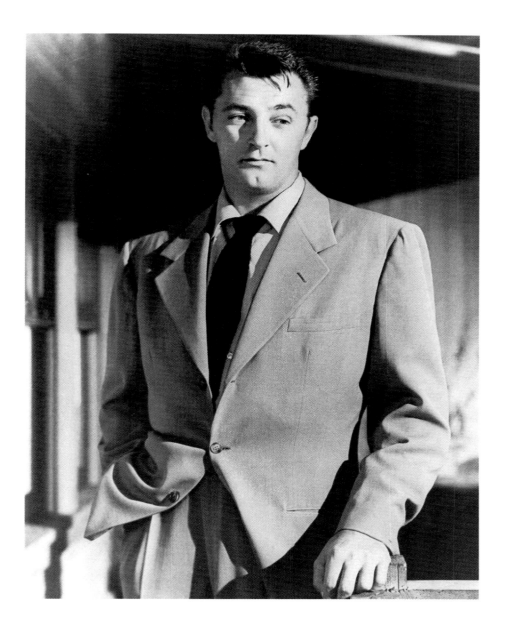

was borne along by the scandal of a sensational abdication and a marriage to a woman who was both a commoner and a divorcee… All this would seduce America, first and foremost, and its darling offspring, the Hollywood stars, in particular. While London's top tailors strove to accommodate the suggestions of that great trend-setter who so well combined elegance and unaffectedness, nobility and benevolence, style and casualness. An itinerant existence where appearance vied with being, container with content and the mirror with its reflection.

In the United States, except for period films, male film stars were then on the whole free to put together their own wardrobes. Many actors who were contemporaries of the Duke found an identity in HRH's elegance. And they drew considerable inspiration from his style. Fred Astaire was always the most lighthearted and irresistible of proponents. In his footsteps came Cary Grant, Clark Gable, Humphrey Bogart… and many others who would familiarize a sizeable public with that straightforward simplicity. Which is still the key example of classical elegance--a style which combines daring with tact, and knows where to draw the line.

Wars, with all their horrors, never rule out changes of detail, which are often

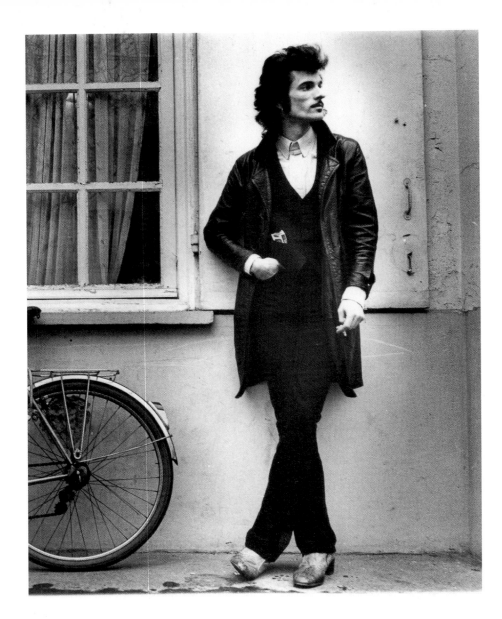

significant. The world of appearances is no exception to this rule. The Second World War would thus ratify the changes ushered in by the Great War. In 1945 everything still seemed just the way it was, yet everything had changed. As the victor in Europe, America would now dictate its own laws, with no inhibitions. In addition to its production standards, Europeans in particular discovered American clothes that were attractive, well made, nicely cut, and all ready to be worn. New materials, often the product of military research, also triggered many formal changes, organizational and commercial alike. They would transform the high street in the 1950s, while a still novel phenomenon would also insidiously see the light of day. The adult world, which was swiftly eclipsed, would call it "the young."

Before the 1950s, in the world of yesteryear, youth was merely a passing phase between innocent childhood and the age of reason. Young people were awkward, they had no purchasing power and no influence; they were just waiting to become grown-ups--to have a life, in a word! "Liberation" is not a hollow word, it has also turned that limbo into a social phenomenon. While the Duke of Windsor and one or two eternal teenagers of the Roaring Twenties, became "old fogeys" in turn, there emerged what

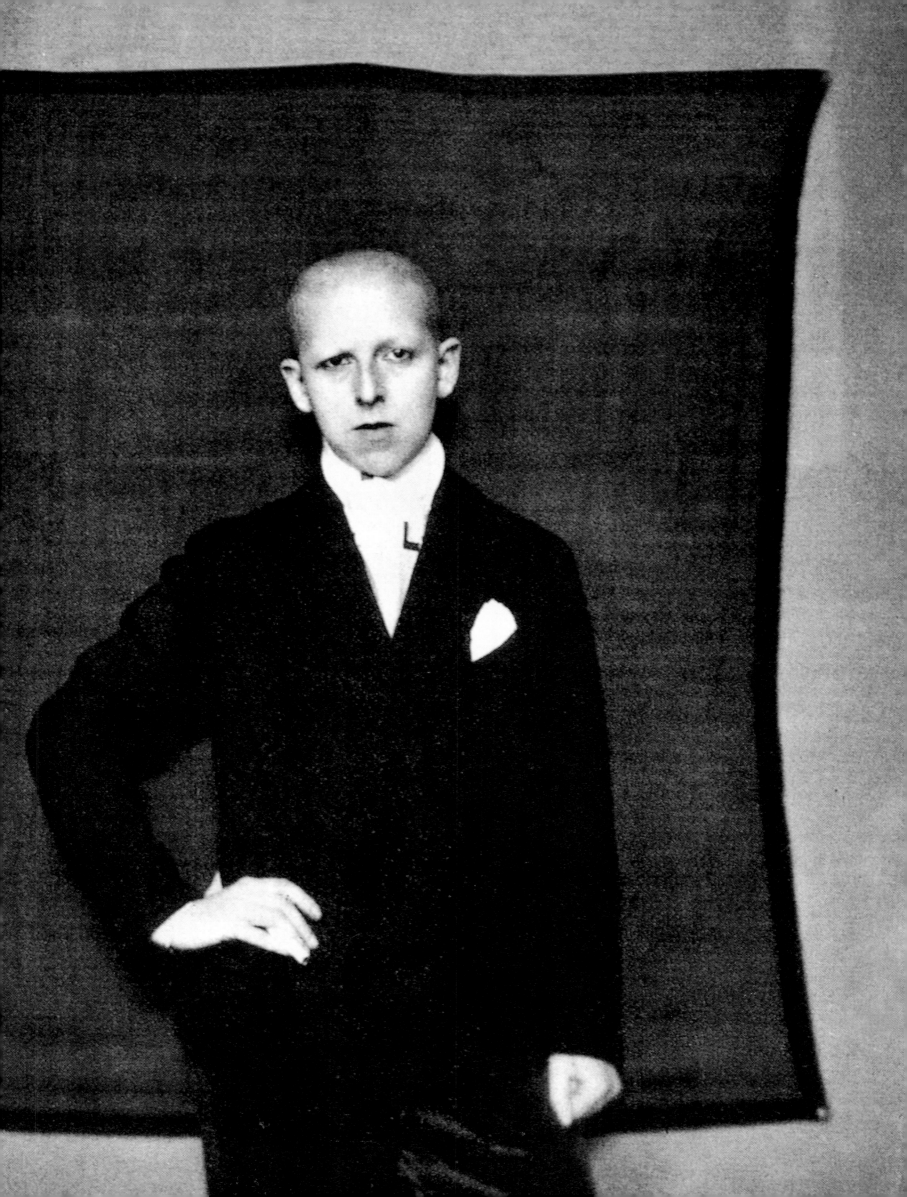

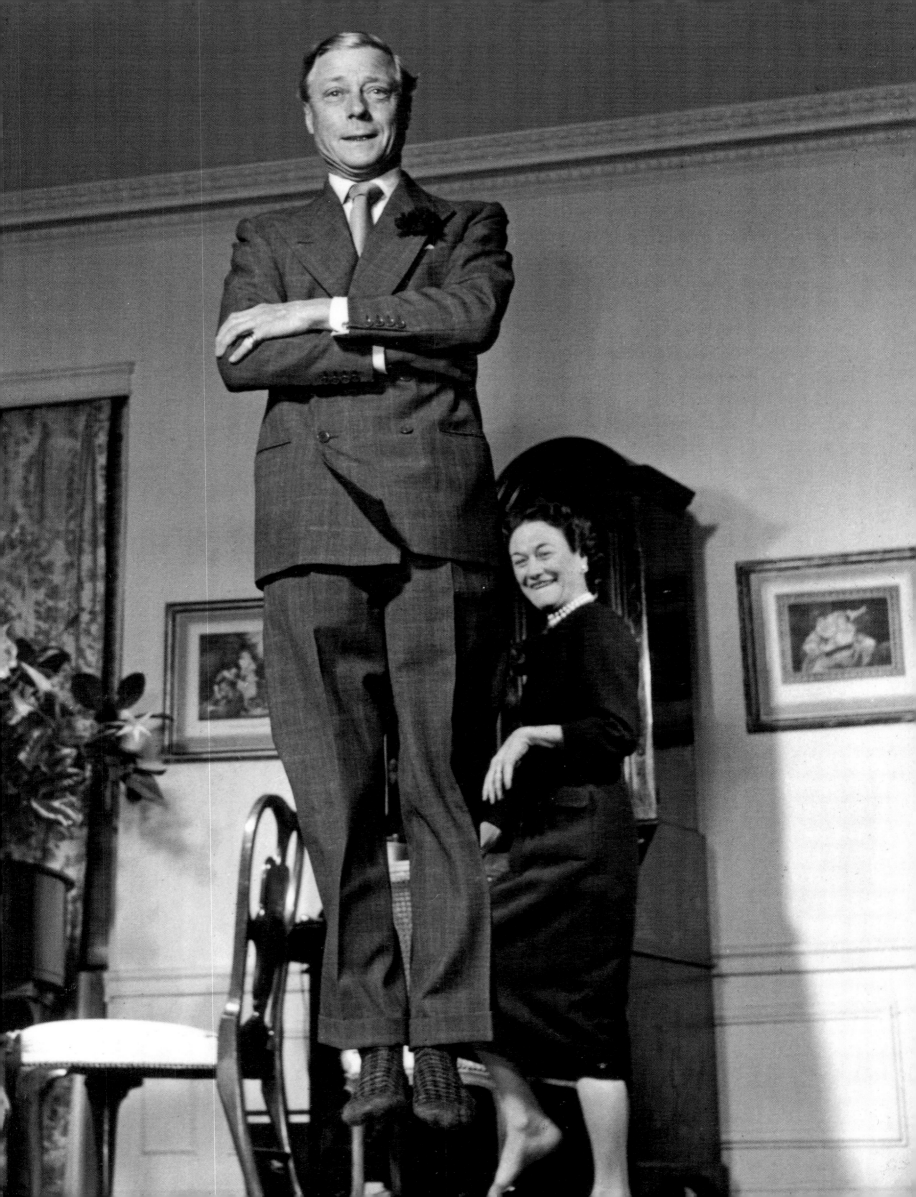

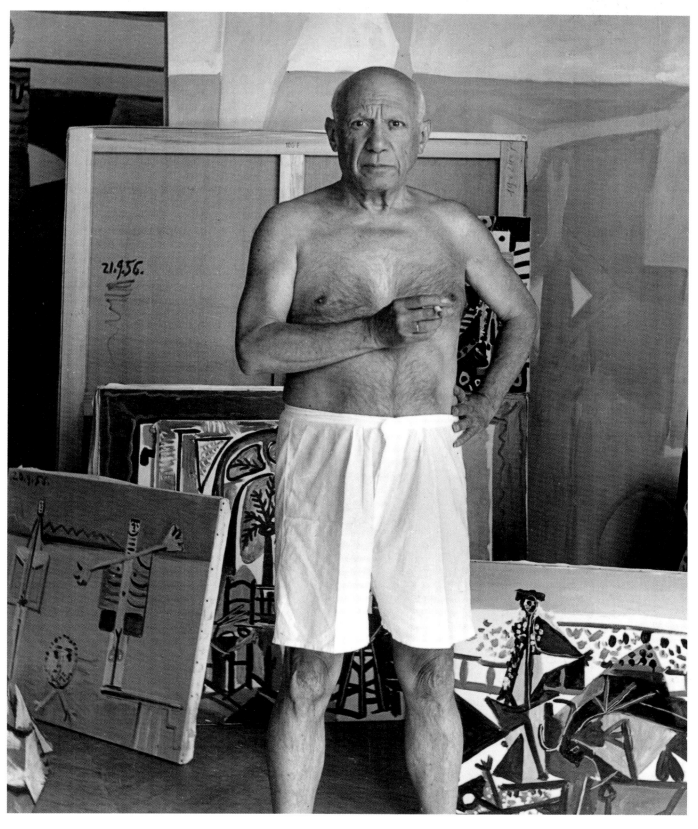

*Opposite:*
The Duke and Duchess of Windsor clown around
in their sitting room in Paris. Photo by Philippe Halsman.

*Above:*
Pablo Picasso in his Vallauris workshop,
1956, photographed by André Villers.

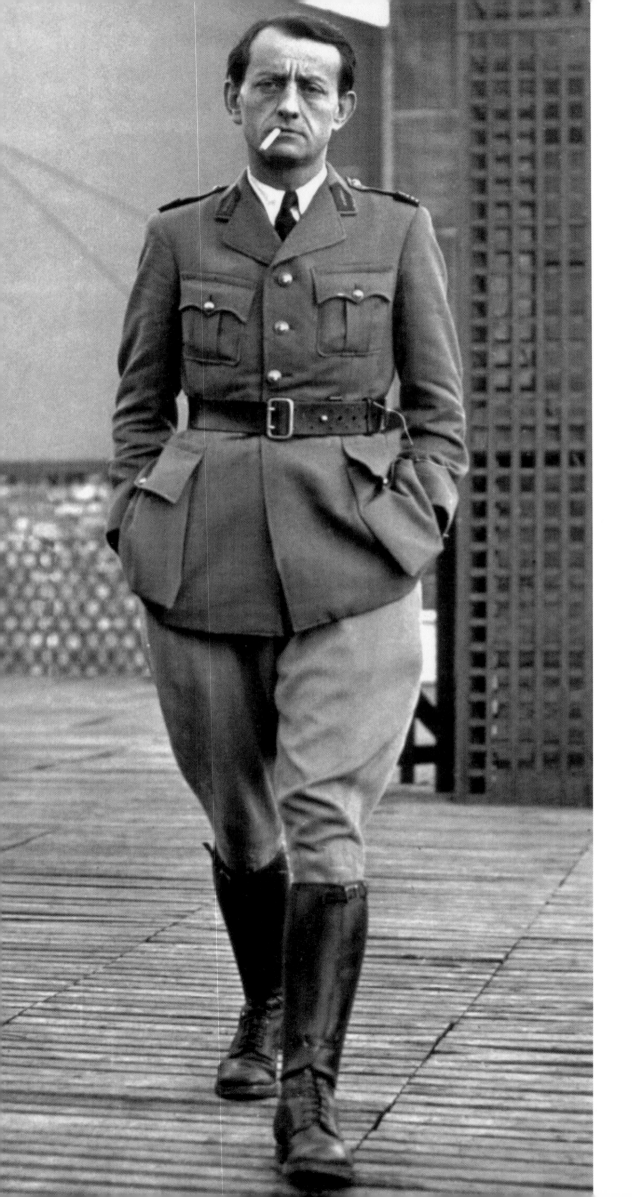

*Left:*
André Malraux in 1939.

*Right:*
The Duke and Duchess
of Windsor arriving at the
airport in Nice, 1960.

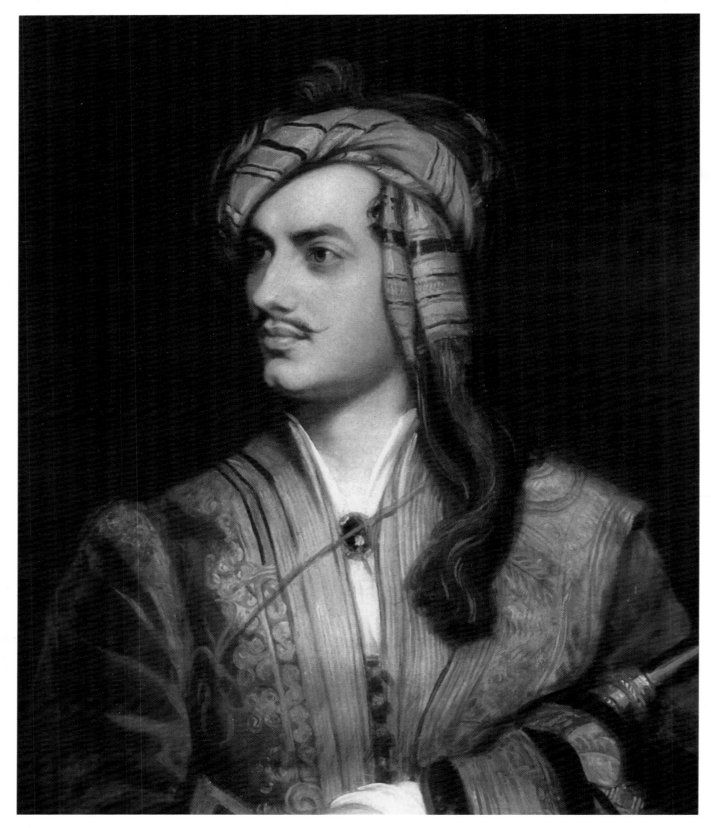

*Above:*
George Gordon Lord Byron, rendered by T. Phillips (1788-1824).

*Opposite:*
Count Etienne de Beaumont (standing) in beachwear,
with Mr. Buster and the Marquise de Polignac (seated),
at *Monte Carlo Beach,* 1938.

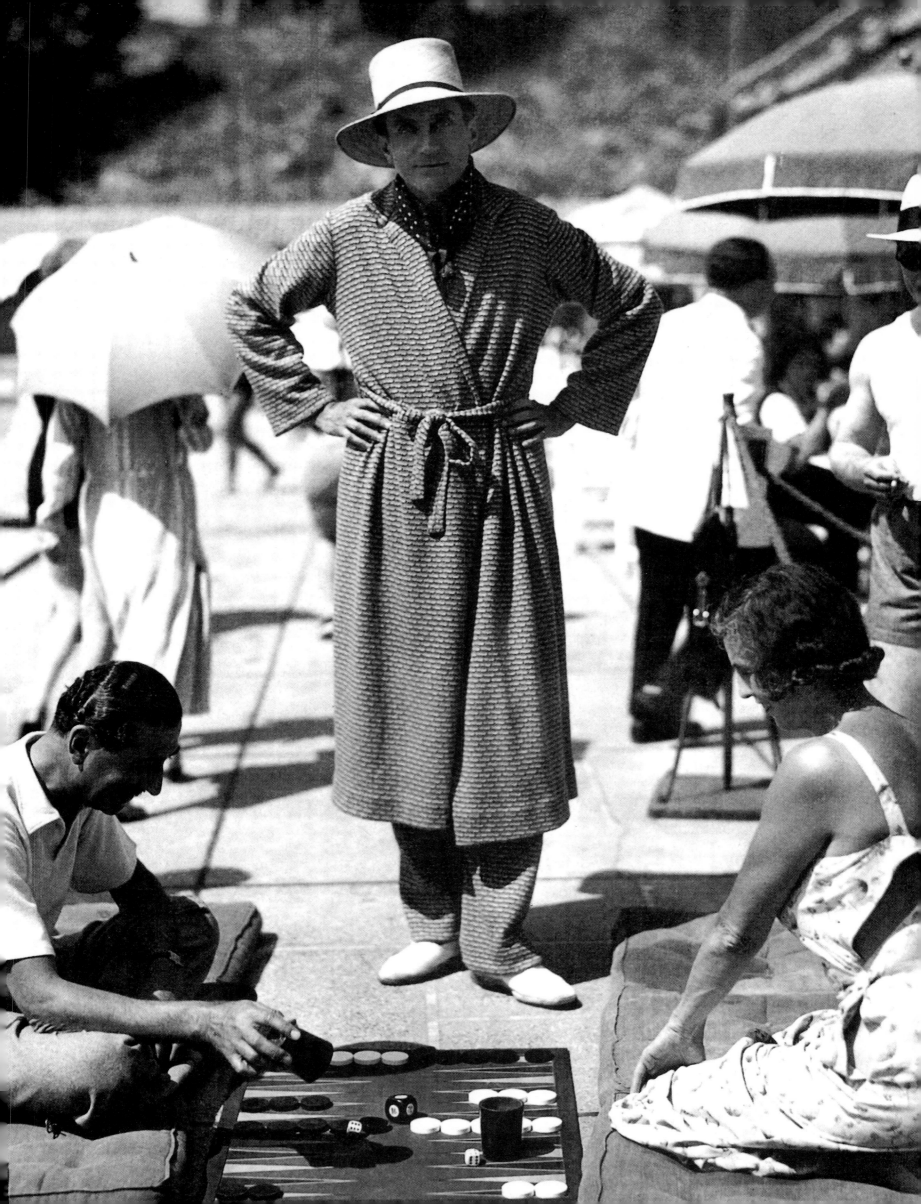

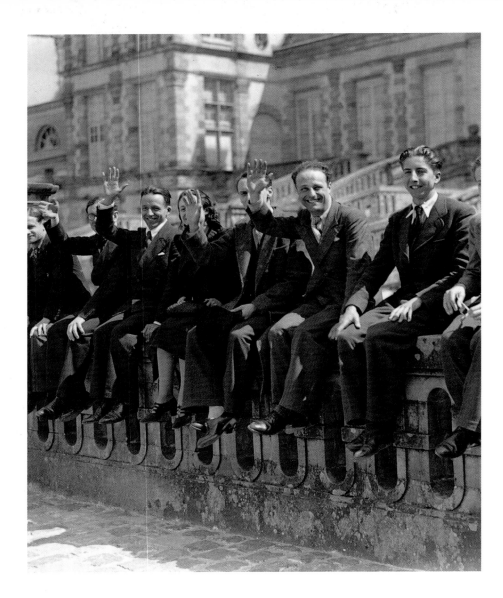

would come to be called the baby-boom generation, with all the ferocity of a tidal wave. In the refound affluence of the 1960s, this new wave would become a force to be reckoned with. It was no longer a revolt, but a revolution. Or, to use the language of newspapers of those times, a social phenomenon.

A fashion trend came into play under the German occupation called, with memorable onomatopoeia, which was as atypical as the "Incroyables" during the Terror of the French Revolution--the Zazous.

For a young man in the 1940s, to "swing" did not just mean asserting your liking of American jazz, which was banned by the Nazis. It meant at the same time refusing compulsory labor in Germany, and rejecting a world of older people identified with the oppressor's tyranny. Just as for the rebels of 1792-1795, for the young Zazou in 1943, appearances became a form of expression: large checked jacket with a half belt, drain-pipe trousers, short enough to show off brightly coloured socks in large all leather shoes… Never going out without dark glasses on, slicking his long locks back into a quiff. And then dancing, dancing, dancing the night away in a France brought to its knees. Thumbing his nose at the *"Travail, famille, patrie"* (Work, Family, Country) ethic.

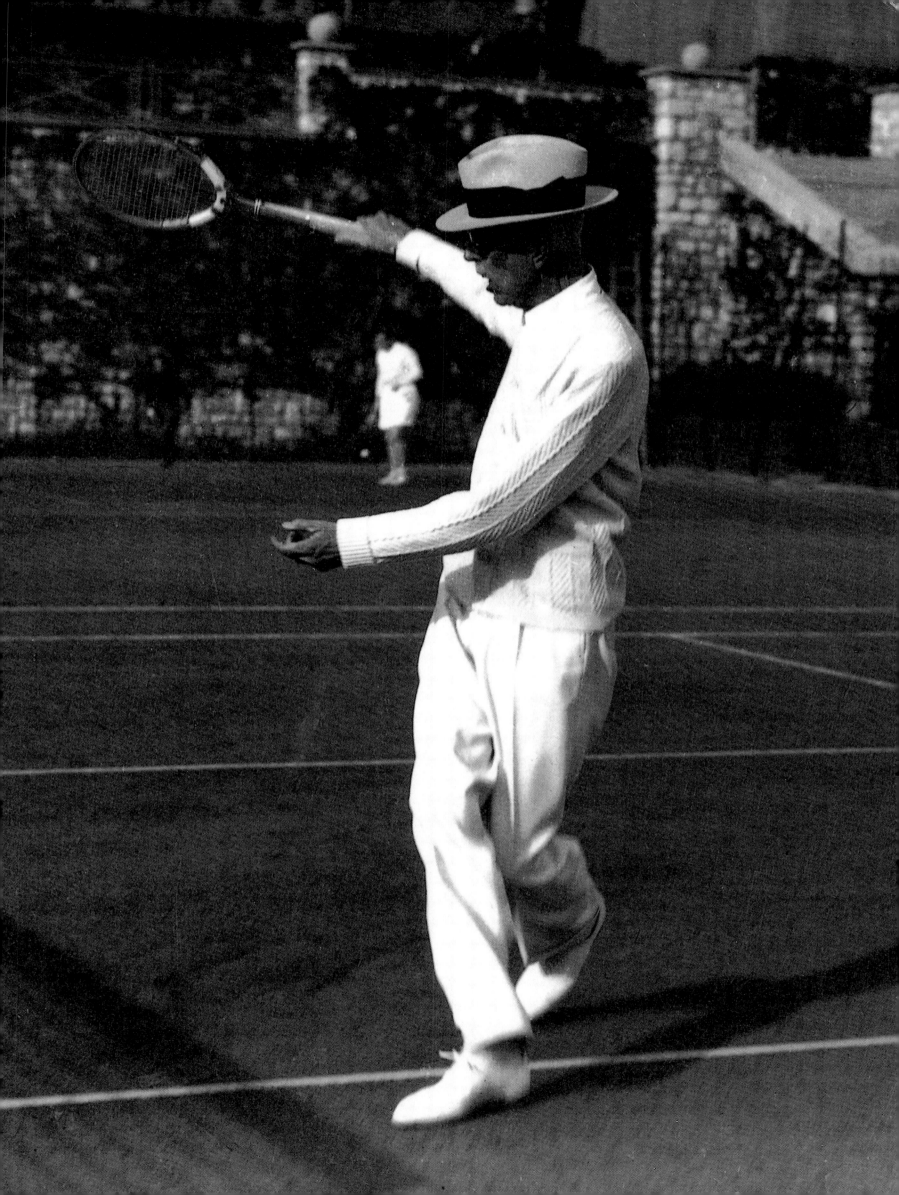

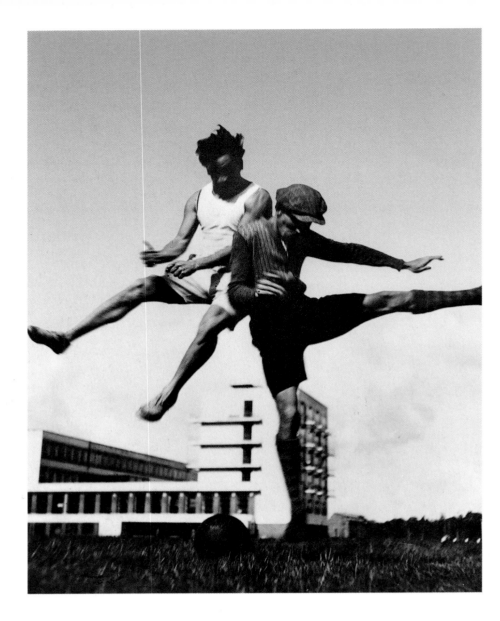

Cocking a snook at the restrictions dictated by the Vichy government. How much trafficking and resourcefulness were these teenagers, usually from modest backgrounds, able to engage in, to afford such sartorial abundance, when every scrap of material in France was being accounted for? In any event, Zazou mockery demanded a certain bravado. While the French militia, guarantors of moral order for the Nazi occupier, brutally hunted down all isolated non-conformists. This subversive attitude was stripped of its main *raison d'être* by the Liberation of Paris.

Jazz swung on. Finally out of hiding, it flourished from 1945 on in the wake of the liberating GIs. Die-hard Zazous went underground with newcomers into the cellars of St. Germain-des-Prés. From now on, the enemy was the others: the middle-classes, war veterans, and sellouts. Never before had young people sported clothes that were as systematically shabby or espoused mores that were so patently free. In the eyes of the world, a little patch of Paris between the Café *Flore* and the Rue Dauphine became the cradle of a movement that was called "existentialist." From Incroyable to Zazou the youth phenomenon was here to stay this time around. It would soon have its own philosophy, its own music, its stars, its turf, and its dens of inequity. It also had its

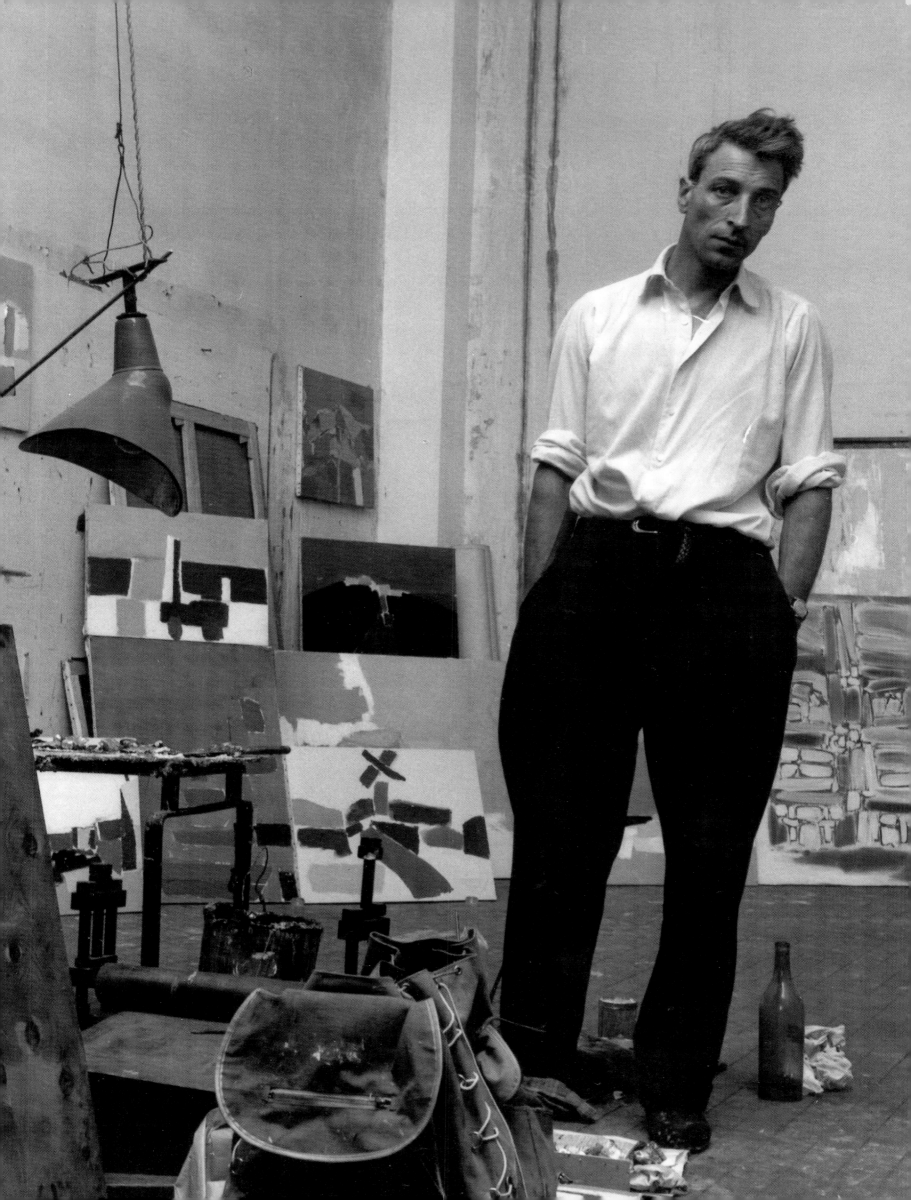

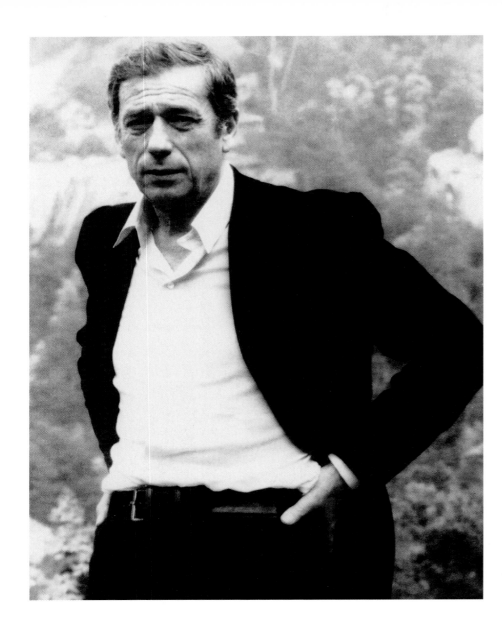

own outfits. But even more than all this, it would represent a breath of freedom and optimism for the next generation, already a market. For there is nothing like pocket money to establish a new fashion. The first people to become aware of this would spread a materialism based on the American model throughout Europe, without any qualms. A lust for life was compatible with a lust for consuming. The "youth" phenomenon gave rise to a before and an after in both the world and the world of fashion. The masculine world, so proud of its ancestral certainties, was for the first time knocked off balance.

The son's identification with his father had hitherto forged a bond of continuity between generations--the first razor blade, then the first fitting with the tailor were preludes to the first visit to the brothel. "Ah," might sigh the madam of the well tended establishment to which the father had recommended his lad, "like father like son". That's how things were!  At least until the early warning signs of what, in the late 1960s, would come to be called the anti-Establishment protest movement. Having reached adulthood, with the age of majority now lowered to 18, a whole generation of school children, all well fed, vaccinated, tanned, eager to bite into every forbidden

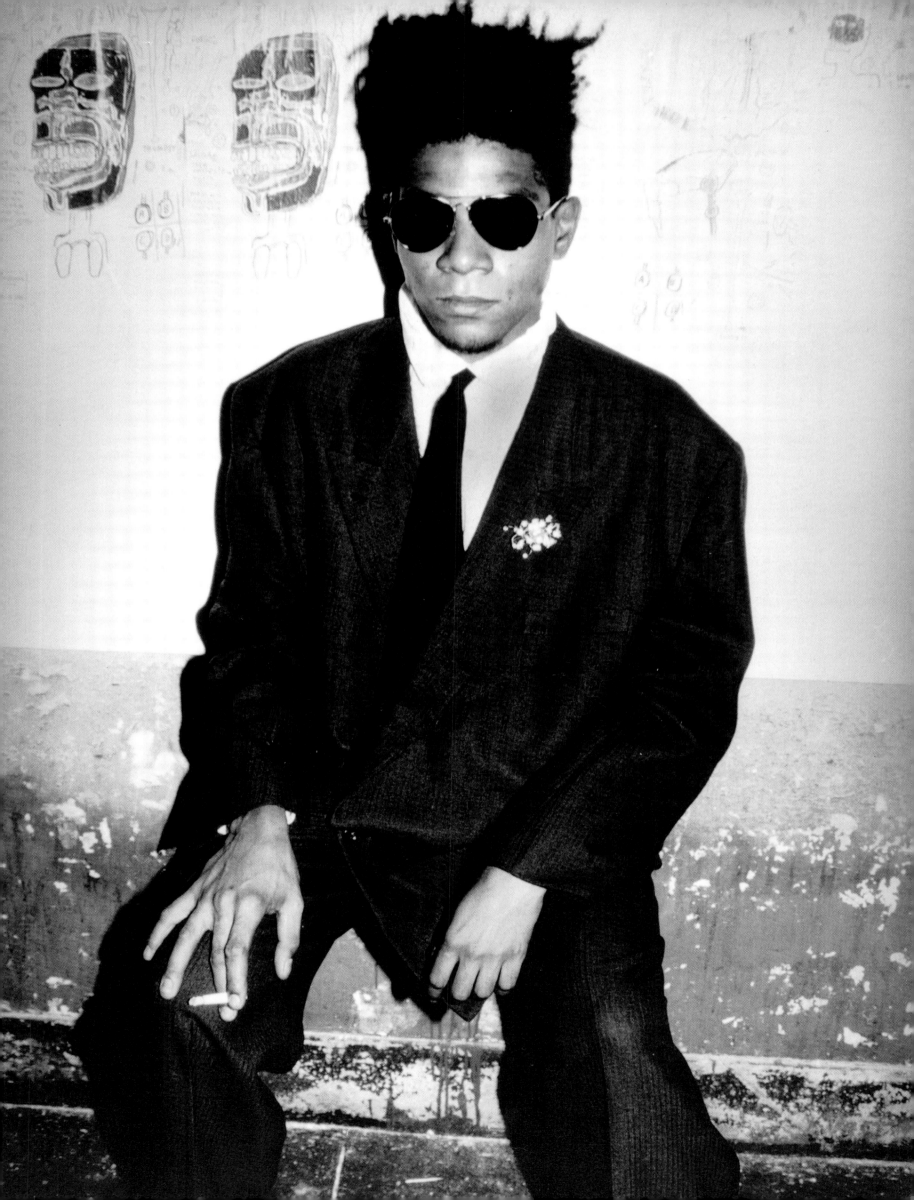

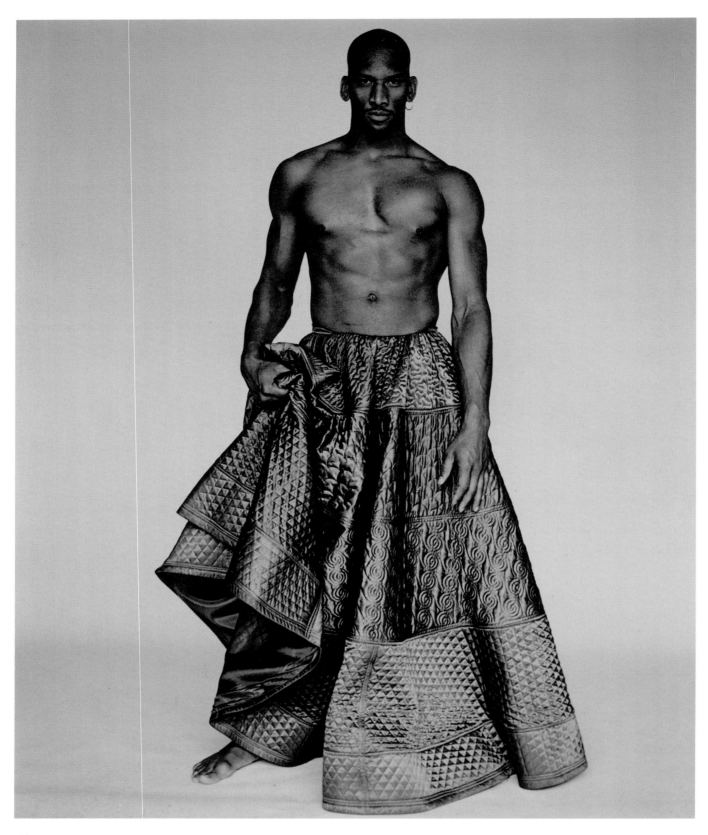

*Above:*
Long quilted skirt designed by Jean-Paul Gaultier, and photographed
by Paolo Roversi. (Men's Collection Fall/Winter, 1985-1986).

*Opposite:*
*Hooded Boy,* photo by Kurt Markus, 2000.

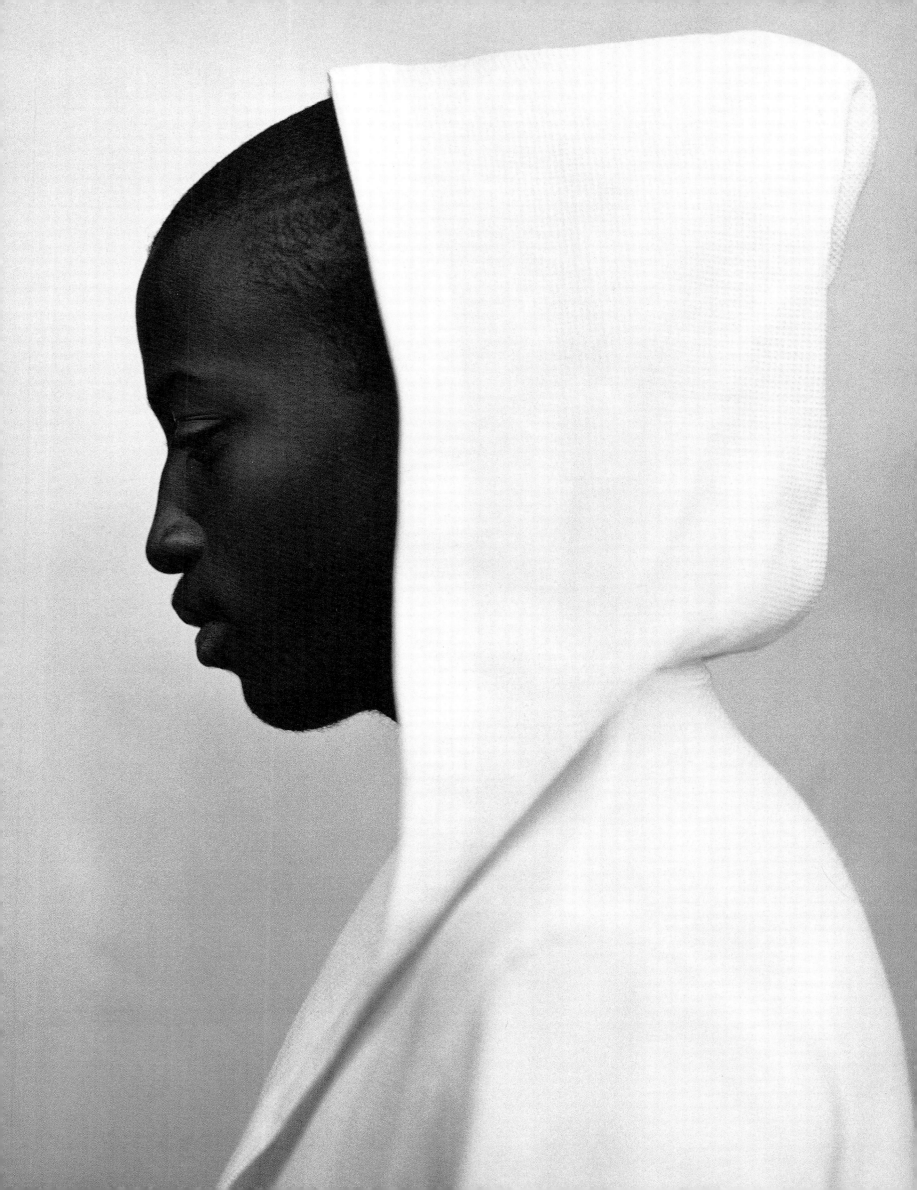

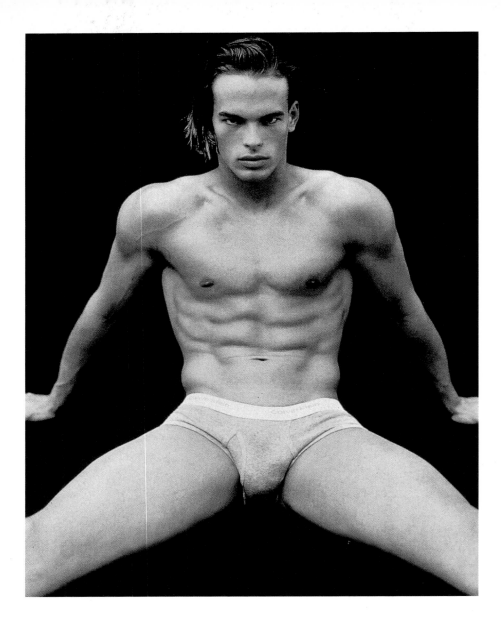

fruit, clashed with its seniors, who had often been prematurely aged by their ordeals
and who could not identify with these long-haired kids, for whose freedom some of
them had sacrificed their own youth.

Between the spirit of fine arts and café anarchy, the offspring of Sartre's nausea
invented the Left Bank look. The anti-everything stance of the early suburban rockers
who, with their studded leather jackets and their grim outlook, embodied the first
rebels without a cause. Many others have followed in their footsteps. The militants of
the Latin Quarter rose up against parental power. Hooligans and delinquents beat up
on spoilt little rich kids and went looking for girls. Even well brought up sixties' rock 'n
roll fans, dancing the twist at their rave-ups, treated their parents like old farts. Being
young meant being anti. Jean Cocteau, a forerunner in such matters had clearly
understood as much when, in his own day, he declared: "I'm very sure about what I
don't like." Fashion would offer this uprising of spoilt brats a particularly appropriate
battlefield. All fashion is, by definition, young. If it's not, it's dead.

The pact signed between youth and fashion in the latter half of the 20th century would
have such widespread effects on the western world that a book such as this could

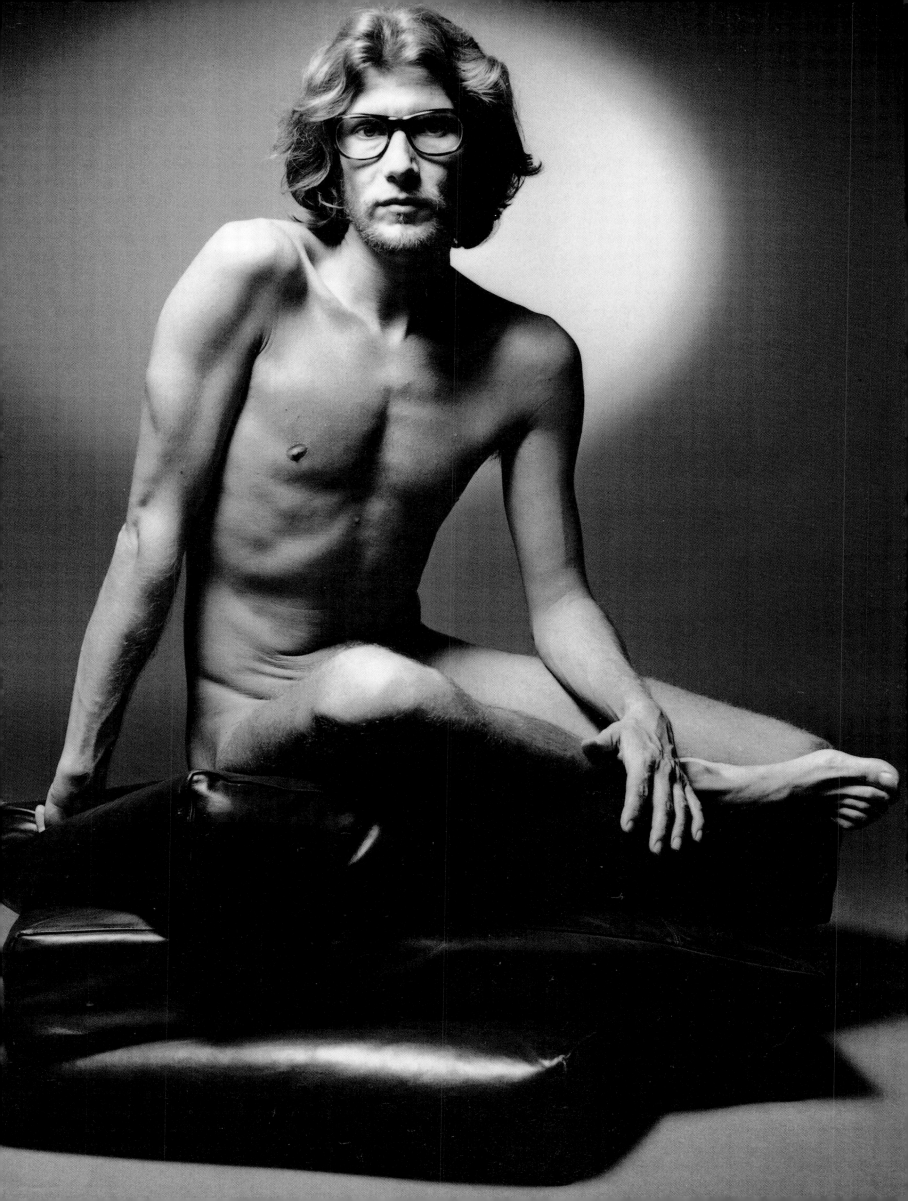

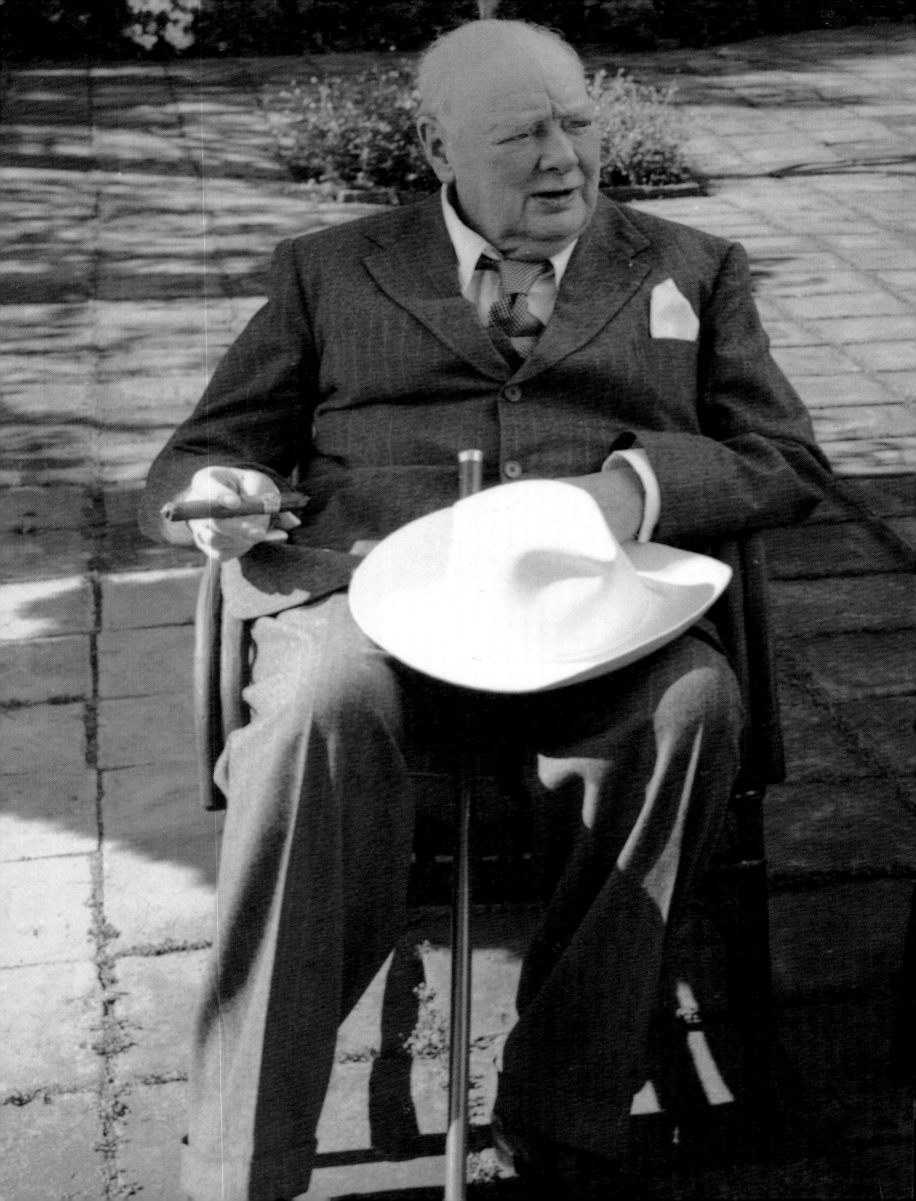

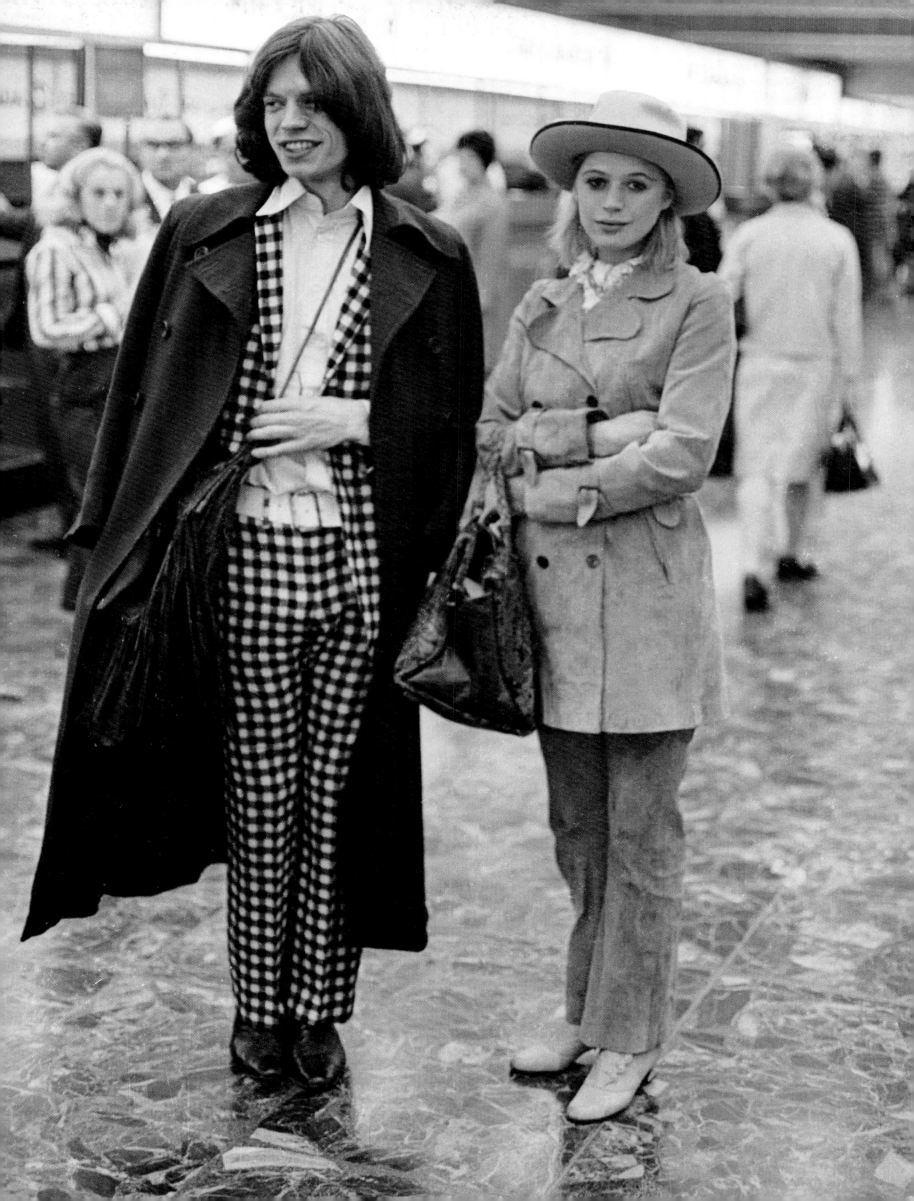

never cover them all. James Dean's films, Elvis Presley's songs, Miles Davis' music, and the pioneers of the beat generation were all already ushering in a breath of fresh air. Hawaiian shirts, jeans, easy to wash accessories that didn't require ironing, jackets with padded shoulders, the Ray Bans worn by helicopter pilots, their fur-lined, worn leather jackets, their khaki pants, their sweat shirts… a whole range of US army issue surplus clothes started to capsize an established order of things--and clothes. While London's tailors stuck to their guns, suburban English Mods and Teddy boys sported provocative costumes. A whole camp youth rediscovered London. Victorian in inspiration, the whiff of neo-dandyism in the air, embodied just as much by the eccentricities of a photographer like Cecil Beaton as by the animal impact of a rock star like Mick Jagger, would have verged on obscurantism if its discrepancies had not underscored the vague androgyny of a whole style based on an unapologetic, complex-free elegance.

While London was being credited with a monopoly of chic and shocking ideas, and Paris was recognized for its ability to lend these ideas a chord that was at once intellectual and practical, a new industrial network had been set up in Italy in the postwar years, without much fuss at all. Benefitting considerably from the American help offered to the peninsula as it emerged from the dark years of Fascism, an amazingly competitive European ready-to-wear sector would come to the fore. The United States might excel in mass products offering the best value-for-money, but from the 1960s on, Italy would manage to mass produce innovative and luxurious clothing for men, popular with women who were popular with men. England, which was oddly devoid of any such manufacturing systems, would imperceptibly lose its supremacy as arbiter of elegance.

The last four decades of the 20th century witnessed the upsurge of tailors, manufacturers and then designers from the Italian Mezzogiorno. From this period on, northern Italy took men's clothing design in hand--and had the machinery to do so. By snapping up every market and radically, and at the right time, transforming its set ups and production standards, the Italian ready-to-wear sector also managed to persuade modern man to be a creature of his time--and without losing a drop of his integrity. So when, in 1970, Nino Cerruti inherited a dynasty of Italian manufacturers, well aware that it was not enough just to produce quality raw material, he embarked on launching his first up-market men's collections. Their reintroduced classicism would

*Preceding pages:*
Left: Winston Churchill at cap Ferrat, 1962.
Right: Mick Jagger and Marianne Faithfull at the London airport, July 1969.

*Opposite:* Lance Staedler for Fabio Inghirami, 1986.

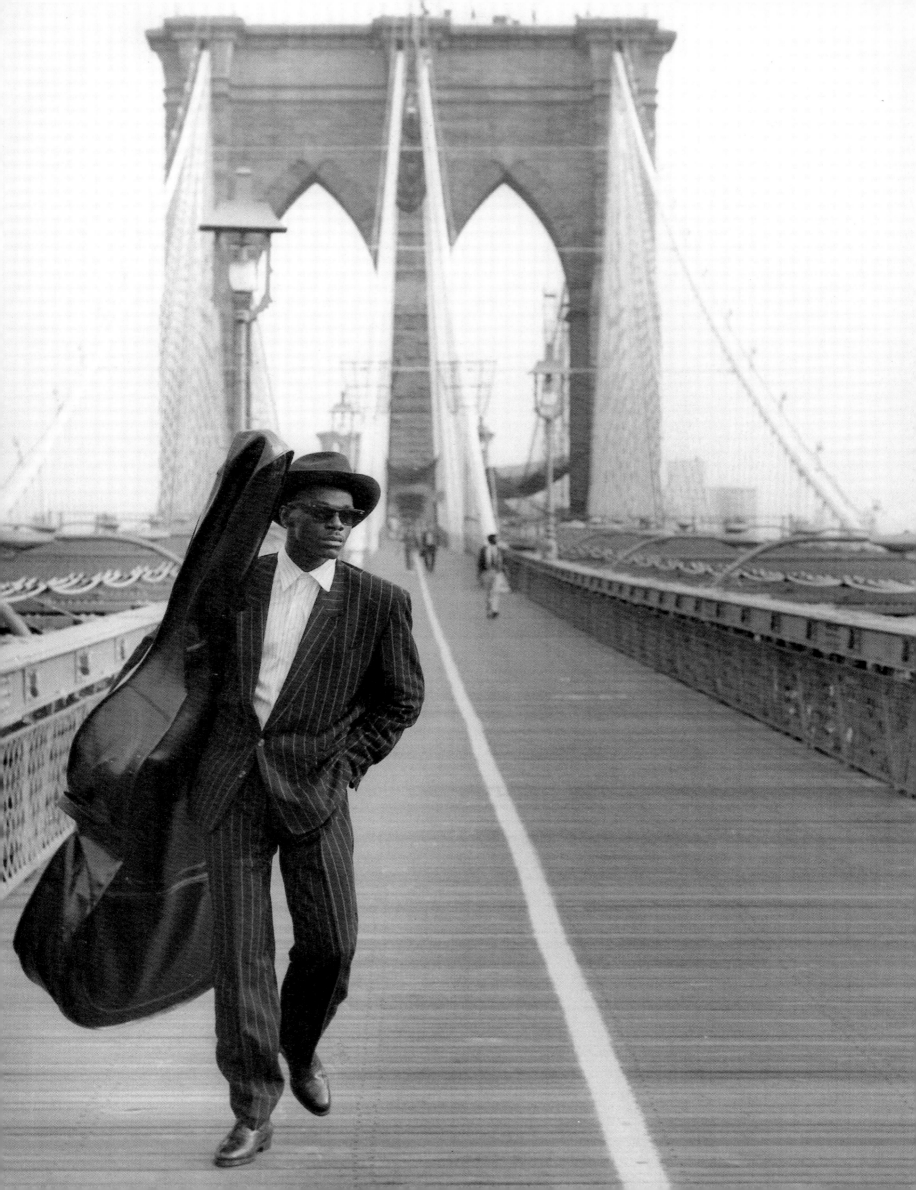

meet with immediate success. Enough to apply throughout the collections--this time aimed at women--the same principles originating from the man's world. A lot of women's fashion brands have already tried to tap into men's fashion, particularly with accessories such as ties, but with the opening in the Place de la Madeleine, in Paris, of the "Cerruti 1881" boutique, in 1973, the trend was reversed this time around. It would be streamlined, developed, and diversified by Nino's personal assistant. From 1970s, that excellent tailor Giorgio Armani introduced a new cut for the jacket which systematically revolutionized men's suits, and used new fabrics, lines and combinations, all of which enabled him to swiftly impose his overall vision of style on a significant and soon to be international male clientele. This was before he also came up with lines designed for young working women who were free, or keen to look as if they were. In some 30 years, with a wide range of lines, this masculine/feminine activity built up an international empire which, today, makes the Armani company one of the very top businesses in the Italian economy. This indisputable success, on a worldwide scale, underscores a phenomenon that was developed between the lines throughout the 20th century--the ever-growing interaction in modern clothing

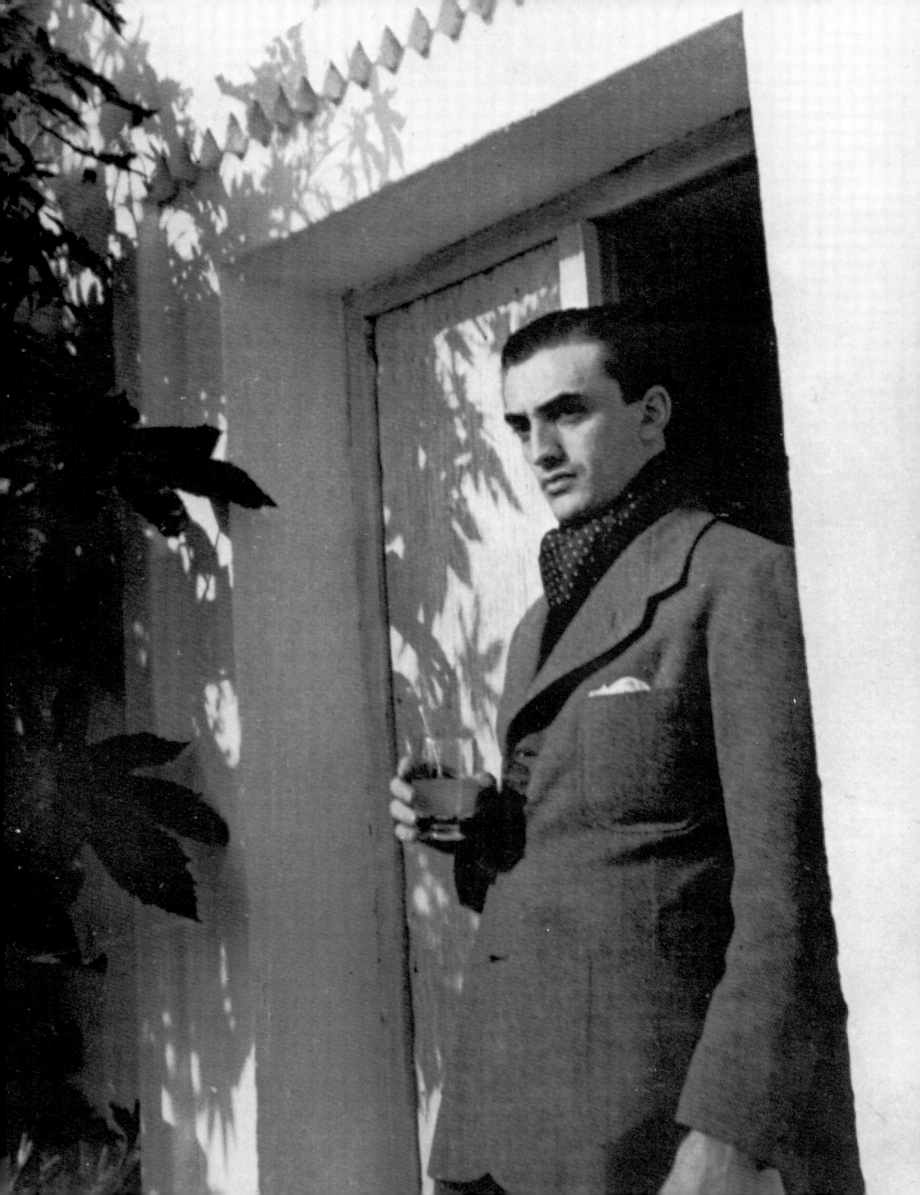

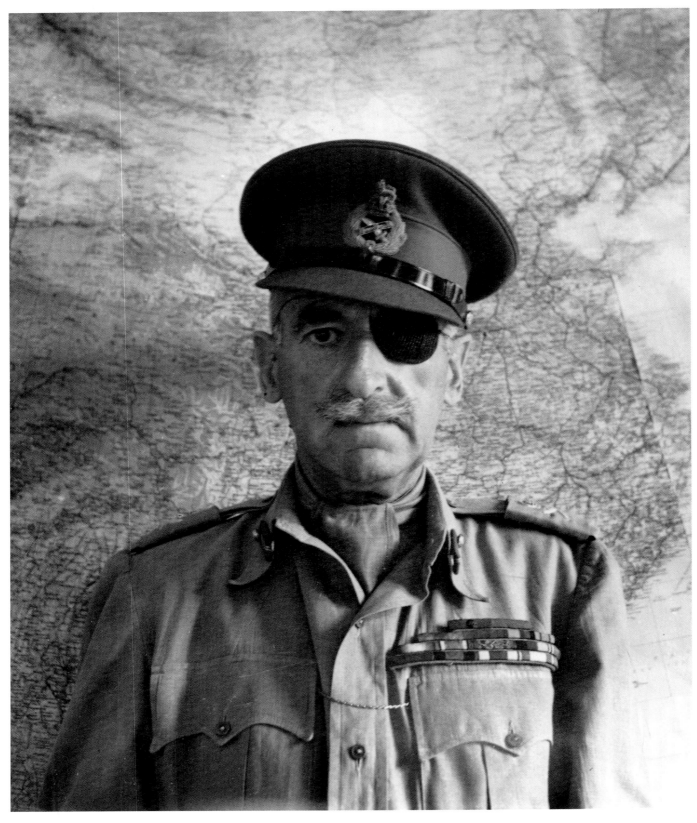

*Above:*
Portrait of General Carton de Wiart, 1944.

*Opposite:*
Cole Porter having breakfast. Photo by Jean Howard. Service by Paul.

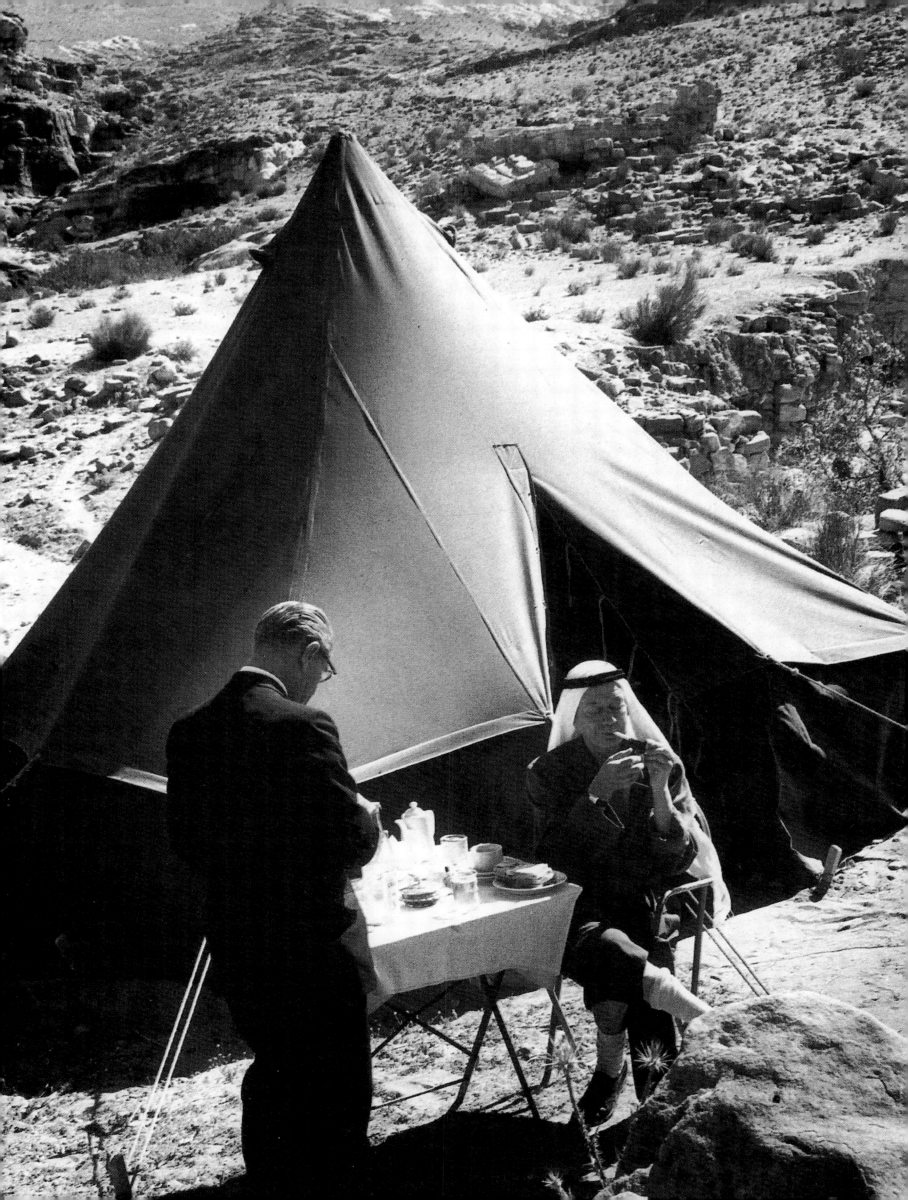

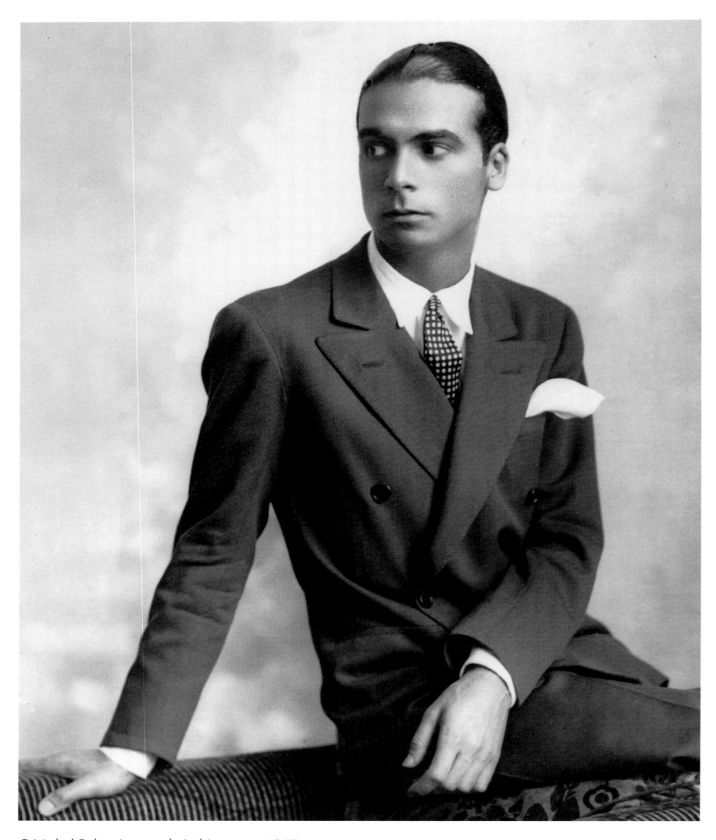

Cristobal Balenciaga early in his career, 1947.

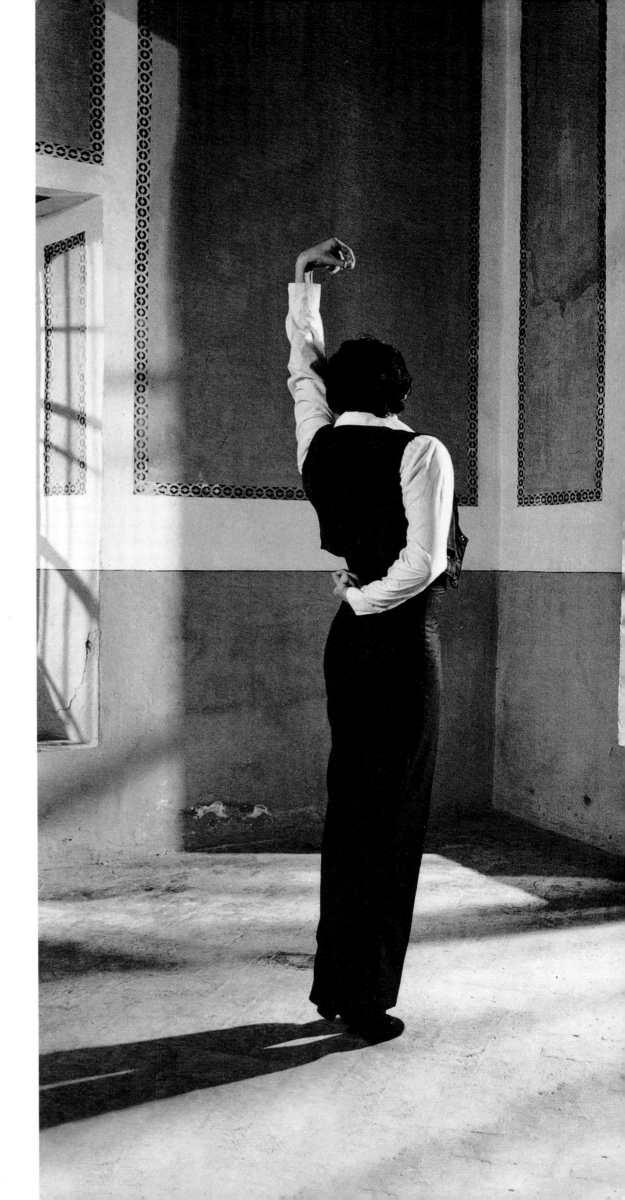

Flamenco dancer, photo
by Isabel Munoz, 1997.

between men's fashions and women's fashions.

As an age old ingredient of classical eroticism, up until the Belle Epoque, dressing up girls as boys rarely went beyond the confines of the stage or specialized establishments. From the 1910s, however, the prestige of a royal highness was behind the first practical appropriation of men's suits by women. Alexandra, Princess of Wales, whose status as wife of the future king Edward VII of England obliged her to travel a great deal, ordered a new type of dress from her usual supplier, Redfern, a couturier with premises in both London and Paris. She wanted more practical clothing than the impressive get-up that still prevailed among high society ladies, doing their good works, prior to the 1914-1918 war. For this slender, practical young woman, a stroke of genius had Redfern adapt the jacket recently made fashionable by well-dressed gentleman. By combining this with a simple, long, straight skirt cut from the same material. This marked the birth of the woman's suit, and we know what has happened to it since. Ten years later, women started to wear shorter hair. Half a century before Yves Saint Laurent, Coco Chanel would plunder the male wardrobe on behalf of women. It is not our task here, however, to explain why women's fashion-- which, since the Belle Epoque, witnessed so many revolutions, inventions, and propositions --should, at the end of the 20th century, look for the reasons behind its survival in the very restricted vocabulary of men's clothing.

The male losing ground is primarily concerned with defending a territory more and more under threat each day, but he persuades himself, even in the year 2000, that the influence of fashion on his daily life is superficial. As if those nobly proclaiming that "woman is man's future" were afraid that she might already represent the best aspect of his present. In just one century, the one will have tackled, head-on, more change than in a millennium, and embraced it enthusiastically, while the other sees the dangers of a ground swell in any new wave.

Having taken the rarefied world of women's fashion by storm, Pierre Cardin, who was still young, tried his hand at designing suits for men. His variations on the cosmonaut theme earned him more attention than clientele. In the 1960s, several others strayed into even more formidable situations. By dodging the pitfall of this futurism in favor of a light retro perfume, Saint Laurent Rive Gauche managed to survive. But in the early 1970s, men who would risk wearing a label with such successful feminine connotations were few and far between. It would be another ten years, and it would

Jitendra Narayan Bhup, just after his enthronement as Maharaja
of Cooch Behar, formal portrait by Lafayette in 1913.

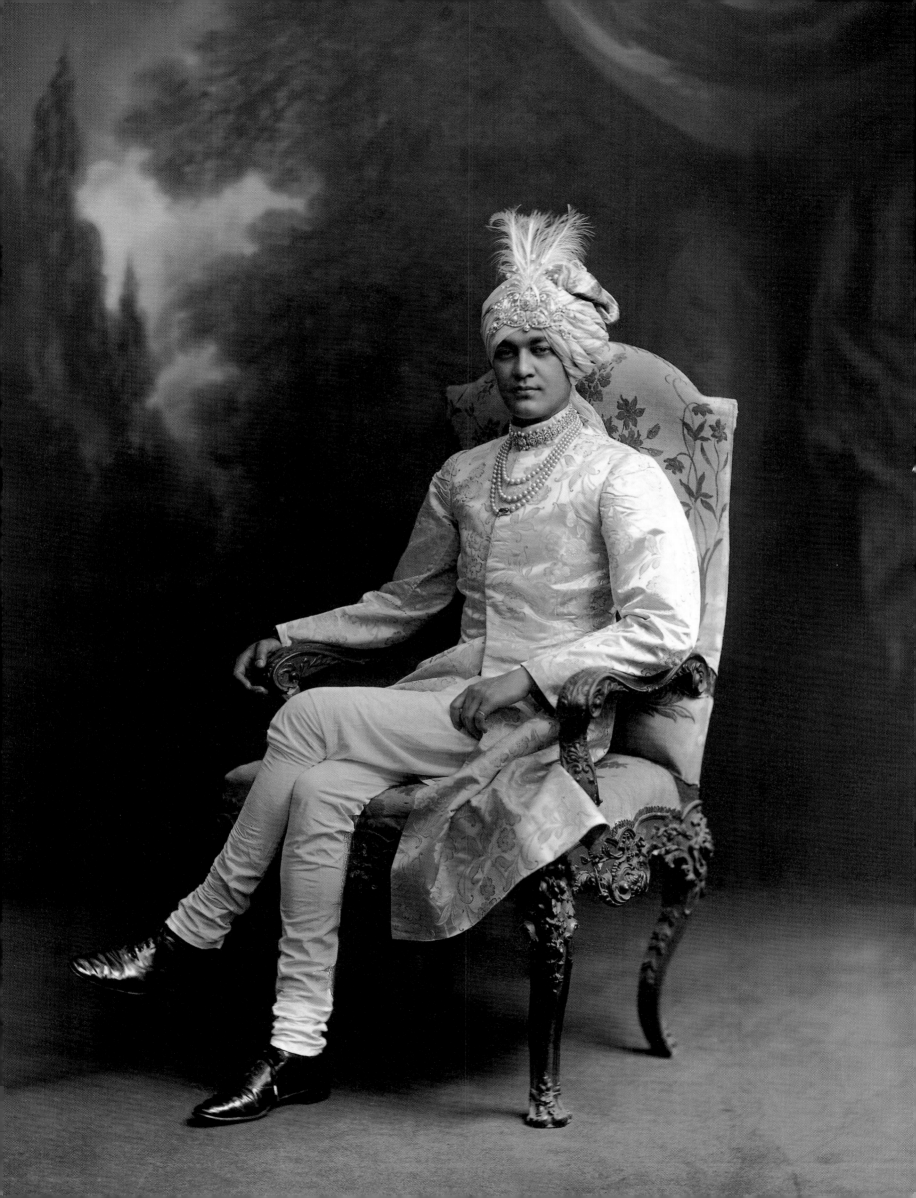

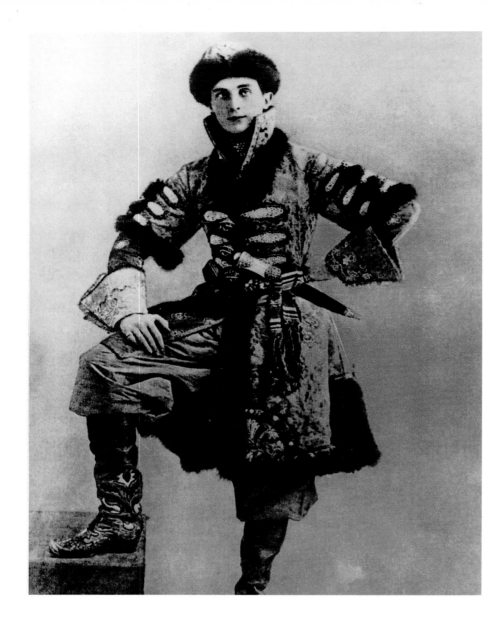

take Kenzo's wit, which was more comforting than Yves Saint Laurent's Proustian image, before a young, playful and cheerful "masculinity" would take root in the exclusive ready-to-wear sector. To this day, it is still virtually impossible to sell lines aimed at both genders in the same shop.

The Japanese of Paris have, without telling them in so many words, merely unpretentiously and unprovocatively applied to men the formulas which, ten years earlier, had enabled them to completely alter the wardrobes of young women of their generation. While, through a European network of shops as consistent, sober and precious as cigar-boxes, the Armani style pursued its inexorable upward course among young businessmen concerned with looking good while still looking respectable. Kenzo, at the other end of the spectrum, submitted every conceivable look to review--from the colonial to the Bedouin, from the Scottish to the Japanese, from the sailor to the punk... Using an uncoordinated, joyous and yet unpredictable palette, he took all kinds of flack, but his reputation came out of it intact. A virtuoso when it comes to the right amounts of sweet and spicy, winning the audience over, and slipping his fondness for things festive into his collections, the Kenzo line for men

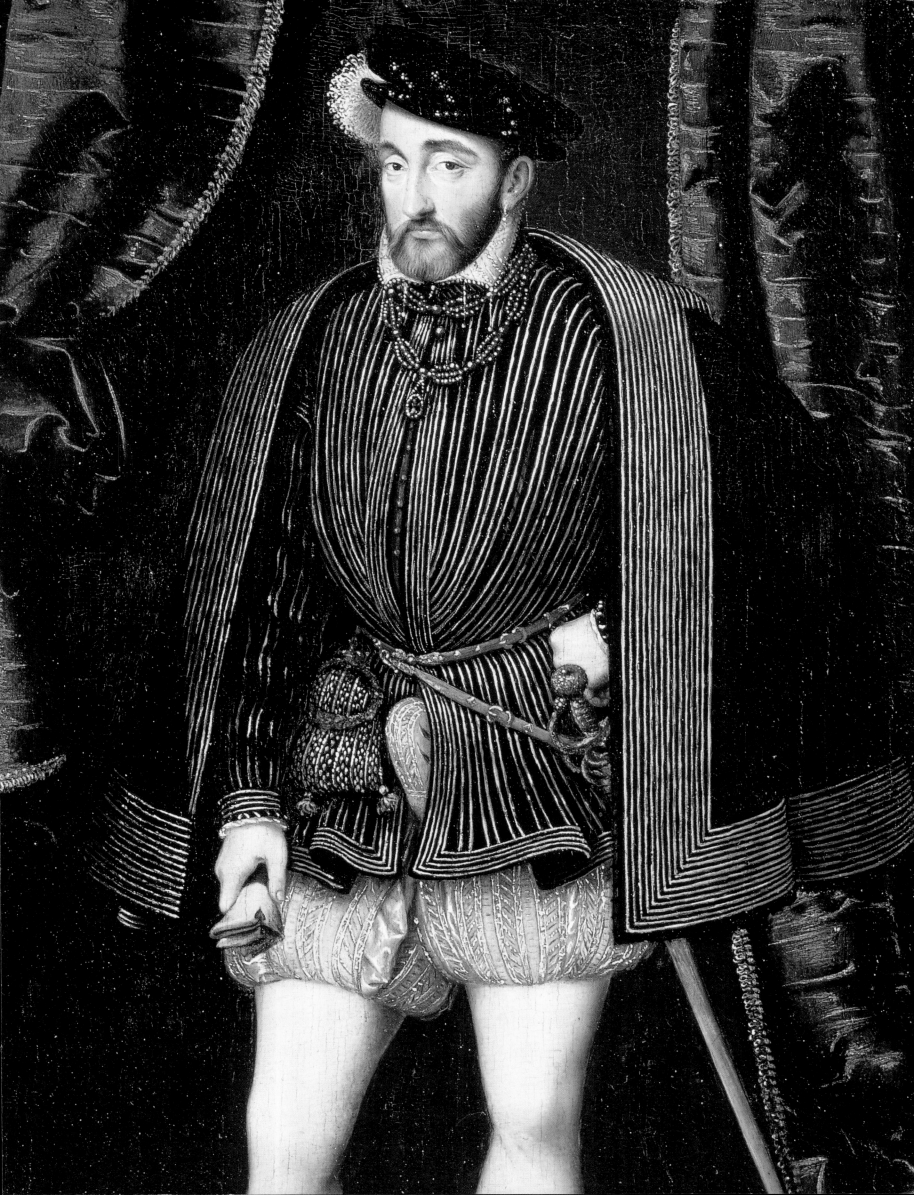

The painter Balthus
by Dominique Issermann.

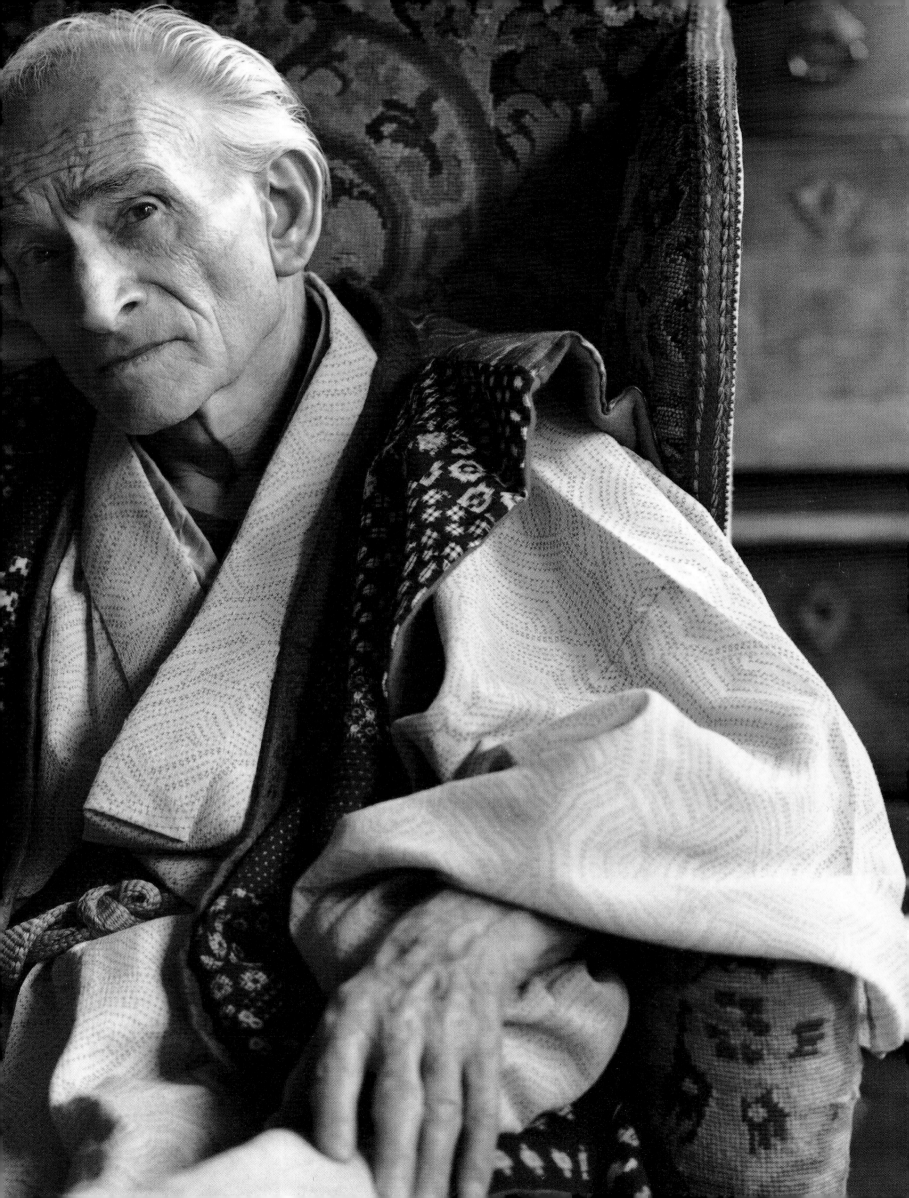

doesn't just stand out against urban drabness, but its undeniable refinement makes it a sign of class. The class of a man who's relaxed, cool, and young at heart, and seems to be on a never-ending holiday.

From 1985 onward, the shift in the male look ushered in by those henceforth called "the Japanese" turned out to be far more radical. Unlike Kenzo, these "Japanese" didn't fit in with Paris or its fashion, or with French ways of making things. Armani wanted to be persuasive. Kenzo seduces. Yohji Yamamoto and Rei Kawakubo (for Comme des Garçons) would start out by terrorizing. For the very first time, in the as yet ill-defined men's market, we find the same mechanisms at work that govern women's fashion since it has been freed from the rules of etiquette. Hitherto, apart from one or two eccentric attempts with little future ahead of them, men's attire was limited to confirming traditional uses, give or take a few variants. Through this "Japanese connection", it would now authorize its own dissent. By completing, in the century's final decade, a break which everyone had given up on. It went way beyond the challenge introduced by these fringe elements of the land of the Rising Sun. But without claiming as much, they would be its initiators. There's a before-Yohji. As we wind up these thoughts about the way man look, in an altogether provisional way, let us hasten to add, there is not yet an after-Yohji. How did this distant observer of western rituals, whose ancestors, and parents themselves, had worn the unvarying kimono for centuries, manage to exert such terrorism over the leaders of contemporary style?

Distance, as we observed at the beginning of our survey in relation to Beau Brummell, is one of the essential ingredients of male elegance. The distance which inspires the Japanese is clearly both geographical and cultural. The way they have been looking at old Europe since the end of the Second World War is a mix of intense curiosity, a certain reserve, and profound perplexity… Japan wants to understand, take and reconstruct, all at once… but in a different way. Its mirrors reflect for a long time before sending us back our image. And this image is radically altered. By excessive anamorphosis, and a dissent coming from within. This implosion has made it possible to drive that permanent fixture, the grey suit, back into a corner. This approach, more analytical than aesthetic, was probably the only one capable of shattering the mask beneath which the modern look was only half breathing. At "Comme des Garçons" and "Yamamoto," the model is no longer Cocteau, the Duke of Windsor, and Hollywood

Max Ernst, through the lens of Man Ray, 1935.

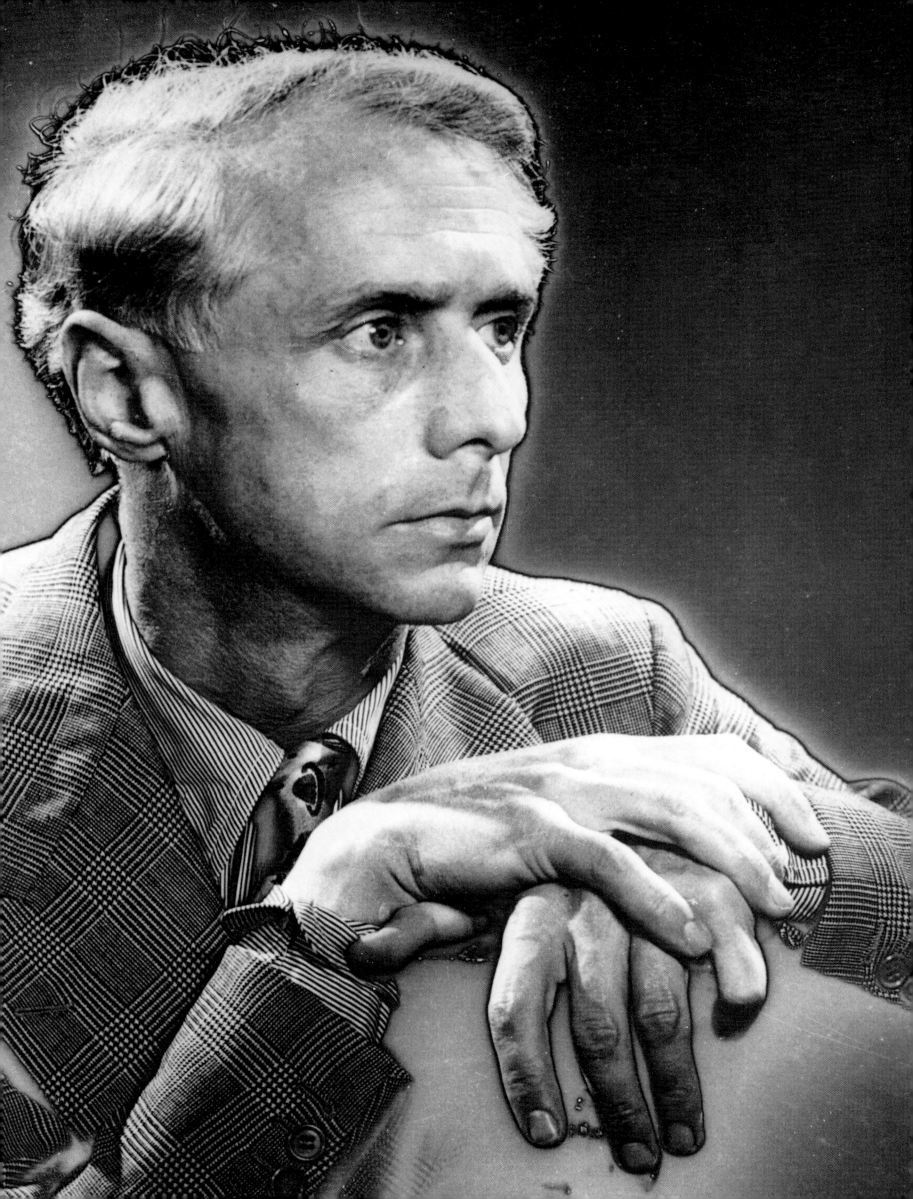

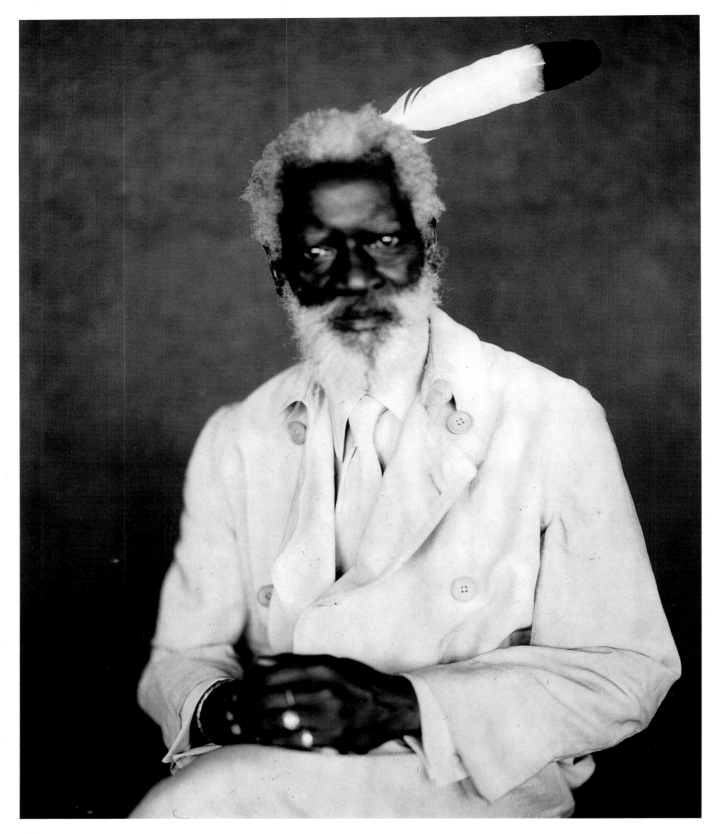

*Above:*
Paolo Roversi for Uomo Vogue, January 1997.

*Opposite:*
Young farmers decked out in their Sunday best
by August Sander, Westerwald, c. 1914.

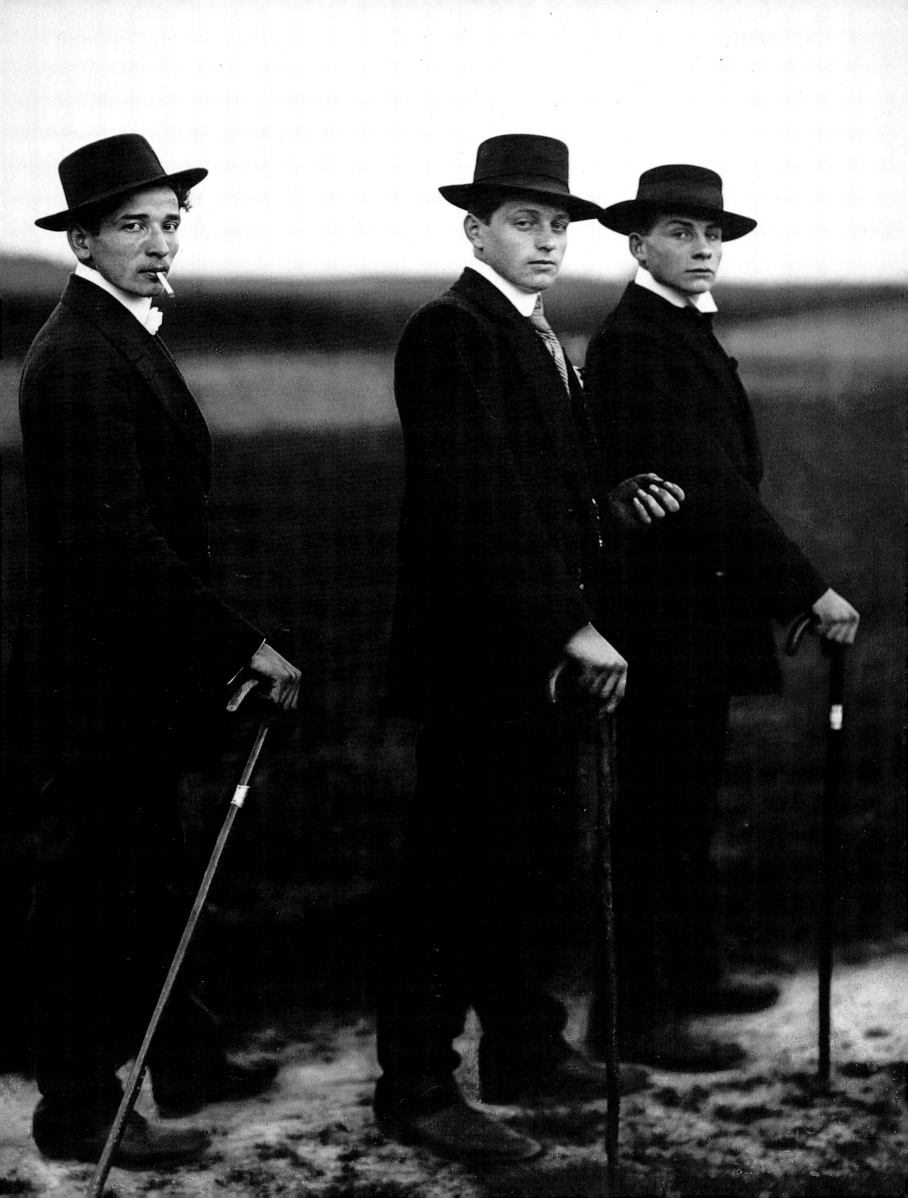

Karl Lagerfeld in front of his
Hamburg mansion, May 1995.

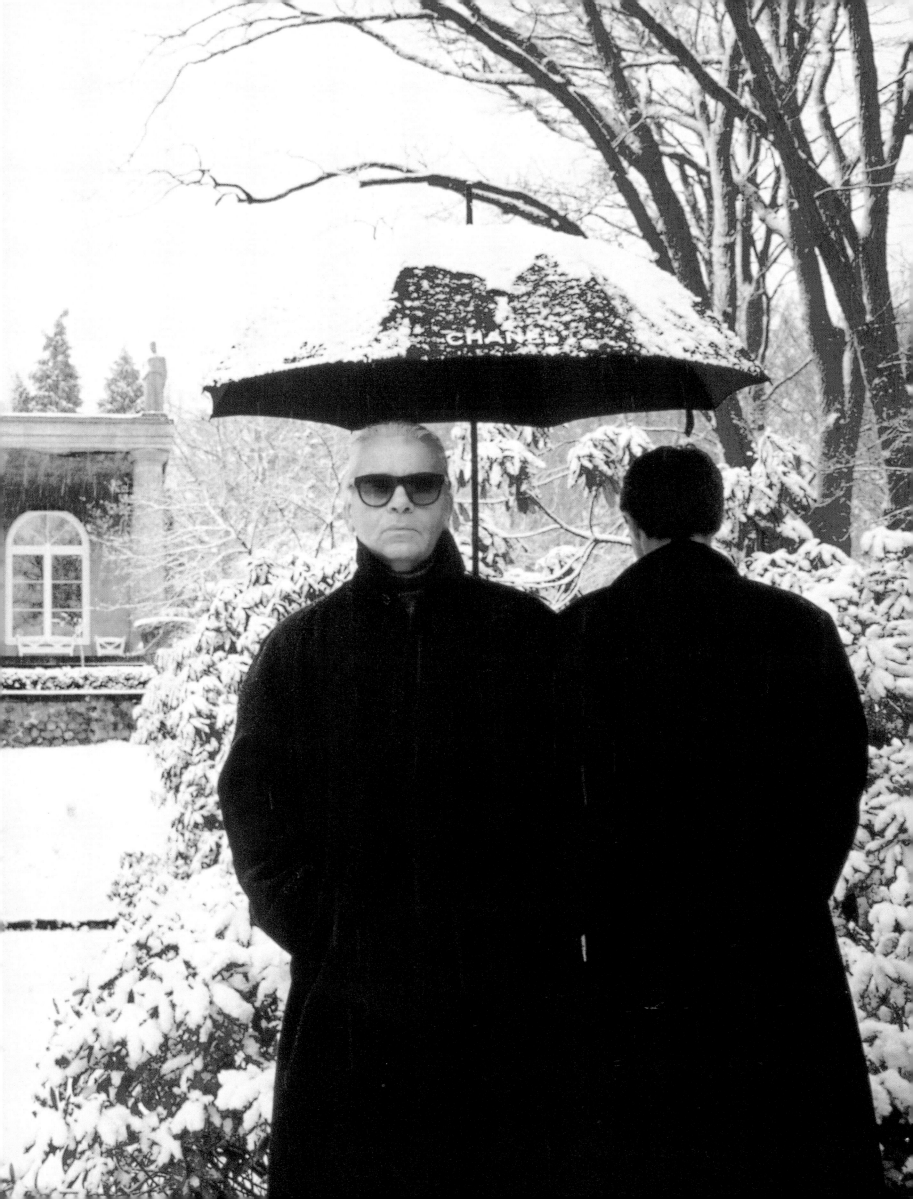

movies, in their heyday. It is very unmistakably somewhere between Marcel Duchamp and Gilbert & George. The scandal triggered by their first shows could have been compared to the one triggered by readymades in 1920. Yohji Yamamoto had a rebellious youth that could be compared to the hippies. Rei Kawakubo kept a keen eye on the punk movement. To these extreme subversions, transmuted by Japan's huge modesty and sense of propriety, and its sense of the unspoken, they added a very refined form of sophistication. The existential elements they juggled with were not those of the traditional revolutionary outfit. Drawing, quite to the contrary, from the culture of two centuries of elegance and fine living, they came up with a quintessential formula of the middle-class suit: tired, crumpled, gloomy, black tie and white shirt, full of carefully calculated awkwardness, its dark colour range painstakingly reduced, and the slightest stylistic effect systematically neutralized. Culminating, at the very end of the century, as the ultimate decadence or renaissance in extremis, in a profile referring to The State of Things filmed in black-and-white by Wim Wenders, or In Praise of Shade, deciphered by Cioran, who was nevertheless in his eighties when he died. The Japanese are quite something! If the suit of the future is to change, it will have to make a huge leap forward. There's no question of turning back the clock. They've burned all the bridges. Unless things stay the way they are. Like the Egyptians in their day, suspended in the immutability of their ruins, the great adventure is just starting for the profile the man of the future will have.

*Epilogue*

There are 24 steps leading up to the Festival Center at Cannes and each year, in honor of international cinema, a certain number of celebrities climb those 24 steps, besieged by hundreds of photographers who have flown in from all over the world. In 1986, the person the popular dailies spontaneously christened "fashion's enfant terrible" ascended this Golgotha of media coverage, from which he was mercilessly turned away as soon as he reached the top. And yet, Jean-Paul Gaultier was wearing evening attire, as stipulated by the invitations. His attire--of his own invention--was indeed dark, and his shirt a dazzling white. But beneath his dinner jacket he wore short black trousers, revealing two thighs blushing with embarrassment. Still maintaining that inevitable smile, the star of French fashion walked back down the grand stairway, under the reproachful eyes of attendants dressed like casino croupiers.

Rudolf Nureyev, at *Monte Carlo Beach,* 1966.

A few seasons earlier, Jean-Paul had been invited, along with the whole of the who's who of fashion design, to the Élysée Palace by the President of the Republic, and he caused quite a stir, but not a scandal, by sporting beneath his meticulously cut jacket a flowing skirt made in the same fabric. He has taken things a step or two further since then. Eager to prove that he could find his way into the inner circle of great Parisian couturiers, he chose to show a series of sumptuous evening gowns, made-to-measure by the rule book, and worn by male models displaying an unambiguous virility. Nothing about this smacked of the long-standing tradition of female impersonators nor drag queens, without whose presence no party would be considered a success on the other side of the Atlantic. With a quiet forcefulness--the same that once prompted Yves Saint Laurent to pose in a studio with his sister, both clad in the same unisex safari jackets, Jean-Paul carries on his discourse on gender-mixing in a straightforward, unprovocative way. Creating an inevitable muddle of feelings, this exchange of fantasies with their mixing of races and types combined with this rejection of all a prioris harbingers the construction of a new world. Confined just to Gaultier, this manifesto might appear to be that of a utopian *élite*. But a brand concept,

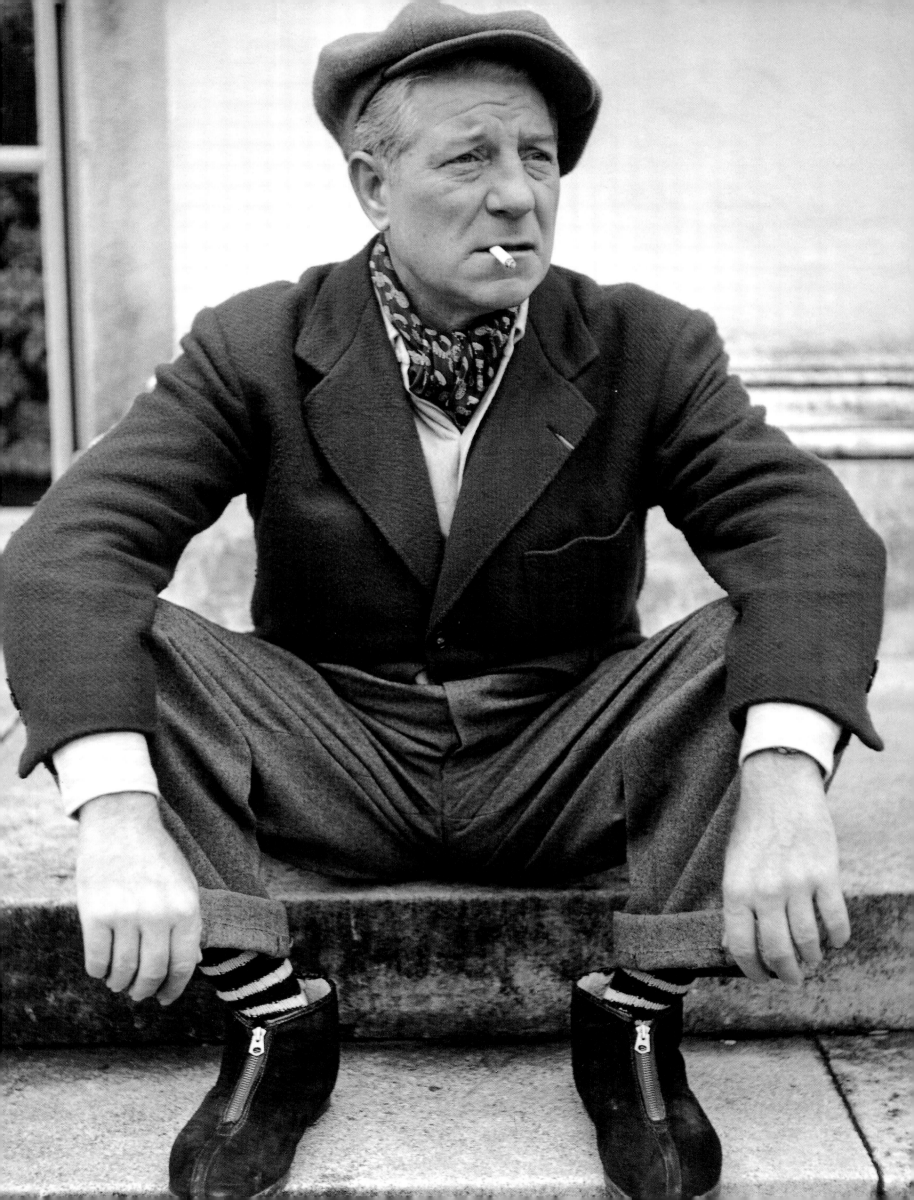

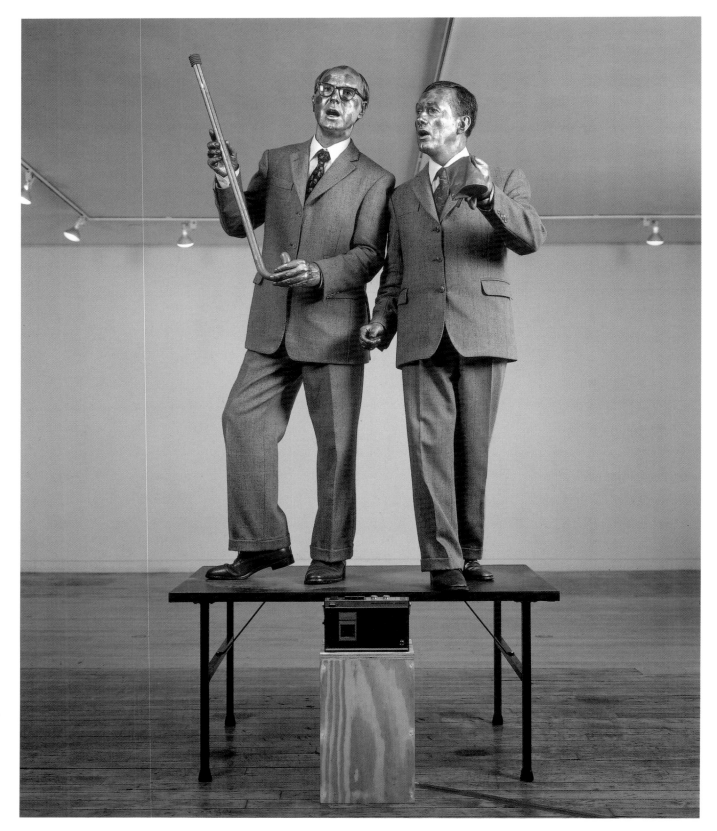

*Above:*
Gilbert & George, *The Singing Sculpture,*
photographed at the National Gallery, Sydney.

*Opposite:*
Yohji Yamamoto's Men's Collection for
Fall/Winter, 1986-1987, photo by Nick Knight.

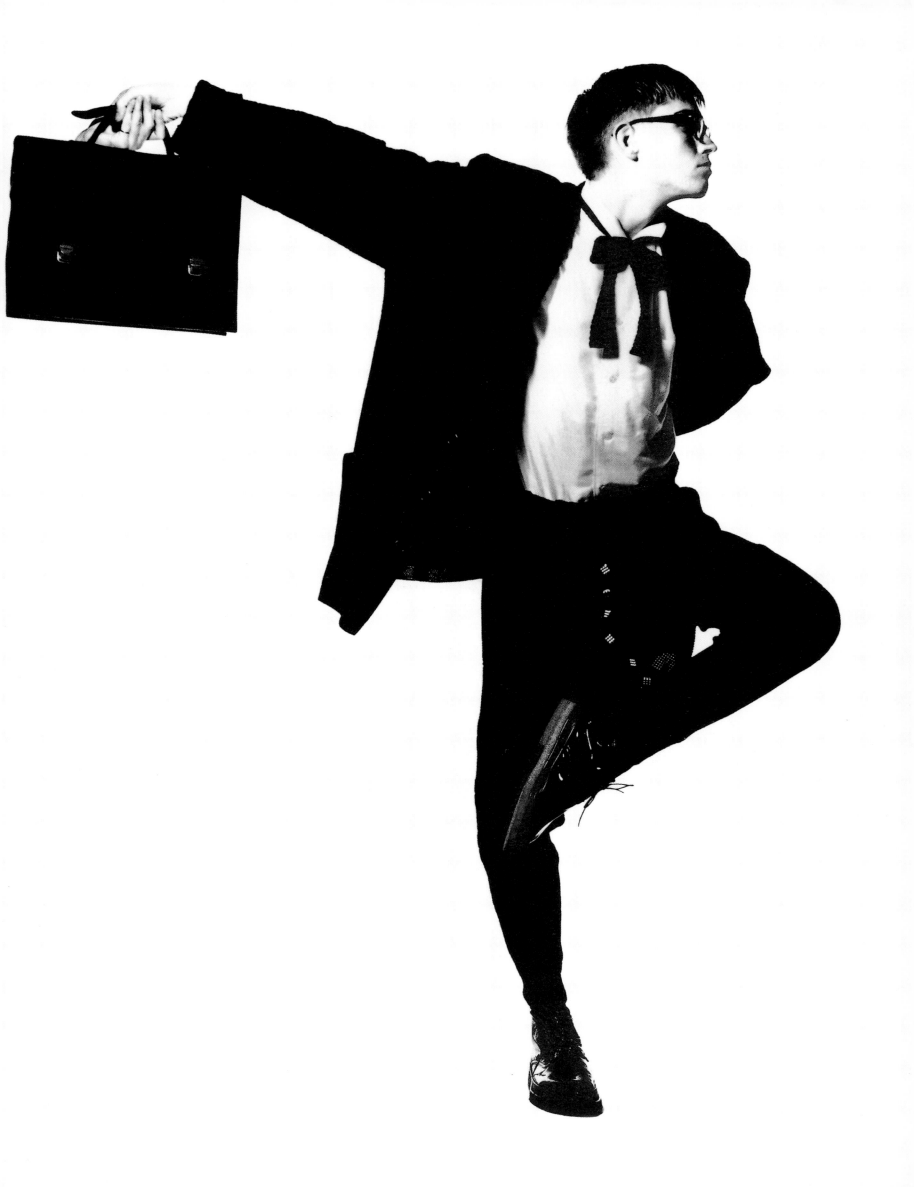

like Calvin Klein's, specialized in the American mass product, makes use of the same discourse when it adapts pouch-front briefs to evanescent top models, or markets a unisex perfume to the chant of the admittedly not very risky slogan "Be Yourself!" Where is allure in all of this? We might well think the old concept obsolete, once and for all. But the opposite is the case. Not just Japanese designers have recently demonstrated that there's more to glean from a stance than a look. More in a lifestyle than in the actual choice of a piece of clothing. The allure--to imitate the style of the famous saying about culture--is what is left to man when he's forgotten all about the ways and habits of elementary stylishness. Anything can be said to anyone. Provided that you say it politely, my grandmother would say--and she would have felt disgraced by following fashion. But at more than 100 years old, she hadn't put on a pound since her marriage. Nor had she lost one iota of her girlish looks and charm. It wasn't a question of honor or pride for people like her. They quite simply didn't imagine things could be any other way. A body, a piece of clothing--the one for the other, the other through the one. Both ambling along, with ease and without affectation. And without any concern save that this one, having been slipped into that one, should feel sufficiently comfortable not to be thought about. As for the rest, everyone senses it intuitively: the allure only exists in the eye of the beholder.

Prince William at Eton, June 2000.

# PHOTOGRAPHIC CREDITS

Cover: © Cecil Beaton. Courtesy of Sotheby's London; 5: Private collection; 9: © Eisenstaedt/PPCM; 11: © Rue des archives; 12: © Die Photographische Sammlung/SK Stiftung Kutur/August Sander Archiv, Cologne/Adagp, Paris 2000; 13: © Alexia Silvagni/Michele Filomeno; 14: © André Rogi, 1938; 15: © Herbert List/Magnum; 16-17: © Wayne Miller; 19: © Photo P.Horst/Hamiltons Photographers Limited/Fiona Cowan; 20: © Claude Schwartz/Agence Vu; 21: © Zalewski/Rapho; 22: © Hulton/Getty One Stone; 23: © Eisenstaedt/Life Magazine/PPCM; 24: © Photo Paul Almasy/AKG Paris; 26: © Christie's; 27: © Rue des archives; 28: © Rue des archives/Agip; 29: © Royal Archives Windsor Castle; 31: © Walter Carone; 32: © Bibliothèque nationale de France; 33: © AKG Paris; 34: © Collection Viollet; 36-37: © Hulton/Getty One Stone; 38: © Martin Santos Yuberos; 39: Private collection; 40: © Photo Giraudon/Art Ressource NY; 41: © George Rodger/Magnum; 42: © Bauhaus Archiv, Berlin; 43: Jacques Borgé Collection ; 45: © Henri Cartier-Bresson/Magnum; 46: © Peter Rowen. Courtesy of Galerie Jérôme de Noirmont; 47: © Keiichi Tahara; 48: © Hulton/Getty One Stone; 49: © Oliviero Toscani/ Condé Nast Italia; 50: © Walter Carone; 51: © Rue des archives; 52: © Photo Laziz Hamani/Assouline; 53: © Photo Lucien Crouzet/Collection Michel Avousten; 54: © Archivio Fotografico Teatro Alla Scala; 55: © Hulton/Getty One Stone; 56-57: Hulton/Getty One Stone; 58: © D.Broussard/Elle Scoop; 59: © Roger-Viollet; 60: © L'Illustration/Sygma; 61: © Ministère de la Culture, France/A.A.J.H.L.; 62: © Roger-Viollet; 63: © Rue des archives/Agip; 64: © Rue des archives; 65: © Archives de la SBM; 66: © Jacques Lowe; 67: © Jacques Lowe; 68: © Jean-Marie Périer; 69: © Dennis Stock/Magnum; 70: © Bruno Bisang; 71: © PPCM/EON/United Artists; 72: © Cecil Beaton. Courtesy of Sotheby's London; 73: © Photo P. Horst/Hamiltons Limited/Fiona Cowan; 74: © Rue des archives; 75: © KOBAL/PPCM; 76: © Martin Santos Yuberos; 77: Paramount; 78: © Claude Gassian; 79: © Photo John Wakeham for Claude Cahun; 80: © Philippe Halsman/Magnum; 81: © André Villers; 82: © Rue des archives; 83: © Associated Press. Private collection; 84: © Rue des archives; 85: © Archives de la SBM; 86: © Rue des archives; 87: © Archives de la SBM; 88: © Bauhaus Archiv; 89: © Ministère de la Culture, France/Patrimoine photographique Catalog; 90: © PPCM; 91: © Roxanne Lowit; 92: © Paolo Roversi; 93: © Kurt Markus, 2000; 94: © Calvin Klein/ Bruce Weber; 95: © Jeanloup Sieff; 96: © Rue des archives, Archive Photo France/Catherine Terk; 97: © Hulton/Getty One Stone; 99: © Corbis/Courtesy of Condé Nast Italia; 100: © Cecil Beaton/Sotheby's London; 101: © Photo P. Horst/Hamiltons Photographers Limited/Fiona Cowan; 102: © Cecil Beaton/ Sotheby's London; 103: © Jean Howard; 104: © Photo Lipnitzki-Viollet; 105: © Isabel Munoz/Agence Vu; 107: © Victoria & Albert Museum Picture Gallery; 108: © Rue des archives; 109: © AKG Paris; 110-111: © L'Office/Photo Dominique Issermann; 113: © Man Ray Trust/Telimage/Adagp, Paris 2000; 114: © Paolo Roversi/Condé Nast Italia; 115: © Die Photographische Sammlung/SK Stiftung Kultur/August Sander, Cologne/Adagp, Paris 2000; 116-117: © Jean-Marie Périer/Elle Scoop; 119: © SBM Archives; 120: © Raymond Cauchetier/Les Cahiers du cinéma; 121: © Walter Carone; 122: © Prudence Cuming Associates Ltd; 123: © Nick Knight; 123: © Sipa Press.

# ACKNOWLEDGMENTS

We would like to express our special thanks and recognition to all those who in some way or other contributed to this book; whose especially indebted to: Miguel Angel, Marlon Brando, Alain Delon, Willy DeVille, Gérard Garouste, Jean-Paul Gaultier, Gilbert and George, Johnny Hallyday, Mick Jagger, Kenzo, Earl Klossowski de Rola, Karl Lagerfeld, Eric Pfunder, Prince Philip, Yves Saint Laurent, Prince William, Yohji Yamamoto, and Bruno Bisang, Dennis Broussard, Raymond Cauchetier, Gilbert & George, Laziz Hamani, Dominique Isserman, Nick Knight, Roxanne Lowit, Jacques Lowe, Kurt Markus, Messieurs MacDermott and MacGough, Isabel Muñoz, Jean-Marie Périer, Paolo Roversi, Jeanloup Sieff, Alexia Silvagni, Lance Staedler, Dennis Stock, Keiichi Tahara, Oliviero Toscani, André Villers, Bruce Weber.

The publisher is especially thankful to Jacques Helleu for lending his favorite picture, "Philip, Duke of Edinburgh."

We also express our recognition to the agencies, collectors, galleries, magazines, museums and companies we contacted: Adagp, AKG photo (Fabienne), Agence Vu (Malika Barache), Archivio Fotografico Teatro alla Scala, Association des amis de Jacques-Henri Lartigue, Association pour la diffusion du patrimoine photographique, Michel and Marijo Avousten, Bauhaus-Archiv Museum für Gestaltung, Gabriel Bauret, Bibliothèque Nationale de Paris, Marie-Christine Biebuyck (Magnum), Jacques Borgé, Christian Bouqueret, Brioni, Pierre-Yves Butzbach (Télimage), Cahiers du Cinéma (Catherine Fröchen), Serena and Catherine Carone, Chanel (Marika Gentil), Christie's, Comme des Garçons (Yelka Music), Condé Nast Publications Inc., Corbis-Outline (Arnaud Adida), Fiona Cowan (Hamiltons Photographers Limited), Nicolas Dadeshkiani, Anne Druba (Schirmer/Mosel Verlag), ELLE, Sue Daly (Sotheby's), Michele Filomeno Agency, Sylvie Flaure, Jérôme de Noirmont Gallery (Vincent Boucheron), Jean-Paul Gaultier (Lionel Vermeil), Giraudon, Heidi Hartwig (Roxanne Lowit Photographs), Hulton Getty/Fotogram-Stone Images (Maël), Kenzo (Ruth Obadia), Keystone, Calvin Klein (Alix de Chabot), Maria Markus, Richard L. Menschel, Musée d'Art moderne de la Ville de Paris (Gérard Audinet), National Gallery New South Wales-Sydney, Jean-Jacques Naudet, NK Image Ltd (Phillippa Oakley-Hill), Nathalie Ours, Die Photographische Sammlung/SK Stiftung Kultur-August Sander Archiv, Marc Possemier, PPCM (Fabienne), Prudence Cuming Associates Limited (Natalie), Rapho, Sébastien Ratto-Viviani, Roger-Viollet (Michèle Lajournade), Marina Rossi (Vogue Italie), Rue des archives (Catherine Terk), Yves Saint Laurent (Dominique Deroche), SBM, Scoop (Patricia), Michael Shulman (Liaison Agency Inc.), Irène Silvagni, Sipa Press (Martine), Studio Luce (Anna Hägglund), l'agence Success (Jean-Jacques), Sygma, Victoria and Albert Museum (Nick Wise), Yohji Yamamoto (Angie Rubini).